Photo Inspiration
Secrets Behind Stunning Images

Credits

Acquisitions Editor
Courtney Allen

Project Editor
Dianne Russell
Octal Publishing, Inc.

Copy Editor
Bob Russell
Octal Publishing, Inc.

**Editorial
Coordinator**
Carol Kessel

Editorial Director
Robyn Siesky

Business Manager
Amy Knies

**Senior Marketing
Manager**
Sandy Smith

**Vice President and
Executive Group
Publisher**
Richard Swadley

**Vice President and
Executive Publisher**
Barry Pruett

Project Coordinator
Dianne Russell
Octal Publishing, Inc.

Production Services
Octal Publishing, Inc.

Photo Inspiration, Secrets Behind Stunning Images

Published by
John Wiley & Sons, Inc.
10475 Crosspoint Boulevard
Indianapolis, IN 46256

Copyright © 2011 by Pagina Förlags AB

Published simultaneously in Canada

ISBN: 978-1-118-29052-1

Manufactured in the United States of America

10 9 8 7 6 5 4 3

For general information on our other products and services or to obtain technical support, please contact our Customer Care Department within the U.S. at (877) 762-2974, outside the U.S. at (317) 572-3993 or fax (317) 572-4002.

Wiley publishes in a variety of print and electronic formats and by print-on-demand. Some material included with standard print versions of this book may not be included in e-books or in print-on-demand. If this book refers to media such as a CD or DVD that is not included in the version you purchased, you may download this material at http://booksupport.wiley.com. For more information about Wiley products, visit www.wiley.com.

Library of Congress Control Number: 2012934906

Contents

THE BOOK you are now holding in your hand is not like any other Photo book that you've seen before. It's not a standard coffee-table book, because it contains detailed descriptions about how every photo is made. But it's not like an ordinary photography tutorial, either, because it doesn't contain test images. In fact, it's a combination of an exquisite coffee-table book and a "how-to" guide. Indeed, it's a unique publication that happens to include over 100 extraordinary pieces of art.

This book doesn't have a beginning or end. It's not divided into sequential chapters. You can flip through the book in any way you like, stopping at an interesting page to learn more about how a certain photo was created.

Many photographers spend thousands of dollars on photographic gear. Yet, ultimately, most learn that a fantastic camera doesn't automatically take fantastic photos. After a while, your expensive equipment will just be collecting dust, because you have lost interest. On the other hand, an experienced professional photographer can take fantastic pictures with pretty much any camera, even a mobile phone, for example. Photography is not about the equipment, it's about imagination, communication, and a way of seeing. This book might be the best photography investment you have ever made, because it is filled with inspiration, and it will help you take the next step as a photographer and artist.

All of the photographs in this book are gathered from 1x.com, the world's most popular curated online photo gallery, with up to 150,000 individual visitors a day. 1x.com is a photo community with a difference, because every photo published has been hand selected by a team of eleven curators, with expertise in different areas. For this book, we have selected some of our favorites among our already very high-quality photos, so in essence, it's the best of the best. We have also made sure to select photos that are especially interesting from a learning perspective.

Our curation process ensures a high level of photographic excellence in the gallery; it's hard to get published. At first glance, this might seem elitist, but we believe that maintaining high standards and expectations is the best way to challenge individuals to improve. Thus, it's not so about elitism; it's about caring. If a photo is not selected for publication at 1x.com, it doesn't mean it's the end of the story. Learning is one of our key values, that's why we created this book, and that's why we have created a unique set of online tools to learn photography that includes direct feedback from our community.

You will not see anything like the in-depth discussions that are in the 1x.com critique forum elsewhere on the web. With the same philosophy of quality as in our gallery, our moderator team ensures that the quality level in critique is equally high. Short comments such as "nice shot" or "not my cup of tea" unaccompanied by an explanation are not allowed, because they don't help the photographer to develop. Through their written critiques, the moderators will give you tips, hints, and encouragement about how to develop your skills.

To be able to gain feedback on a photo, you first have to write a critique on two other photos. First, this ensures that all photos accumulate a lot of useful feedback, and second—and at least as important—teaching is often the best way of learning. When you write feedback about someone else's photo, you really have to analyze it in terms of light, composition, message, mood, and story. This will lead to you viewing your own photography from a different perspective. You will develop your way of seeing.

Sometimes, beginners are afraid to write feedback on others' photos because they don't think that their opinion matters. However, everyone should keep in mind that the majority of people looking at a photograph are not going to be photography experts, and therefore, it's equally interesting to know how non-experts interpret a photo.

At the same time, we should not ignore what the experts have to say, either. What really makes our critique forum stand out are our experienced and especially appointed senior critics, who will provide expert critique on your photos. We believe that a mix of experts and amateurs makes a perfect blend.

Giving is the best way of gaining, and teaching can be the best way of learning. Another great way of teaching and learning at the same time is writing about your own photos, such as the photographers did in this book. When describing your photo, you have to ask yourself important questions. What really was the idea behind it? What did you want to say with it? What could you have done differently? There's a vast resource of detailed photo tutorials on 1x.com for your inspiration.

In this book, we have gathered the collective wisdom of more than a hundred skilled photographers. Because the tips and hints are specific about each photo, I will take the opportunity to share my most important general hints about taking photos.

A common hint in books teaching photography is to break the rules. But before you start breaking the rules you need to know and master them. You must learn how to walk before you can fly.

You shouldn't break a rule just for the sake of breaking it. If you break a rule, there must be a reason for doing so. The same goes for every technique that you use or effect that you apply to a photograph. There must always be a reason, and the goal should always be to reinforce the idea and message of the photograph. If you apply an effect to a photograph or include an element that doesn't fit at all, it's a breach of style. Not to confuse the viewer, you should avoid doing so, unless the exact point is to create an interesting contrast.

This doesn't mean you shouldn't experiment. Forget the rules sometimes, go wild, be creative and you will discover new unknown continents of the photographic world. Combine different techniques and always look for a new angle, both literally and figuratively. A skilled photographer can make any subject his or her own, for example there are many original photos of the Eiffel Tower published on 1x.com, even though it's one of the most photographed landmarks in the world.

A big part of my inspiration behind 1x.com is the book *Zen and the Art of Motorcycle Maintenance*, by Robert Pirsig. This classic read is about defining quality and asks questions about what is good or bad? What is art and what is not? How does a photo gallery curator decide which photos to hang on the gallery walls?

Pirsig defines art as caring about your work. Thus, anything can be refined into an art: science, music, painting, making food, keeping your garden, or even sweeping the floor or fixing your car. Art is about caring about your work and being genuine; it's that simple. This means you have to go out and photograph every day and never give up if you really want to improve. No matter what certain books or people tell you, there are no shortcuts. To really succeed, your photos must come from your heart and be a reflection of your soul.

Quality and learning are two of the most important aspects of 1x.com. The third is being part of a community. When enjoying and creating art, borders are irrelevant. 1x.com is a true melting pot with over 180 different nationalities represented, and you will make new friends from around the globe. Because there are so many talented photographers in our community, you will have the opportunity to learn from the masters by chatting with them directly.

The goal of 1x.com is to promote photography as an art form, and as stated in our motto, to reach for the sublime. Learning is so important to us, because we believe that everyone has a huge inner potential, just waiting to be unlocked. With the right encouragement, inspiration, and dedication, we believe that anyone can become an artist.

Special thanks to Chris Dixon, Gerard Sexton, Jef Van den Houte, John Parminter, Klaus-Peter Kubik, Per Klasson, Lennart Medin, Tobias Richardson and all the photographers for making this book possible and to co-founder Jacob Jovelou for programming the whole site and making 1x.com possible.

–Ralf Stelander, founder of 1x.com

Abstract photography is often defined as images in which the subject is not immediately apparent. It uses the visual language of line, shape, and color to create images that function outside of references to an obvious subject. It removes recognizable detail and instead focuses on intuitive recognition.

It could be said that abstract is the most cerebral but also the most intuitive of all the different genres of photography. Abstract combines reason and intuition to come up with work that exhilarates both the photographer and the viewer.

Abstract images are cerebral and often ambiguous. They make the viewer think. And they raise questions. "What is it?" "Does it matter?" "How was the image made?" "Why was it made?" "What did the photographer have in mind when she made the image?" "What does it make me think of when looking at it?"

Abstracts communicate intuitively through:

Emotions. Abstract images make the viewer feel as if they've been transported to a place created by the image, a place of imagination and play. They can pique our curiosity and often cause a foolish laughter when we suddenly discover a new way of seeing.

Imagination. Abstract images encourage the viewer to create stories, to view things differently, to understand subjects outside of their stereotypes, not only in photographs but in daily life.

Play. Abstract images are full of play. The photographer plays with line, shape, and color to find the subject. The images tease the viewer, and the viewer interacts with them both rationally and intuitively, almost as if playing a game.

The best abstract images combine all of these elements. They appeal to the viewer's mind as well as the emotions. They work when the viewer becomes intrigued and curious and yet also allow the viewer to come up with their own interpretation or fantasy. The best abstract images are also, of course, beautiful.

Here are some tips for taking abstract photos:

Know the basics. Conventional photographic principles (shutter speed, aperture, focusing, film speed, lighting effects, filters, and so on) apply to abstract photography as much as they apply to any other genre.

Know your equipment. Macro and telephoto lenses are useful for abstract photography, but any camera/lens can be used. Compact cameras, with their very close focus, can produce excellent results.

Explore the potential of your camera and your post-processing software. Try extreme f/stops, abnormal exposures, double exposures, camera movement, lens zoom, blending of images.

Break the rules. The subject does not always have to be in focus, nor is the *rule of thirds* written in stone. Do whatever works to bring your vision to life.

Experiment, experiment, experiment.

Practice, practice, practice.

Always remember that abstract photography is a way of seeing, not a technique.

–Ursula I. Abresch

Abstract

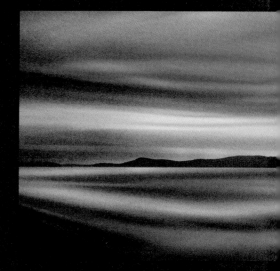

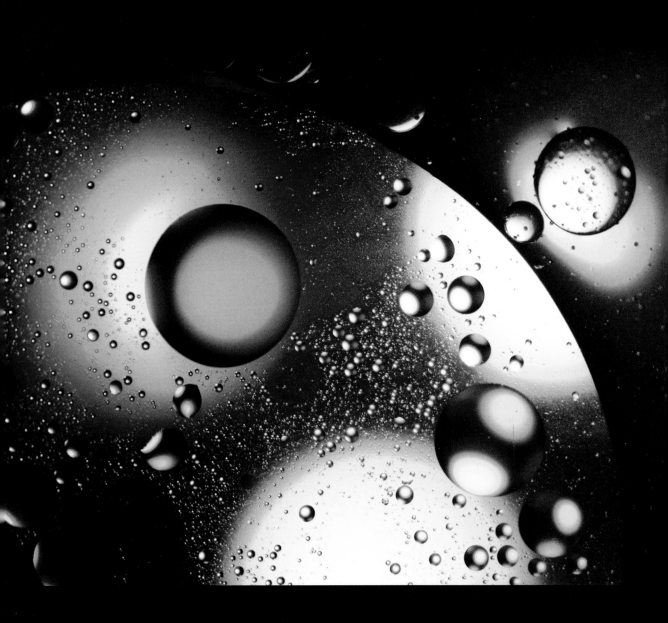

Nikon D700 • Nikon 105mm lens • f/4.5 • 1/250 second • ISO 250 • on-camera flash

Sunrise

 Chris
Dixon

It was cold, wet, and gloomy outside (a typical English winter's day), so I decided to have a play with creating an "oil and water" abstract, something I had not done before but had been inspired to try based on similar shots in 1x.com and other sites.

I retired from IBM last year with a view to using photography as a means to get out of the house and go and see different places with my wife. I had played with cameras in the past—the usual family and holiday snaps but nothing more—and then I discovered 1x.com. Inspired, I have now turned photography into a self-funding hobby; any new equipment I want has to be paid for by selling pictures.

Before I started, I did some research via Google on how it was done so that hopefully I could create something a little different, and in the process, establish what I would need in the way of lighting and props.

To hold the oil and water I selected a blue tumbler so that it would help add a bit of color to the shot. I used a small battery-powered cupboard light made up of three LEDs, some orange gels borrowed from our local drama group, (but please don't tell them) and some olive oil.

I placed the cupboard light on a flat surface with an orange gel on top of it, half filled the tumbler with water, and then stood it on the gel. Adding various amounts of olive oil gave me different effects. These initially started off looking a little flat and uninteresting, so I added more oil. Ultimately, I ended up with about 1/4 to 1/2 inch of oil on top of the water. By stirring the oil a little each time some was added, I created different sized oil bubbles at different depths, giving the scene more of a three-dimensional effect.

As I was adding the olive oil, I took test shots to see how the overall effect was shaping up, and only after I had quite a thick layer of oil on the water was I happy with the result. I think in all I took about 50 shots before I ended up with a set of images that I was happy with. I should add that the shape of the oil circles on the water was due to stirring, and I must admit to a large element of luck.

I had my Nikon D700 with a 105mm lens mounted on a tripod, pointing down toward the top of the glass. I had tried shooting with and without flash during the experimental stage and quickly realized that the boost in light provided by the on-camera flash made a big impact on the image. I found that for this sort of shot, it was better than a separate flash head because the light was closer to the scene.

I used Live View to help with the focusing. By zooming in on the Live View image I could control the focus better than by using Autofocus. I also used an off-camera remote to ensure that I did not add any blur to the final shot.

I think I ended up with an "oil and water" abstract that is a combination of good shapes, tones, and overall *Star Trek* feel.

The only post processing I did was to crop and rotate my selected image. Because of the lighting I had used—the LEDs, the Gel, and the Flash—I found that nothing else was required.

1) Be prepared to experiment with different things. Personally, I had never shot oil and water before.

2) Have a lot of patience to play about until you get things right. Oh, and an element of luck won't hurt, either. I could reproduce the same image in terms of light and tones but not in terms of the shapes created.

3) Use Live View to help focus on difficult objects.

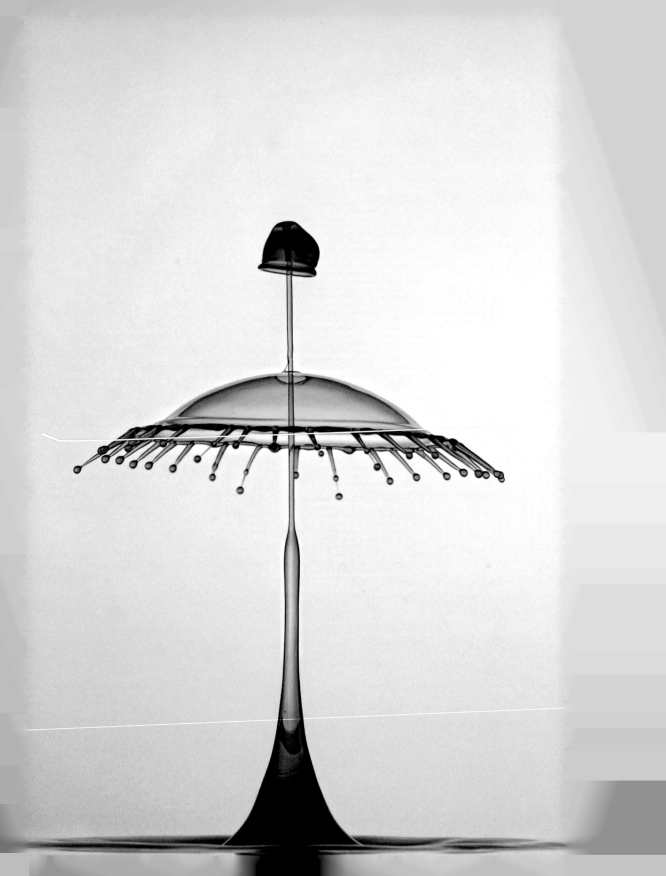

Carousel of the Drop

Creating photographs of falling drops with double crown is a very challenging task. It was my goal to accomplish this, and a lot of experimentation and settings were tested to establish a workflow for reproducing such results.

The image was created by using a Sony Alpha 700 camera and a Minolta 100mm f/2.8 RS macro lens. For flash units, I used a Vivitar 285 HV together with a wireless release device (Yongnuo RF 602). For millisecond-level accuracy control of the falling drops, I used a StopShot. This device also releases the camera with a predefined time delay. StopShot is a flexible timing module made specifically for high-speed photographs.

The camera was mounted on a tripod at a 90 degree angle to the point of impact of the drops. Two flash units were stacked and lit the scene from behind through a translucent glass.

The liquid for the drops was thickened with guar gum to lower the viscosity and contained some blue food coloring. This made the shape of the drops more appealing.

With the image, I wanted to show the beauty of moments we cannot realize with our eyes. The feedback I receive is consistently positive because it allows us a glimpse at magical moments that are normally not visible.

For creating images like this one, certain technical equipment is necessary.

You need electronic devices that make it possible to release drops with an accuracy of milliseconds via an electromagnetic valve. The device must also trigger the camera and flash units via photoelectric sensors or through time delay.

You also need flash equipment that can be set to a very short illumination time (below 1/20,000 second), because the motion freeze is not done by the shutter release time but by the lighting duration of the flashes.

For your first experiment, you can use milk, which has a lower viscosity than water, so it does not move so fast. Milk also renders beautiful shapes.

 Markus Reugels

I am 33 years old and work as a parquet recliner. I took up photography after the birth of my son. What initially started as family and macro photography quickly became my hobby. Taking photographs of water drops started a year ago. This subject was so fascinating that I continuously explored further possibilities.

Image conversion from RAW was done in Adobe Photoshop Lightroom 3. Additional post processing was done in Photoshop CS5.

Level correction. For each color channel, the unused tonal values were cut by moving the small sliders for shadows and lights from the beginning, respectively, to the end of the level curve.

Contrast enhancement. I used a new black-and-white adjustment layer with blending mode set to Soft Light and 30% opacity.

Edge contrast and sharpening. On each of three image layer copies with blending mode soft light, I used the high-pass filter. To enhance edge contrast, you should use a radius setting of approximately 30 and adjust the opacity with a value between 20% and 30%.

For bigger details, adjust the high-pass filter on the second layer to a radius of between 5 and 7. Larger details are enhanced and the contrast is slightly enhanced. Opacity should be approximately 50%.

Sharpening takes place on the third layer copy. Use a high-pass filter setting with a very small radius of 0.5 to 1.5. Opacity can remain at 100%.

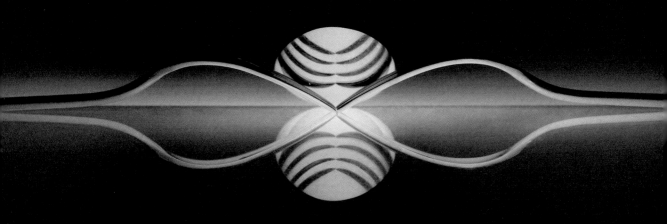

Sony Alpha 500 • Sigma 105mm macro lens • f/5 • 1/250 second • ISO 200

Spoon and Forks

It all started a while ago in my bedroom, a place for me to experiment.

The reason I started with cutlery was because of my job. I was offered the opportunity to give part of a course about product photography. Previously, I only had experience photographing insects in our backyard, so I had to practice with objects and lighting.

My first cutlery picture was of a single spoon and its reflection. I had only a small sheet of Perspex (shiny milk white), a small lamp, and some boxes to support the Perspex. By playing around with the spoon and the lamp, I soon discovered that it created a nice reflection with plenty of symmetry. Through trial and error, I discovered the best position for both the light and camera to achieve optimum results.

For this picture I used a product table, together with that very small piece of Perspex, which I placed on the table. Underneath the table, I put a lamp aimed upward with a 29 cm reflector (32 Watt, 4300K). On top of this, I placed a piece of black cardboard with a 6 cm hole cut out of it. The lamp was placed close to the bottom of the tabletop, with the opening in the cardboard directly beneath the spoon (in this case, the middle of the picture). It was essential to place the forks at the edge of the Perspex so that the visible line is (almost) exactly between the reality and the reflection. The camera was mounted on a tripod, a little higher than the table.

I was looking for strong graphical forms, with no colors disturbing it. I wanted a picture for a wall, one that people will look at for a while before figuring out what they are seeing (the spoon is not directly recognizable). Of course, lighting is very crucial—especially in this picture—not only for the atmosphere, but to create the right reflection.

Photography is like writing with light; I think it is even more important than composition, for example. It gives a photo something magical. So concentrate on the light. What happens if you move a lamp? What does that do to the shadows, and in this case, the reflection?

Look before you shoot. Try different compositions, move the light, look from several angles to find the best combination of composition, light, and viewpoint before you take the picture. When you think you have the right combination, then start shooting and adjust the camera settings until you have the image you're after.

Look at objects you interact with in daily life and think about what could be a good candidate for a picture. What would the object look like in combination with a reflection? Is the form suitable for the purpose?

Wieteke de Kogel

I live in Enschede, Netherlands. I am a teacher of mechanical engineering at Twente University.

Because I always shoot in RAW, post-processing is necessary, but this picture is simple and appears almost as it was shot. The biggest problem with my camera is the noise, but Camera RAW in Photoshop CS5 can handle that perfectly now. Also in Photoshop, I converted the image to grayscale, removed some spots, and reduced the brightness of some of the reflections.

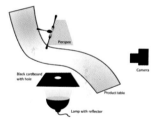

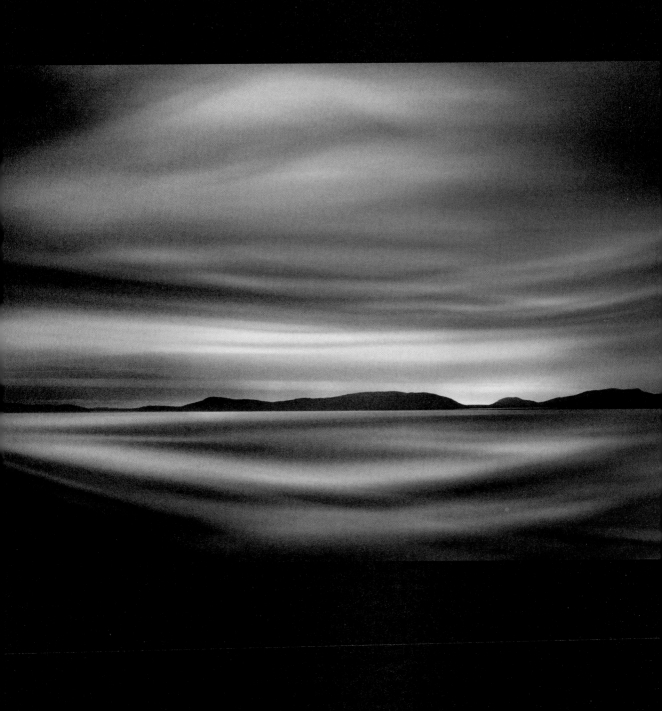

Image 1: Nikon D200 • Nikon 18-70mm f/3.5-4.5 lens • f/8 • 1/125 second • ISO 100 • RAW

Image 2: Nikon D7000 • Sigma 150 f/2.8 macro lens • f/5.6 • 1/60 second • ISO 100 • RAW

Coastlines

This image is intended as an abstract impression of an evening on the Pacific Northwest coastline.

Coastlines is not simply a blending in Photoshop of two separate digital images, but three digital files. (I used one of the pictures twice.)

The first image was shot on a ferry. The photo is a typical image of the coastline, as viewed from the ferry during its commute.

The second image, a closeup of water in a pan, was made indoors. The setup for this shot was as follows:

- A pan of water on a table
- A dark room
- Reflective material (wrapping paper in this case) behind the pan
- Tripod-mounted camera, positioned a bit higher than water level
- A flash on remote cable to the left side, illuminating the paper behind the water

Carefully focus on a point in the middle of the pan—I find an object such as a paperclip useful to aid with this. Move the water around gently—

I used a Rocket blower to create turbulence on the surface, as if it were waves—and then took the shot.

My hope is that with images such as *Coastlines*, which conjure impressions of a place or a subject, I can get to the essence of what makes a subject what it is.

Loosely, these photos classify under the category of "photo-impressionism." With them, I can abstract subjects and provide much more character than with a representational photo. Photo-impressionism allows me to express feelings, thoughts, dreams, and fleeting moments in time, when a small change in light can make the difference between the plain and drab, and the utterly glorious.

But more so than anything else, the concepts of photo-impressionism make me, and the viewer, pay attention to color. I love color! I play with color and use it almost as if it were the subject itself, which, in a way, it is, at least in photography. Light is color.

Ursula I. Abresch

A photographer in the West Kootenays, in beautiful British Columbia, Canada. Ursula has a degree in education with a concentration in art and history.

The processing was done in Photoshop CS5.

First, I worked on the second image (water in a pan). I created a copy layer and applied a mild tonemapping in the Photomatix Tonemapping plug-in to bring out color in the dark shadow areas and brighten up the image overall. I blended this copy layer in lighten mode with the original. The Nikon D7000 has an editing feature called Fisheye, which I used to create a second version of this image. I did the same Photoshop adjustments to this as I did to the non–fish-eyed image. Then, I merged these two versions of the same image with the fish-eye layer set to normal mode with an opacity of 50%.

I then worked on the image of the strip of land and the ocean and sky. I leveled the horizon and increased contrast to a much darker strip of land. Next, I made a copy of this image and pasted it on top of the water in the pan image. Then, I created a mask for the portions of the strip of land image that I wanted to keep, discarding all information below the horizon, but softly blended in the clouds with the water image. I kept the dark land area. Next, I blended the two images into one and merged them for a final workable copy. Finally, I gently dodged/burned the horizon, the land, and just above the land portions of the image.

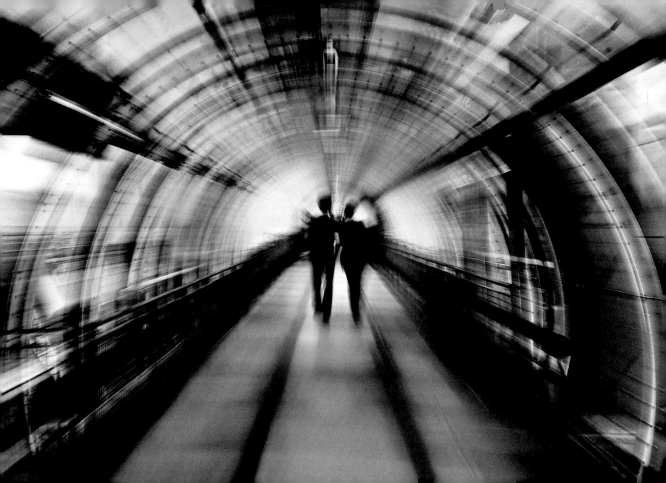

Time Travelers

I really like to experiment with zooming because that suction effect brings out another dimension in photography and gives it a sense of movement. Zooming is a kind of an obsession for me. For it to be successful, there has be a kind of structure that defines the space surrounding the subject.

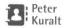 Peter Kuralt

Ten years of intense occupation with philosophy would make me a philosopher. But there is an even greater passion inside me—photography. Deep and sublime art, structured as a language with strength to mediate passion and ineffable feelings intonates my life. Photography is an endless discovery that brings light into the lives of both those who produce it and those who observe it.

I was in Paris again, and as always, I found it a photographer's heaven and hell. On one hand, you can find so many interesting subjects there; on the other hand, most of them were already captured millions of times. In this kind of situation, I always try to forget everything I know about the famous places and great photos I have seen and listen instead to my inner feelings.

When I visited the famous George Pompidou museum of contemporary art, I tried very hard to capture an interesting architectural shot. Nothing satisfying came out of it, so I decided to enter the museum and relax by taking in the masterpieces of art. But immediately upon entering the glass-enclosed skywalk from which most of the tourists enjoy the panorama of Paris, I knew I found what I was looking for. The structure of the skywalk is uniform and transparent, so there was enough light to make a colorful photo that would incorporate my "suction effect." Moreover, there were constant rivers of tourists walking around, and they could become my subjects. I already saw the picture in my mind; all I needed to do was to capture it.

Because of the strong light, I knew that I needed to push my Canon 5D to its limits. I set the ISO to 50 and aperture to 22 to gain longer exposure time. I used a 24-105mm lens, which gave me enough zoom range. I found a steady position for my body to avoid any shaking. I am not very fond of using a tripod for zoom effects, because in my opinion, it's too uniform.

After some test shots—which are almost always needed to get the proper result—two visitors passed by. That was exactly what I was hoping for. A single person or too many people would not give the dynamic I wanted.

I took several shots and ended up with two or three that I liked. Finishing the image required only some small post-processing corrections, and then *Time Travelers* was done.

Distant Galaxy

I love playing with light, colors, and shapes. I often use liquids when taking photos. Liquids are difficult to control, so there is always a random element in the picture and it is hard to predict the final outcome. I can control the colors and shapes, but the final result is controlled by the liquids. For this photograph, I chose colors that would bring harmony to the photo. I applied small patches of different oils in water by using a pipette. My intention was to create a small universe, and I think I succeeded.

 Carola Onkamo

I am captivated by colors, shapes, and light. My eye is often drawn to small details in my near surroundings. I always search for a special angle that creates harmony and makes a picture interesting. Photography makes me feel good, and I am very happy when someone else enjoys my work. That kind of positive response gives me the inspiration to continue making new photos. Feel free to visit me at www.carola.1x.com.

I try to do as much in camera as possible to avoid any unnecessary post-processing. That being said, for this image I adjusted the contrast in Photoshop. I also eliminated some dust spots by using the Clone Stamp tool.

The photo is a single shot. I used a light table for lighting from below, and spotlights were used to lighten the subject from the sides. The liquids were poured into a transparent glass bowl that was placed on top of the light table. I did not use a flash.

I wanted to create a feeling of harmony between color, shapes, and light. The picture should appeal to the imagination of the viewer and inspire personal interpretations.

The image was flipped horizontally during post-processing, which I believe creates a stronger harmony and flow in the photo. However, viewers and print-buyers are welcome to orient it any way they want. Perhaps the viewer can see something I have not even thought about. The beauty of abstract photography is that there is no right or wrong when interpreting the picture. To me, this is one of the fundamental joys of abstract shots.

I encourage the reader to turn this book upside down and compare the impression. Watch the picture actively but in a relaxed manner, and give the photo time; it will grow on you.

If you want to create something similar to this, let your imagination free. Trial and error is the key. Different kinds of liquids with different temperature and density will yield varying results. The colors should not contain pigments, because they will be too big in macro photography. I exclusively use food coloring, which does not contain any pigments and can easily be mixed with other colors.

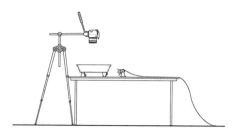

PHOTOGRAPHY is the art of recording with light. Usually, this means that what the viewer sees is more or less exactly what he would have seen had he been standing next to the photographer at the time of capture. In some cases, however, the camera helps us reveal a reality that our own eyes were not able to perceive. Astrophotography and macro photography are two natural examples.

Action photography, whether by freezing the frame in the middle of an athletic feat or by using extreme wide angles, is another of these situations. The desire for accuracy (whatever this loaded term really means) fades away, replaced by the search for *impact*, a way to involve the viewer and make him feel that he was not just a spectator of the scene, but rather a full participant in it!

Action images, far from being clinical analysis of the movement of an athlete, should instead create a deep connection with the viewer, conveying a strong story and the emotion of the moment. It should grab the guts and, for just a split second, make the viewer *know* that this is what it feels like to climb a frozen ice pillar, or to perform a perfect soccer trick.

There are many ways to achieve this, and most rely on suggesting speed and movement via extremely high shutter speeds to freeze the action, sometimes in mid air. Care should be taken to obtain an "impossible" frame— only when the position of the subject appears to defy the laws of physics will the brain automatically suggest that this is indeed the record of a split-second action. High-speed burst modes are a blessing but will not replace a deep knowledge of the sport and an instinct for knowing just the right moment to capture.

Alternatively, for subjects who move in a relatively straightforward way, longer shutter speeds and careful panning can actually convey speed.

The other crucial element in most action photography is extreme focal length, at either end. Very long telephotos will compress perspective totally and get the viewer very close. In addition, they are often the only solution when access is an issue, for instance in stadiums.

At the other end, extreme wide angle can be the perfect tool to really pull the viewer in the frame, by creating enormous depth, suggesting proximity and dynamism. Deformations in the edges of the image can either be a defect or, if used smartly, help push the extreme message even further.

Just like in any other domain of image making, there is no recipe for a perfect action shot—ask any skateboard fish-eye shooter. Just as with every other art form, there is only one way to guarantee that your creations will resonate with (some) people: you have to put yourself on the line, and pour a little bit of your soul into every image.

–Alexandre Buisse

Action

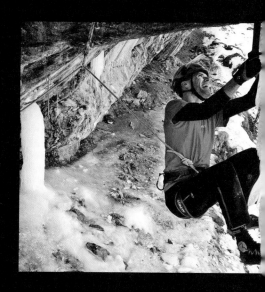

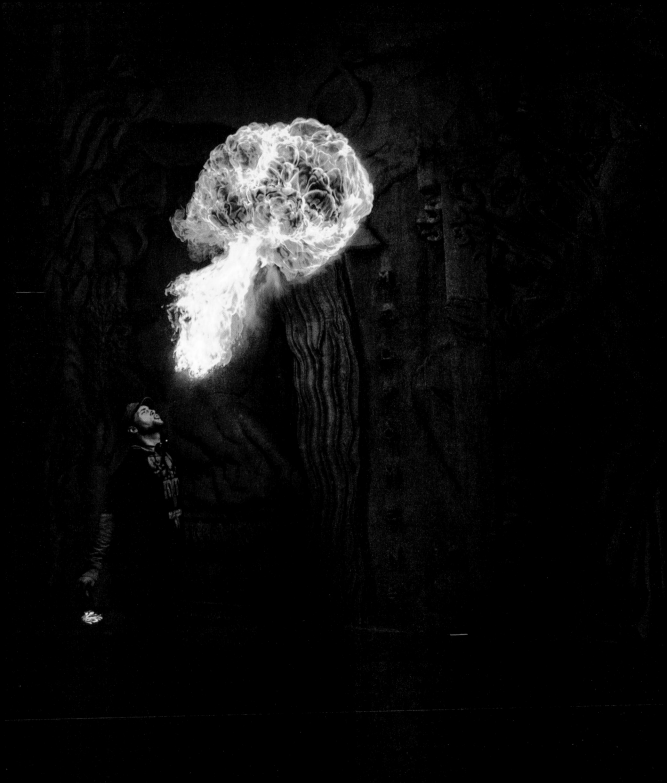

I Feel So Small

First of all, this kind of shot can be dangerous—for the fire breather, for you, and for the surroundings! So, work with people who truly understand fire breathing.

The first step is to find a fire breather. If you happen to be in Paris, it's quite simple; they perform every Saturday evening at the Palais de Tokyo (close the Eiffel Tower and Trocadero). Once nightfall arrives, so do the fire breathers.

The settings on your camera is the most important: if you do not have them right, you can forget about the post-processing. Use the lowest ISO possible. The post-processing will bring some noise to the image, so the less you have at the beginning the better it is.

Also, bear in mind that all fire breathers will have different ways of working. Some eject the fuel quite rapidly, yielding a very powerful flame, whereas others take their time, and thus the flame will be less vigorous. So, you really need to do some testing for the settings, but it will be a small adjustment. The flame lasts about one or two seconds; in rare cases, it might last three seconds. And it creates quite a lot of light.

Use manual focus and a short exposure time (to freeze the flame).

When you are looking at the result, it is important that you have the texture on the flame and a minimum of over-exposed areas. You really need to focus on the flame and not the background; the background will appear during the post-processing. Capturing in RAW format is really a *must*.

 FrankBa

I am a photographer living in Boulogne-Billancourt, France.

I will not make a very detailed tutorial with all parameters used; rather, I'll give the general procedure.

The overall idea is to use the RAW twice: one for the flame, and one for the background. For this, you can use any tool that will do that such as Nikon Capture NX 2 and Adobe Camera Raw.

For this one, I used an HDR software (Oloneo in this case, but you can use any HDR software).

Once you have two pictures (one with a correct background and one with a correct flame), you are almost done. To finish, you simply merge the two pictures into one image.

I used Photoshop, with layers and layer masks and hid what I did not want to show. Starting from the background, I masked the overexposed area (the flame). I used the Brush tool at about 50% to do it smoothly. Once it was done, I merged the two layers.

After that is comes the usual process levels, curves, sharpness, saturation, and so on.

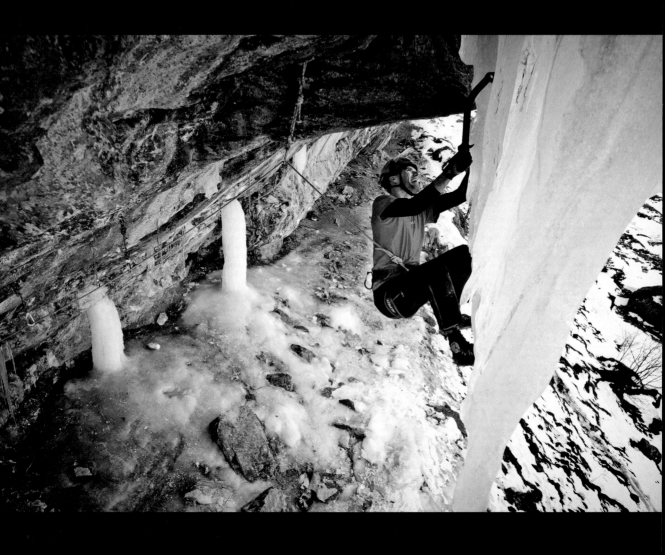

Nikon D90 • Nikkor VR 16-35mm f/4 lens • f/8 • 1/60 second • ISO 400 • RAW

Pink Panther

The idea for a trip to Switzerland (where this image was taken) came from Kristoffer Szilas, a sponsored climber and personal friend. He needed both motivated partners for the relatively little-practiced sport of mixed climbing, and a photographer to take good pictures for his sponsors. I planned to spend a week shooting photos and video from a fixed line above the athletes and doing some climbing myself.

At one point, I saw that Ramon Marin, another top climber from Spain, was on his way to a successful ascent of the classic line "Pink Panther" (M9+). I happened to have the perfect angle to show him transitioning from the rock to the hanging ice, and only had to wait for the perfect moment when his facial expression would give the viewer an idea of how difficult the route really is.

This is a single shot, among about twenty others that show him trying to rest in the crux of the route. Because I had such a good viewpoint, I preferred waiting for visually interesting moments rather than just shooting away long bursts with the motor drive of my camera.

Pink Panther was taken with a Nikon D90 and the Nikkor 16-35mm f/4 VR lens, which has become my preferred wide-angle lens for its relatively low weight and gorgeous image quality. I do not use any filters or other accessories; simplicity is key in the mountains.

I used the foolproof settings of Aperture Priority, f/8, and ISO 400, which allowed me to shoot at 1/60 second.

This was acceptable because the subject was relatively static, but I would otherwise have increased ISO to compensate for the relatively low light.

To obtain good climbing imagery, it's often crucial to get the right viewpoint, which usually means fixing a rope and ascending it with the climber. I had to hike around the cliff, find a good tree, build an anchor and then rappel down. I also used several ice screws as anchors to stop myself from swinging, because the angle of the cliff meant that I was suspended in free air the whole time.

As in most climbing photography, impact comes from emphasizing perspective, which is often achieved by shooting wide from above. The hanging icicle in this shot also gives an idea of how wild this place is and how crazy the people are who want to climb there.

The reaction was just as I expected, admiration and bewilderment at being in such a place. I think most viewers really felt deep down that people like Ramon are really special, in some way. True adventurers.

Alexandre Buisse

I am (almost) a professional adventure photographer and occasional filmmaker. I mostly cover climbing and mountaineering, but I also shoot mountain landscapes and all sorts of extreme activities.

I am also the author of a just released book on hiking and climbing photography, *Remote Exposure* (published by Rocky Nook).

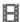

Processing was minimal and done entirely in Adobe Photoshop Lightroom. This particular image had a conversion to the Camera Standard profile, followed by minor adjustment of the black, fill light, clarity, and vibrance slider, and finally a mild vignette applied. It took less than a minute to process from start to finish.

1) Wait for the right moment. I have dozens of photos of Ramon climbing, but only a handful have a really strong message or story.

2) Put some serious effort into accessing the best viewpoint for the photo you want to take. It is far more crucial than any gear issue.

3) Never forget safety. I can think of half-dozen ways that I could have become injured shooting this, so I was very careful to protect myself the best I could. As I learned in another occasion, it is sometimes best to walk away from good photo opportunities rather than put yourself or your partners at unnecessary risk.

Canon 5D mark II • Canon TS-E 17mm f/4L tilt/shift lens • f/20 • 1/320 second • ISO 640
No flash, all natural light

Freedom

This one was created as an entry to a challenge. The subject was "fences." I scratched my head to find a creative way to feature fences. Fences can obviously engender a prison-like feeling, so the idea of freedom quickly appeared. From there, I sketched out several options, and I found this one to be pretty effective.

I wanted silhouettes for the fences and the model (me), with a rather shiny and reflective background. So I ended up looking through local websites about tides and beaches, and found a spot where sun orientation, sunset, and low-tide times were all converging together.

I bought all the "set" material (planks, nails, hammer) and drove to the site. Once there, I broke some wooden planks and nailed them to a structure that I buried in the sand. Then I just waited for the sun to oblige, did some jumps, and there it was.

The image is a single shot, made by using a tilt/shift lens (Canon TS-E 17mm f/4L) mounted on a 5DmkII body. The lens was shifted in order to achieve a large depth of field: the planks were in the foreground while the subject had to be quite a distance away. The detailed settings were as follows: 17mm, ISO 640, 1/320 seconds, f/20. No flash, all natural light.

The camera was on a tripod, and my wife used a remote shutter to capture me as I was in the air.

Several people told me that it appears as if I'm jumping into water, but in fact, it was sand at low tide (there was a thin layer of residual water, hence the reflections).

The picture's message is pretty obvious: one can earn his own freedom, at the cost of some work (in this case, symbolized by the fence to be broken).

I was relatively happy with the final result, but I did not foresee the very enthusiastic reaction of the viewers. The photo won that particular weekly challenge (with the highest mark I ever scored on that website), made it through the 1x.com screening, and even made it to the 1x.com front page main banner! I would never have dreamed of such a success for this shot, and I am quite thrilled about it, I must say.

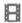 **Christophe Kiciak**

I took up photography in June 2009. At that time, I was searching for a way to express both the rigorous scientist and the creative artist in me. There are few hobbies that let these two work together, so I was really enthusiastic about it. I am now spending all my free time studying various techniques, contemplating the marvellous works of others, and of course, making pictures.

The processing was done in two main steps: RAW conversion in Photoshop Lightroom 3, and detailed processing in Photoshop CS5.

During the RAW conversion, I added color filters (mainly orange and purple) in order to create that warm mood. The original was in the yellow and dark blue tones, which I thought were too cold.

In Photoshop, I mainly denoised the image (using the Topaz Denoise plug-in) and cloned out some imperfections in the sand (small rocks).

For shots like this, preparation is the key: composition, rough settings, weather, sun position, sunset hour, tidal hour, location, and so on. The Internet provides incredibly comprehensive access to all sorts of data, so use it!

Process you image with a precise goal in mind. Random processing ("let's add a vignette, it usually works." "Oh, saturation is always nice," and so on) rarely works. Processing must support the whole concept. Each step you take must have a logical explanation with regard to what you want to achieve as a result.

Nikon D70 • Nikkor 18-70mm f/4.5 lens @ 70mm • 1/640 second • ISO 200

Finished

This photograph was taken in 2007 during a climbing trip on Kalymnos, a Greek Island close to the Turkish coast. I had been to the island before and seen the incredible sunsets that seem to occur almost every night. On my return trip, I knew I wanted to leave with an image that captured the spirit of the climbing and the sunsets.

I wanted the image to show both the beauty of the situation and convey some of the emotions and feelings associated with climbing. The theme here is that it is the end of a good day, and the climber has worked hard and achieved his goal; both he and the day are "finished."

I had an idea of the photograph I wanted to capture—a silhouette of someone climbing the rock with a dramatic sunset as a backdrop. *Finished* was taken on one of the first evenings of the trip. We had decided to climb one of the cliffs that bathed in sunlight until the end of the day. As always, I took my camera.

Luckily, my friend, Bruce, took his time on the route, and as he descended into the void beneath the overhanging climb, everything fell into place. The sun was just above the horizon and the color in the sky was ablaze with orange and red. I took a few shots as he came down toward the horizon. When he dropped level with the sun, I positioned myself in line. I had the idea to get him to lean back for compositional reasons, and this is the result—planned but a bit fortuitous, as well.

For me, this photo is a good example of making the most of the equipment you have available. It demonstrates that whatever equipment you have, familiarity is essential. Knowing its limitations and capabilities is so important for a shot like this, for which light conditions are changing rapidly and you have minimal time to think.

I was fortunate that the situation was so perfect. The pose adds to the drama, even though the original intent of his body position was to create a more balanced composition.

Plan ahead for the image you want, but be prepared to adapt as the situation develops. This same mantra repeated is essential for pulling together a cohesive series of images.

Do not just learn from mistakes; if a photograph "works" you should spend some time reviewing the image and learning what makes it successful.

Stuart McNeil

Outside of photography, my profession is civil engineering —something I tie in with a large body of architectural photographic work. I find that having a career and photography as a pastime works well for me. I can take the images I want without any external pressure.

I used Adobe Photoshop to edit the photograph in the following order:

1) I rotated to correct a slight angle in the horizon (always very obvious when you get this wrong and the sea is in the image).

2) I cropped the image to 3 × 2 format (this was required after the rotation), retaining as much of the frame as possible.

No other changes were necessary. The colors are all as seen, possibly slightly enhanced by the image optimization being set to Vivid; the shutter speed kept the silhouette black (I would normally use levels to do this, but it was unnecessary in this case).

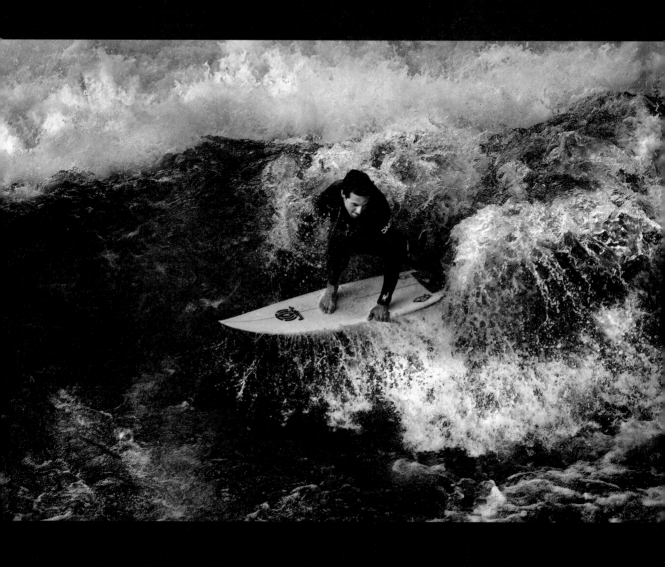

Nikon D3 • Nikkor AF-S 70-200mm f/2.8 lens @ 70mm • f/4 • 1/2000 second • ISO 1250 • RAW
Exposure compensation −0.67

Surfer

There is a place in the city of Munich, Germany, where the flow of the river Isar is opposed in such a way that a high wave is created. Some daring surfers are brave enough to practice there, although the riversides are dangerous. The scene can be witnessed from a bridge that spans the river.

What is there to say about the context of an action picture? It is the situation given. All that counts is to capture the dynamic, that power needed, and that wonder of the moment. My plan had been to show the environment as an element of dynamic and thrilling challenge as well as the emotions of concentration and being "straight to the point."

So, here I had the situation I was looking for. The light is mostly from the right or back, diffused by some trees on the riverbank. I studied the location and determined that late afternoon would be the best time for shooting, because the light was already warmer but still in high dynamic range, coming from my back.

In all action shots, it is important to achieve short exposure time. I choose a camera with high ISO capability and a fast lens, which allows a maximum of shutter speed and sharp image quality.

The task here was to search for the right point of view, which would capture a surfer from the front and have him properly placed in the frame, and

then wait. I immediately saw that the image of this particular surfer was the best. His position, the light, his situation—all worked together to express the challenge, to master the fighting and dancing with the wave.

I love to capture things or beings in action, like small birds or macros of flying insects. I do not subscribe to the use of icespray or other "tricks" to get spectacular images. I am convinced that we as photographers have a responsibility for what we capture. Thus, I can say with confidence that three things are needed: time, patience, and large, large memory cards. Learning by doing seems to be the most important advice. Do and do again. And do not trust in the camera alone. I normally set things manually—even the focus. I use a Nikon D3, one of the most useful tools that I know. It is powerful in high ISO and Autofocus, but its Autofocus is not fast enough for all possible situations. Capturing action or pure wildlife requires the most natural setting to achieve a realistic and powerful impact.

 Marei

I am 32 years old and married to the wonderful photographer Christoph. I love to capture nature and shoot outdoors a lot. I am a student of social work, using all my free time for photography. If you like my work, feel free to visit me at http://marei.1x.com.

I use Photoshop CS5. I did the RAW processing in Adobe Camera Raw.

In this image, I only used Camera Raw to increase the clarity a bit and reduce the noise with a low amount of 10%.

Then, I opened the image in Photoshop. First I cropped it a little bit from the right and top and increased the contrast by using Nik Color Efex Pro. I did so to get more punch and detail in the intended black-and-white conversion. In this way, I achieve wonderful black and white results. For the black-and-white conversion, I use the Alien Skin plug-in with the Tri-X 400 preset. I adjusted the contrast and blacks a bit by increasing both. I then also increased the contrasts in levels and curves. I made this correction only in parts of the image, so I first made selections by using the Lasso tool with a very soft border.

ARCHITECTURAL photography starts with finding suitable locations. Good sources for such information are suggestions from other photographers, Internet searches on cities and business districts (Google maps) and photo sites (forums). A good site is also: http://www.mimoa.eu, which lists interesting architecture in a lot of European cities. Be aware that some of these business areas or building surroundings could be private property. So don't be too surprised if a security agent shows up asking what you are doing.

The most interesting lens for architectural photography is a (super)-wide angle. It gives dynamism to your compositions. A zoom lens offers the additional benefit of flexible focal lengths, allowing you to choose the optimum one for your composition. Fish-eye lenses could be interesting for already curved architectural structures.

Telephoto lenses can be interesting for capturing details or for isolating some rhythmic composition elements.

Try to avoid hard light. Morning or late afternoon light (and winter light) are ideal for capturing the structure and the plasticity of the buildings, creating more sense of depth. But due to "planned trips" or changed light conditions, it will not always be possible to get these better light conditions. The challenge then is to look for compositions that work in such light. Even rain can be interesting (offering the possibility to work with reflections). Polarizing filters are very helpful for eliminating unwanted reflections and giving more saturation.

It is important to take your time when photographing architecture. Before starting to take photos, look at the architecture from different angles. Walk around it, try to see possible interesting viewpoints and light compositions. Look especially for the "unseen" view. The composition is key to strong impact. Quite often, the golden rule is "less is more." Keep your composition simple and clean. Look especially for interesting shapes and lines, and for the effect of the light on them. Lines running throughout the whole image often create a strong dynamic composition. Sometimes contrasting elements will give a strong composition; in other circumstances it can be a more symmetric rhythm of lines and patterns in the architecture. Also keep in mind that the sky can be an important part of the composition of your image. It is up to you to discover what makes the difference.

Above all, look for the shot that makes your image unique. Your goal should not be a documentary rendering of the architecture but your personal point of view. This is especially true for commonly photographed landmarks.

For some images it is obvious that the color is an essential element in the composition. But quite regularly it is at least worthwhile to try a conversion of your image to black and white. Some images will just work better like that. This is particularly true for more graphic compositions, shaped by the light. Removing the more documentary color information puts the emphasis on the pure tones, lines, and shapes of the building. There are lots of methods for converting an image into black and white. A very interesting program is Nik Silver Efex Pro. It offers many possibilities for individually optimizing highlights, mid tones, and shadows in the tonal range. You can emphasize the structure and details in specific tonal areas, simulate analog film effects, apply toning, and a lot more.

Do not be satisfied too quickly with your result. Most images will need some basic post processing (tone levels, color, eventually cropping and sharpening, and so on). Try to work as much as possible in a non-destructive mode so that you can change your mind if you are not satisfied (adjustment layers, smart filters in Photoshop, and so on). For more advanced work, the transform tool can strengthen the impact of your composition.

Especially for architectural photography, it is important that any lens distortion is corrected. This can be done in Photoshop, or even better in programs such as DXO Pro.

–Jef Van den Houte

Architecture

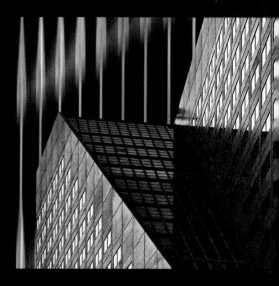

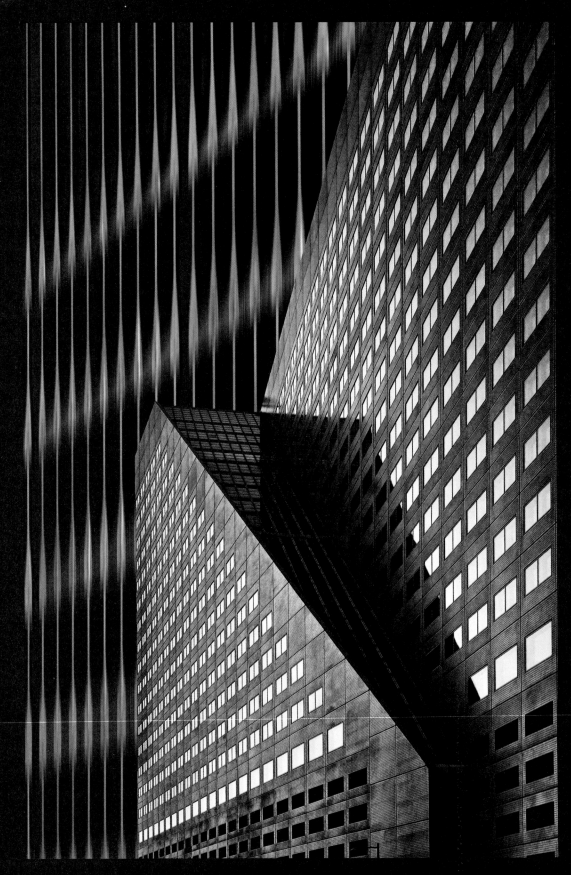

Nikon D300 • Nikkor 16-85mm f/3.5-5.6 zoom lens • ISO 800 • RAW

Image 1: (with the windows) 34mm • f/7.1 • 1/1250 second

Image 2: (the background) 42mm • f/7.1 • 1/2000 second

Patches of Light

In my architectural work, I try to capture the shapes and lines, emphasized by the effect of the light. Cities and industrial parks are favorite places for my photographic work. One of these cities is Rotterdam in the Netherlands. It has been rebuilt after being completely destroyed in World War II. Fortunately, they did not reconstruct with traditional, rather uniform modern architecture, but on many locations, they went for innovative and more creative architecture by famous architects. This image, Patches of Light, was taken on a sunny day in early March. There was a very beautiful soft light that was ideal for photographing architecture.

This image is a composite of two separate photos. Both are hand-held shots with a Nikon D300 camera using automatic white balance, aperture priority, and center-weighted exposure setting.

The first one (with the windows) was taken at focal length 34mm, f/7.1, and 1/1250 second. The second one (the background) was taken at focal length 42mm, f/7.1, and 1/2000 second.

I was very satisfied with the end result. I feel that in the final composition, I fully achieved what I wanted to.

My aim in architectural photography is not to make documentary images. I want to show how I see the building—to create a kind of personal expression of the lines, shapes, and light.

Take your time when photographing architecture. Before starting to take photos, look at it from different angles. Walk around it and try to find interesting viewpoints. Try different focal lengths, if possible. Wide angles are usually very interesting

Also, try converting your image to black and white. Architectural photos are often stronger in monochrome, because you remove the more documentary color information and place the emphasis on the pure tones, lines, and shapes of the building. This is particularly true for modern architecture

Do not be satisfied too quickly with your result. Even basic post processing offers some possibilities and can add substantial extra value to your image. Try to work as much as possible in a non-destructive mode (using adjustment layers, smart filters, and so on).

Jef Van den Houte

Living in Belgium near the city of Antwerp, I have been a passionate amateur photographer since the end of the 70s. Although I like all kinds of photography, my major interest lies in architecture.

I opened the first image (windows) in DXO Optics Pro 6.0, in which I corrected lens distortion, color fringing, and vignetting. I then opened the image in Camera Raw and optimized the levels by using Exposure, Recovery, Fill Light, and Black. The Clarity slider was increased to 40% to add more contrast in the midtones.

I then opened the image in Photoshop. I used the Skew tool to make the left edge of the building completely vertical. I then got the idea of putting another building behind the "windows" building. I found an interesting one with a completely vertical structure of concrete elements.

I processed it similarly to the first image, by correcting the lens defaults with the DXO program and adjusting the tones in Camera Raw.

I selected the sky portion in the first image by using the Magic Wand tool and deleted it. I then pasted in the second image in the Layers palette behind the "windows" building. I applied a vertical motion blur on it to soften it a bit.

Next, I converted the image to black and white by using the Nik Silver Efex Pro 2 plug-in for Photoshop. The final touch was given by local dodging and burning. For that I used a separate layer with 50% gray in overlay mode. Finally, I applied a slight noise reduction and a little sharpening.

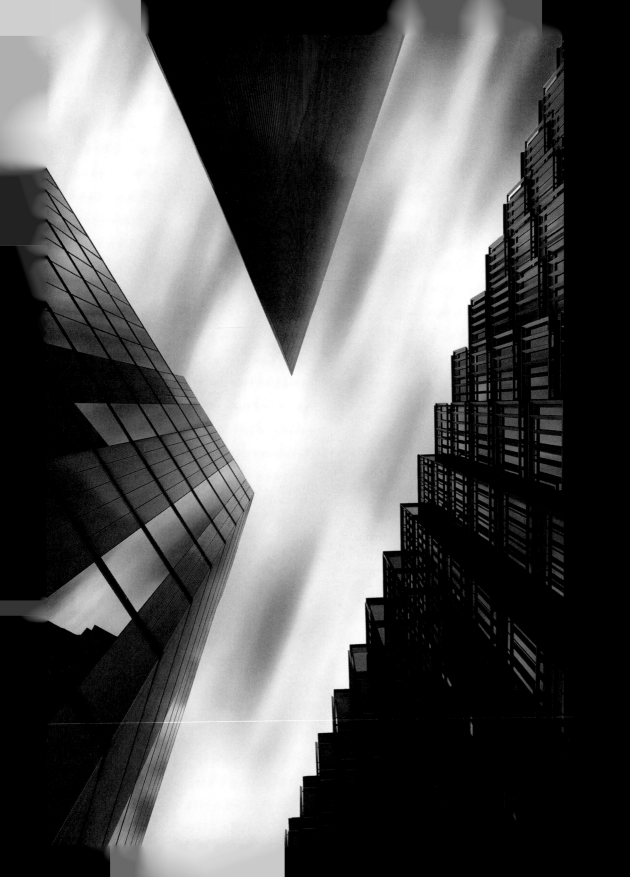

"Y"

I took this photo recently while on vacation. My wife and I were in London for a couple of days and we happened to pass the "More London" development on the southern bank of the river Thames. Being interested in architectural photography, I saw various attractive buildings in the area. The following morning I returned to the location and walked around. During a stopover in Hong Kong, I had just purchased a Canon Right-Angle Viewfinder and was keen to give it a try.

This photo was taken at an often-photographed corner, walking from the Greater London Authority building toward Tooley street. I found this building by accident. First, I was attracted to the step-like facade of the Price-Waterhouse-Coopers building, which forms one side of the corner. It reminded me of stairs, so I framed the photo in a landscape orientation to make the steps lead upward from left to right.

Having the camera pointing straight upright for many photos, I realized how valuable the Right-Angle Viewfinder is. It allows you to frame the shot without bending and straining your neck, so you can spend your money on cameras and lenses rather than on massages and osteopathy.

When sorting through the photos back home, I found a shot where all three buildings were equally balanced in their arrangement.

I then remembered a tip I once received from another 1x.com member: try rotating and flipping photos to see if their impact becomes stronger. When doing that, I realized that the negative space created by the shapes of the three buildings form the letter "Y," so I decided to use this as a basis of my composition.

When shooting architectural objects it's good to spend some time walking around the building, trying various angles. That doesn't mean carelessly clicking away, but a better perspective or subject might be just around the corner.

Use the 1x.com community to get some feedback, either through friends or by submitting critique requests—you learn so much about how others perceive your photos.

Relatively small changes can have a big impact on how your photos are perceived. Pay particular attention to details in your photos.

Good photos usually consist of a simple composition—in this case, excluding the "distracting" clouds and colors helped to strengthen the lines and shapes of the buildings.

 Guido Brant

I am 43 years old and live in Melbourne, Australia. I work as a project manager in a product development company. Although my work is very creative, I do miss the artistic aspect, and this is where photography fits in perfectly. When I joined 1x.com about nine months ago, I became a "serious" amateur.

The image was processed in Photoshop CS5. I cropped the image to the left and right to make the two building lines coincide with the lower-left and upper-right edges of the photo. I used another blue-white sky photo and placed it onto a layer underneath the original photo. I applied a large motion blur onto it as a Smart filter. Next, I masked away the sky on the original photo by using the Polygon Lasso tool, copied the blurry sky layer as a smart object, and then masked the window panels on the building. I used a Brightness/Contrast Adjustment Layer with the same window panel mask to make the reflections of the sky in the windows look darker and more realistic. I also darkened the lower-right corner with a burn layer. Then, I applied a Gaussian blur in addition to the motion blur in the sky and aligned the direction of the motion blur to the building lines. I split the motion blur for the reflections on the left building into three separate layers for each panel area and changed the directions to 39 degrees, 15 degrees, and –6 degrees, respectively. Finally, I added a motion blur layer for the reflections on the right building, and then I converted the image to black and white.

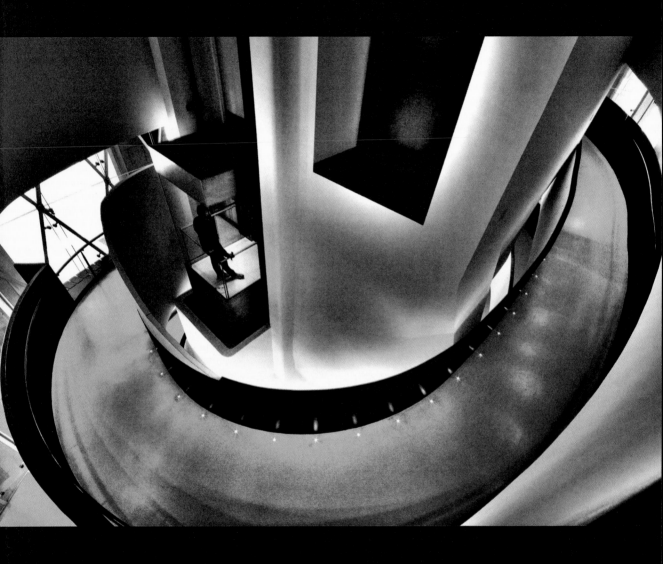

Nikon D90 • Sigma 10-20mm f/4-5.6G lens @ 10mm • f/14 • 1/20 second • ISO 800 • RAW

Working in the Future

I live in Milano, a city with several museums. The 900 museum was set up in an old palace. The most fascinating new feature is a spiral staircase that leads visitors from the ground floor up through the three floors of the museum. So I wanted to photograph this wondrous staircase—a modern and futuristic structure in an old building.

I love architecture. The idea was to take a picture showing the impressive size of the spiral staircase. For this shot, I chose a wide-angle zoom lens. I was walking up and down the staircase, looking for an original point of view, and moreover, a position that would let me capture a flight of stairs in its entirety, with a correct balance of outside lights and shadows to emphasize the dimensionality of the structure. The spiral is half surrounded by a glass wall, through which the sunlight enters. The photo was taken at 2 pm, so the strong sunlight created a mixture of light and shadows in light blue (the color of the stairs). In addition, to give a greater dynamism to the scene and lend an idea of the size of the structure, I waited for someone to enter the elevator that travels inside the spiral.

The photo was taken as a single hand-held shot in RAW so that I could have full control in the post-processing. The ISO setting was 800 because I had to take a picture within a structure with low light, without the tripod, and with a low aperture setting to get good depth of field. I did work with aperture priority settings in order to control the depth of field.

For architectural photos, I generally look for different points of view before taking the shot in order to achieve an original scene. Usually, a wide-angle zoom is the best choice. I use the aperture priority setting to control the depth of field, and RGB curve layers to inject three-dimensionality to the scene.

 Marco Vigorne

I am a 41-year-old amateur photographer, living in Milano. I have a master's degree in electronic engineering. I love architectural and landscape photography.

All the processing was done in Photoshop CS5, in five different steps.

First step: A strong HDR post-processing was done to emphasize details in the strong sunlight and shadows.

Second step: A contrast layer was added to emphasize light and shadow details.

Third step: I added an RGB curve layer. In this step, the red, green, and blue curves were adjusted to emphasize the green and light-blue tones (the actual spiral stair is blue) in the shadows, without saturating any tone.

Fourth step: The image was cropped a little bit at the left to eliminate a ceiling light lamp.

Fifth step: A strong noise filter was applied using the following parameters: Intensity: 10; Preserve Details: 0%; Reduce Color Noise: 100%; Sharpen Details: 100%. Remove JPEG Artifacts was checked.

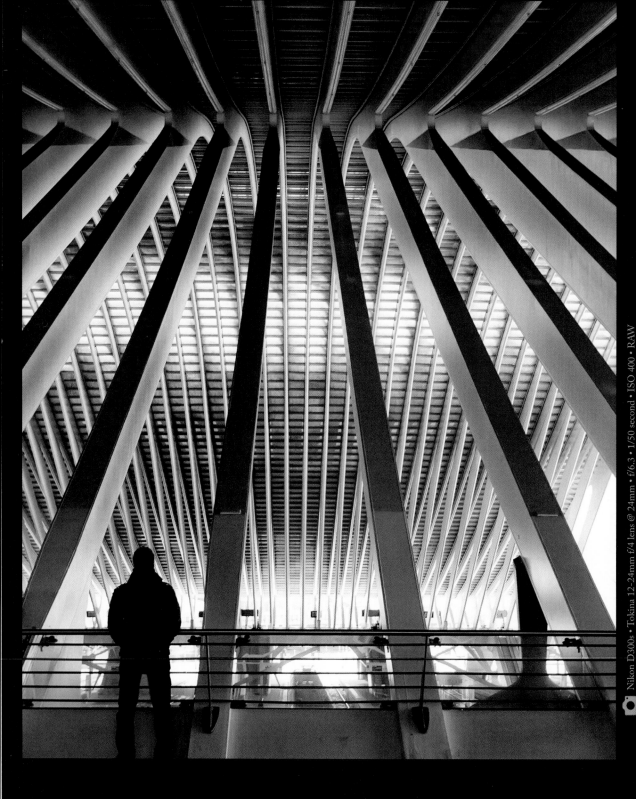

Nikon D300s • Tokina 12–24mm f/4 lens @ 24mm • f/6.3 • 1/50 second • ISO 400 • RAW

En Attendant Godot

The title refers to an absurdist play by the same title, written in 1948–49 by Samuel Beckett, in which two characters wait endlessly and in vain for someone named Godot to arrive.

Liège-Guillemins is the main railway station of the city of Liège, in eastern Belgium. It is one of the most important transportation hubs in the country and is a stop on the high-speed train connection between Brussels and Cologne, Germany.

This station, designed by the Spanish architect Santiago Calatrava, was officially opened in September 2009. It includes a monumental vault over the platforms, constructed in glass and steel that spans 180 meters.

This picture was taken from one of the pedestrian bridges on the level above the tracks. The main interest was the impressive glass and steel vault structure; therefore, a wide angle was preferred. This image was taken on December 27, 2010, at around 1:30 pm. Because it was between the Christmas and New Year's holidays, there weren't that many passengers. Normally, this place is very bright, but at the time I was visiting, the vaulted roof was covered with snow, rendering a highly filtered light.

Suddenly I saw this person standing, apparently waiting for someone, overlooking the activities below. I found that his silhouette made an addition to the image as an anchor, a reference of scale, and an overall finishing touch. The person had only a white shopping bag behind him, which was a disturbing element in the image.

You can see the original image at http://1x.com/mview.php?p=418157.

Here are some general hints for shooting images such as this one:

- Adding a person in an architectural image often offers a much better sense of scale.
- Black-and-white conversion often works well for drawing the attention to lines and structures.
- Don't be afraid to remove some disturbing elements that would otherwise distract the viewer. Sometimes small details have a very big overall impact.
- Wide angle does enhance the feeling of depth. It works very well here with the beams.
- Geometric and perspective correction have a higher impact than you would expect. A slightly curved onset of the beams would be distracting.

 Papafrezzo

I am 42 years old, married, and live in Bergen, Norway. I have a PhD in applied physics. Feel free to visit me at www.papafrezzo.1x.com.

I work with Photoshop Lightroom 3 and Photoshop CS5.

After importing the image in Lightroom and making some basic corrections in Adobe Raw Converter (ARC), the following workflow was used in Photoshop:

Geometric correction (some barrel distortion).

Vertical perspective correction (make the sides of the monitor vertical) and a horizontal perspective correction to make the connection point for the beams perfectly horizontal.

Black-and-white conversion using the Nik Silver Efex Pro plug-in, including modest Selenium toning, as that fits the modern architecture well.

Removal of the shopping bag by painting on the silhouette (pretty constant color) and cloning a part of the fence.

The final cropping and export was done in Lightroom.

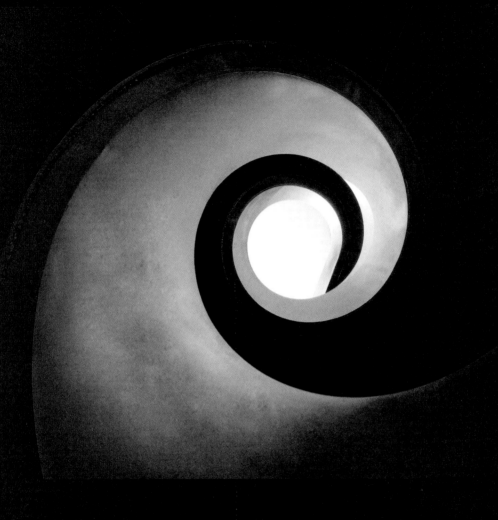

Sony Alpha 700 • Sony SAL-1118 f/4.5-5.6 11-18mm DT lens @ 10mm • f/10
1/10 second and 1/80 second (bracketing) • ISO 100 • RAW

Helical Stair

It was a hot summer morning, and I decided to drive to Basel, Switzerland for a spontaneous photo tour. After several hours, I walked around a building and saw a very special helical stair. It was made of steel and painted black. My heart began to beat faster. My efforts were rewarded, I had found my subject.

I walked around the stair to find an interesting point of view. I quickly realized that these stairs would be best viewed from bottom to top, and thus I prepared my camera, a Sony Alpha 700. It was clear that I needed a very short focal length. I mounted my Sony SAL-1118 4.5–5.6/11–18mm lens to the camera. To take the picture, I had to lay the camera on the floor. The floor was made of hard asphalt, so I placed a soft cloth between the floor and the camera. I then attached my cable remote control to the camera. Now I had to find the right position and angle. I needed approximately ten pictures to reveal the best position to encompass the entire spiral in the picture. Because of the hard contrast (bright sky, black stairs) I decided to work with bracketing to five pictures (−0.3/+0.3/+1/+1.7/+2.3 EV).

All the while, people around me looked a bit amused by what I was doing. But I didn't care. I was too busy with this magnificent helical stair.

My intention was to create a picture of "graphic beauty," without the help of colors. I uploaded the picture to 1x.com for screening, and it was successful. I received a considerable amount of positive feedback. There are many pictures of spiral staircases, but this is a very compelling image, with a special point of view and style.

To create an image such as this, you first and foremost need persistence. Such subjects have to be discovered. You also need a super–wide-angle lens: a focal length of 10mm (crop dSLR) was absolutely necessary for me. Finally, you need a bracketing-enabled camera.

 Takami

Modern architecture is my special subject, as you can see by my 1x.com portfolio and on my home page at www.lieberh.de. I work as a mechanical engineer, which probably explains my love of geometry and graphics.

I used Photomatix Pro by HDRsoft for the calculation of the HDR-Image. It was an advantage that this tool was able to load the RAW files: No JPEG conversion was necessary. By the way, using RAW files should always be the first choice to obtain the best picture quality. I used the standard settings in Photomatix. No special adjustments were needed. I saved the result as a new JPEG file and loaded it into Photoshop CS4 Extended. My first adjustment was to increase the midtones. Because I was not fully satisfied with the detail contrast, I used the Tonal Contrast filter, a plug-in for Photoshop and part of the Nik Color Efex Pro 3 tool. I used the standard settings of the filter. The result looked very good. The next step was to remove a few ugly dents in the metal plates of the stairs. The last step was to apply a black-and-white adjustment layer, and then save the picture as a grayscale JPEG.

CHILDREN are one of the most pleasant and popular photographic subjects. For many people, this subject is seen as the easiest—nothing could be more wrong.

It is not easy to shoot interesting, original, capturing-the-unique-moment photos. That our image was this unique, best reflects the mood of the moment. But first, you have to be patient.

Children should be photographed for many reasons, but mainly because they grow quickly, and the photos are a unique memorial; memories of their childhood.

Natural behavior. When photographing children, you should primarily try to capture their natural, sincere emotions. You should not encourage children to pose, nor should you encourage them to behave in certain ways. Focus instead on the observation of natural behavior of children in front of the camera. You should accustom children to the presence of the camera in their daily lives. They should be unaware that they were photographed.

Point of view. What is the best perspective from which to photograph children? Without a doubt, you should photograph children from their perspective. We try not to look at children "from above." The deliberate use of a different perspective can sometimes provide a unique picture, but this should not be the rule.

Emotions are worth shooting. When photographing children, do not limit yourself only to the preservation of smiles. Let's appreciate the richness of a child's facial expressions. Do not be afraid to show sadness, contemplation, detachment, and melancholy. The world of children's emotions is a rich one. Let your pictures attest to that.

Where is the best places to take pictures of children? The response to this question is very simple: everywhere. You can observe children via the camera lens any place where they are: a house, playground, garden, or park. For parent photographers, the ideal time to take interesting, beautiful, and natural images is to take the children for a walk in some photogenic surroundings (this can be the park, a meadow, a dirt road, an avenue of trees). Let nature be your inspiration. Let your pictures show how children pick flowers in the meadow, run wildly in the rye, walk the avenues of flowering trees, catch frogs in the pond, and talk with snails in the garden. Let's look at children as young explorers and try to capture in photographs how they learn about and discover the world.

Pets are your allies. Contact between children with pets can also be a rewarding photographic theme. Show in your picture how your child is playing with her pet, and how much she cares about it.

Portrait photography and photographing children in studio. Photographing children in their natural environment (home, school, walk, playground) allows the photographer to concentrate on the observation of the child through the lens, with full freedom of movement. However, photographing children in a studio brings with it some limitations.

First, the child is in a place that is unnatural for her. You should try to outfit the studio in such as way that the child will feel comfortable in it. Perhaps having toys on hand would help (balls, blocks, cuddly dolls). Moreover, the right toys might do more than just keep the child's interest, they can also serve as props that might be a perfect complement to your portrait efforts. They can provide the right climate for the picture. And props do not have to be restricted to toys. They can be all kinds of objects: shells, dried autumn leaves, ribbons, flowers, a watering pot, funny hats, sunglasses, scarves, and so on.

The art of photographing children could fill an entire book itself. In conclusion, it cannot be overemphasized that children are naturally wonderful subjects; what is required of you, the photographer, is to have the right attitude. As in so many areas of photography, your success will be determined by patience, ingenuity, and luck.

–Magda Berny

Children

Pentax K7 DSLR • 50mm prime lens • f/4.5 • ISO 100 • 1/180 second
Off camera rf-triggered flash at camera left, fired through a Lumiquest LTP portable
softbox with flash power at 1/4

Autumn

It was the first month in autumn (being March here in the southern hemisphere) and I wanted to make a creative portrait of my daughter, portraying the season as much as her. I had a vision in my mind of the colors and creative effect I wanted to use, a week before the shoot. Having seen similar photographs like this before, I wanted to give it something extra, that invisible element we sometimes feel—the wind.

This was an arranged shot, as is the majority of my work. It was also an opportunity to try a small-sized softbox I bought a few weeks earlier. I knew from the beginning that it was going to be a color photograph, so picking the clothing was easy, and we used what we had at our disposal. My wife had a burgundy scarf, my daughter had the red beanie and gray top. The dry autumn leaves were raked from our lawn minutes before we started shooting. I wanted this to be an outdoor shot; it was taken in our back garden using the gray weathered fence as a background. The fence was underexposed and seemed to work well with the rest of the colors. Because I was using a small off-camera flash, I had to wait until early evening for the ambient light to drop in order for the small battery-powered flash to do its work.

The illusion of wind was created with the fishing-line technique. Using a safety pin or two, I attached a length of clear fishing line to the tip of the scarf. The line was then pulled and waved around by an assistant (my wife) out of frame to make the scarf dance horizontally as if it is waving in the wind. A handful of leaves were thrown in the air, and the exposure was made.

I probably took about 20 or so frames in total. Every time I shot a frame the leaf throwing was repeated.

The purpose was to create a portrait. Upon reflection it is perhaps a portrait within a portrait. An autumn portrait of my daughter, and a portrait of a season.

The finished photo turned out successfully, with the leaves flying through the air giving the image an almost three-dimensional aesthetic about it.

Bill Gekas

I was born and live in Melbourne, Australia. I am a self-taught photographer who learned the technical side of photography by using a 35mm film SLR camera from the mid 90s. I switched to digital in 2005, practicing the art of photography and constantly refining my style.

I always shoot RAW. Processing for this image was done in Adobe Photoshop. Once I opened the file, I applied some pre-sharpening and the photo was slightly cropped and straightened. At that point, I removed the safety pins from the scarf and any evidence of the fishing line by using the Healing Brush tool—an easy fix. I noticed that some of the leaves closest to the light had highlights that needed to be brought down a bit. This was worked on using the Patch tool. The photo was almost ready and just needed some pop to it. I applied a bit more saturation to the entire image and some dodge and burn to take the leaves down some more. A minor curves adjustment, slight vignette, and a final sharpening via the high-pass method polished it off.

1) Pre-planning. Think about it first, visualize it, plan it and the actual shoot is over in no time.

2) When shooting children in a set up environment, try to get the shot within the first 15 minutes; young children usually lose interest after that.

3) An assistant makes the process a whole lot easier.

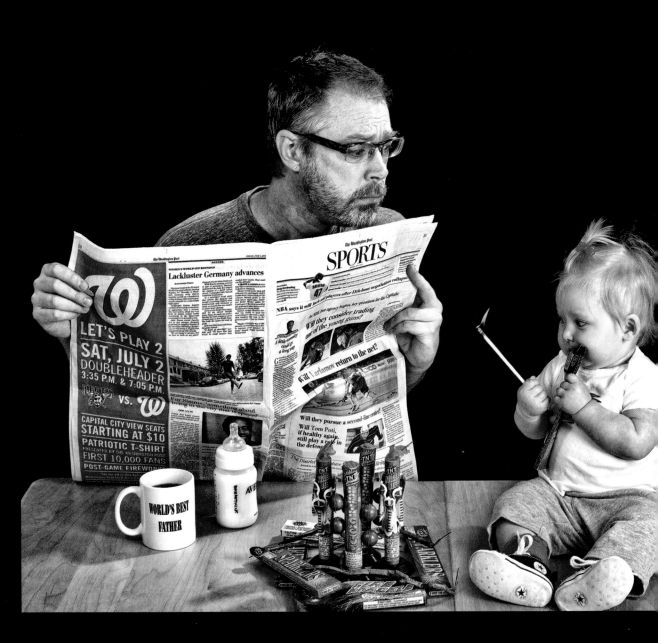

Pentax K5, SMC DA 35mm f/2.8 limited lens

World's Best Father: 4th of July

When I set out to make this shot, I knew I would have to follow three basic safety measures: 1) No open flame near the baby. 2) No fireworks near the baby. 3) No open flame near the fireworks. To follow those rules, I knew the final image would require a composite of three different images.

Shot 1: Father at table with fireworks.
Because the final images would require two different shots of the same table, I first mounted my camera on a tripod to ensure that the first and second shots would line up easily.

I lit the scene by using a three-light setup. The key light came through a white umbrella from the left side of the scene, set at a 45 degree angle from the subject, 3 feet above the table top. The secondary light was a small soft-box from the right of the scene at the same height as the table, pointed at a 45 degree angle toward the pile of fireworks. The third light was placed directly behind and to the right of the chair where I would sit, approximately 5 feet above the surface of the table.

Once I had the scene lit and the camera angle adjusted to my liking, I positioned the pile of fireworks on the table. I set the camera to take 25 shots by using the repeated timer, and then I moved into the chair, making sure to direct my gaze to where I knew the baby would be sitting.

Shot 2: Baby holding unlit match.
After successfully completing the first shot, I removed all of the fireworks from the table, but kept everything else (camera on tripod, strobes) exactly the same.

We then placed Alice Bee (my daughter and the model for this photo) on the table and handed her an empty sparklers box and an unlit chimney match. We took several different shots; I was quite lucky to get one in which her gaze was in the right direction, she had the box with the words "TNT" in her mouth, and the match was pointing in the right direction—and all of that before this seven-month-old model became cranky.

Shot 3: The lit match.
Compared to the first two shots, the third shot was a breeze. We removed Alice Bee from the table, and she received a well-deserved bottle and a nap for her efforts. My wife then lit the chimney match and held it at approximately the same angle as Alice Bee had held it in the second shot. I snapped off several shots as the match burned down, with the camera still on the same tripod and the strobes remaining unchanged.

 Dave Engledow

Although I received a degree in photojournalism, I have never pursued any sort of career in photography; however, I have had a small number of gallery exhibitions and scattered publication. I was inspired to purchase my first dSLR about a year ago, upon learning that my wife was pregnant with our first child. I have shot and edited more images in the past year than I have in the previous 10 years, combined.

I first determined the best image from each of the three groups of shots and opened all three images in Photoshop CS5.

Starting with image 1, I selected the entire canvas and made a copy. I then pasted this selection directly onto image 2. I used the eraser tool and painted over the section of the table where the baby was supposed to be. Using the Quick Selection tool on image 3, I made a rough selection of the tip of the burning match and pasted this selection onto the main image. I then moved the flaming match tip on top of the unlit match in Alice Bee's hand and erased every bit of the pasted on matchstick, except the flame.

I next created a duplicate layer and used the Topaz Adjust plug-in to enhance some of the small details and open up a bit of the shadow detail. I created a second duplicate layer and used the Topaz Clean plug-in to lightly smooth out some of the skin tones. Finally, I adjusted the color balance, saturation, and vibrance.

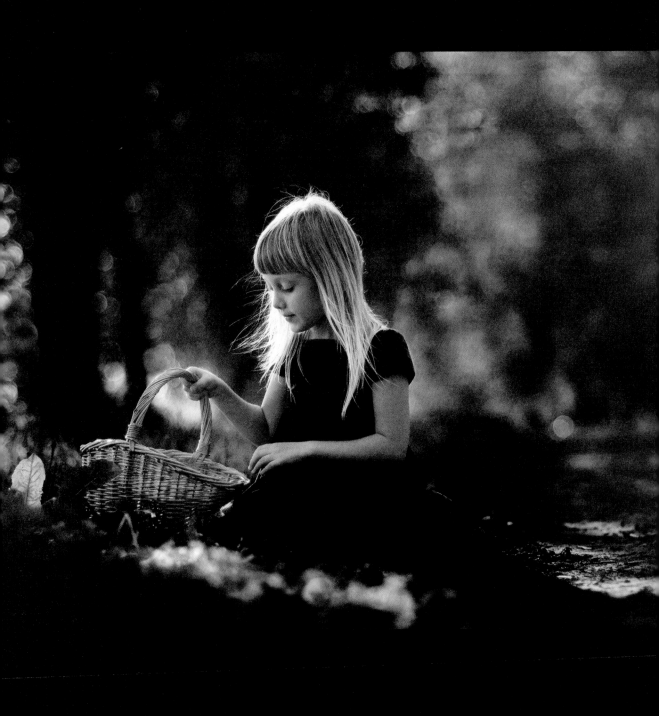

Nikon D300 • Nikkor 85mm f/1.8 lens • f/1.8 • 1/800 second • ISO 160 • RAW

The Autumn Has Come

Most of the photos of children in Magda's portfolio are inspired by a color, by the beauty of the surrounding world, and by the available light. A frequent subject in her photography is a child in contact with nature. That is also the case with The Autumn Has Come.

Magda took this photo during one of her walks with her daughter. She chose a large chestnut avenue as the ideal place for it. Site selection was essential, as the picture was to be in shades of autumn, showing warm greens through yellows, oranges through shades of brown.

Naturalness is very important to Magda in her pictures of children. She deliberately chooses costume and props for her images. In this case, Magda chose a dress in colors similar to the environment, and a wicker basket in which the girl, her daughter, could gather chestnuts.

Magda also carefully considers the time of day when an image will be made. In this case, the photo was taken around 5 pm, when the sun is quite low and the light is characteristically soft and warm.

After finding the right place, Magda asked her daughter to place the basket on the ground and sit beside it. The sun was at the camera right. The reflector was slightly to the left of the girl at a distance of about 2 to 3 meters. The picture was taken into the sun to get the beautiful, glittering bokeh. A slight breeze fanned out the hair, while the sunlight illuminated it into a kind of halo.

When shooting in a backlit situation such as this one, it's necessary to throw fill light on the model. Magda used the reflector to do this. She also really wanted a nice background blur to set off the model, so she chose maximum aperture for the lens.

This image is one hand-held shot (no tripod), no filters on the lens. A circular reflector (1 meter diameter, silver surface) was used to throw light on the subject.

The moment is what makes the difference in Magda's photographs of children. That is very apparent in this picture. The decisive instant for Magda to press the shutter was seeing the child look into the basket, a slightly hesitant gesture with her left hand as if she were trying to reach for what's in it. The story is not just about how warm and beautiful fall is, it is also about how children create their own world; a world of treasures and secrets. What is in the basket? Maybe it's a chestnut, maybe an autumn leaf. Viewers can answer for themselves.

Magda Berny

Magda is a 35-year-old child photographer, living in Poland.

The image was processed first in Photoshop Lightroom for basic adjustments, and then in Photoshop CS3 with the Nik Color Efex Pro plug-in for final presentation.

In Lightroom, the image was cropped to an 8 × 10 format, retaining 100% of the original on the shorter side. White balance was corrected. The Fill Light tool was used to draw a little detail from some of the darker, somewhat underexposed areas.

In Photoshop, a few overexposed areas in the image's background were corrected by using the Clone Stamp tool. Next, three of the Nik Color Efex Pro filters were applied in separate layers: The Darken/Lighten Center filter to illuminate the model slightly; the Skylight filter for better color saturation; and the Glamour Glow filter for a slight softening of the bokeh.

The eraser tool was then used on this last layer (the Glamour Glow filter layer) to remove the effect from the model. The layers were merged, curves were used for a final tonal correction, and the image was sharpened by using Unsharp Mask.

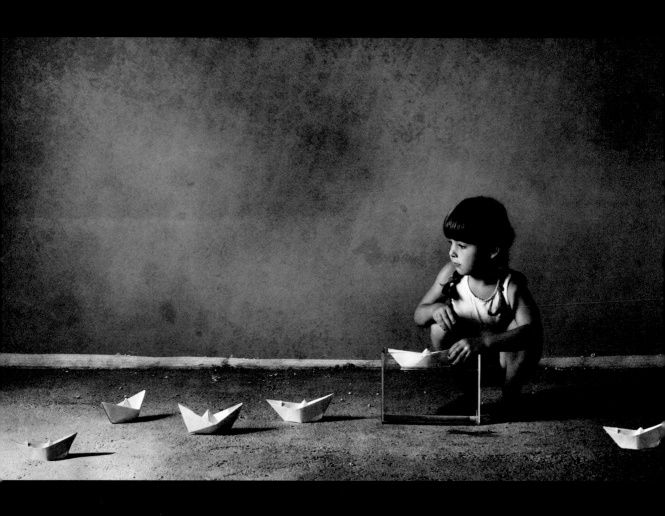

Nikon D80 • Sigma 24-60mm f/2.8 lens @ 32mm • f/8 • 1/80 second • ISO 200

Expanding the Horizon of Imagination

This photo was taken during the summer. We were renovating our house. The rooms were still empty, without any furniture. It did not look cozy but I have always wanted to take photos in such an environment. Near the window, there was an empty aquarium. One day, I just looked at it and had an idea about a little girl playing with some boats. So, I put some water in the aquarium, made a few paper boats, and just waited until my daughter, Maja, became interested in this little scenery. She came in after a while and was totally engrossed by it. I took my camera and shot several pictures.

This photo is a single shot, using one flash with a softbox.

With this image I wanted to show the world of a little child, left alone with her own dreams and imagination. It also shows that a child does not need much to feel free and have lots of fun.

I hope that viewers, upon seeing this image, will share my emotions and have the same feeling. I felt as if I were five years old again, in that simple and safe world, where everything is possible.

After publication, I received a lot of positive reactions, which, of course, made me very happy and meant a lot to me.

Let your imagination work; look for some good ideas. Have an open eye for the world around you.

Try to create something beyond the average.

Do not just take pictures, but try to express something with them, and wait for the right moment to take your picture.

 Monique

Born 1979, Monique is the mother of two and an amateur photographer, living in Poland.

I shoot all of my photos directly in JPEG. For processing, I used Corel PaintShop Pro.

First, I cropped the image somewhat and cloned out a disturbing socket behind my daughter.

Then, I converted it to black and white, using desaturation. I further optimized the contrast and tone curves.

I created a separate layer, applied some texture to it, and blended it with the original photo by using the Soft Light blending mode. I lowered the opacity to 30%. The texture was erased from my daughter along with some other elements to get a more natural look.

The texture, being brown, was finally slightly desaturated to give the photo its light-brownish tint.

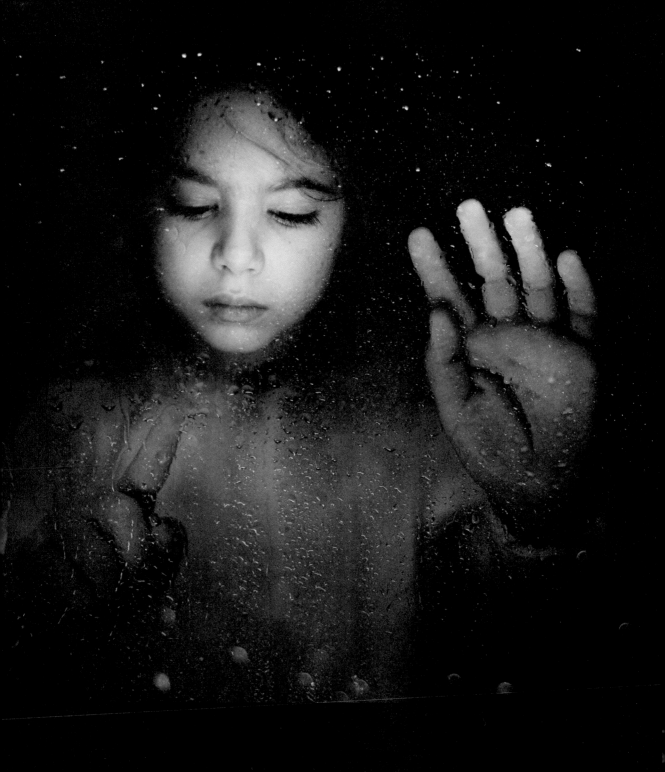

Nikon D700 • Sigma 24-70mm f/2.8 HSM EX DG lens • f/2.8 • 1/160 second • ISO 200 • RAW
Flash: Nikon SB 600 with a diffuse filter • tripod

Rain Painting

For a long time, I had been interested in liquid photography and experimenting with water drops. Depending on the camera angle and light sources, I can achieve quite interesting results. My experiments are mainly done with macro photography. This was my first attempt to include liquid photography techniques in a portrait.

My main focus was proper lighting of the water drops as a picture accent, while at the same time outlining the face of the model. The first lighting scheme was not very successful. The flash made the wet glass visible, but the water drops were just a bokeh.

This picture is part of the second session, which was done using a different light source setup.

For this shot, the camera was set on a tripod, facing the subject at eye level. The model is behind a wet glass which is lit from below by an SB600 flash unit, triggered remotely via a Nikon CLS.

The model is my beautiful six-year-old daughter. She was used to having me around with my camera. Actually, she did not pose intentionally for these photos. I really like natural-looking portraits. In this scene, she just became wrapped up playing with the water drops. The challenge for me was in rearranging the flash setup. I needed to change the position and power of the flash several times without disturbing her. Fortunately, all my messing around did not disturb her, and I think I managed to catch her emotion well.

The main light in this picture is from a flash positioned below the glass. To light up her face I used the built-in flash of the camera with a small diffuser. The room was isolated from daylight and other undesired light sources but the walls were painted in white.

I often take photos of my daughter, but this specific session took place a few days before her sixth birthday. I again realized how fast she is growing up and how important it is to capture moments in her life. The presence of the child's spirit brings the magic to this picture.

 Slavinai

I am from Bulgaria and have four years of experience as an amateur photographer.

You can find my photo gallery at http://www.flickr.com/photos/slavinai/.

I use RAW format for my pictures. The conversion and post-processing was done in Photoshop CS5, in which I only did some cropping, increase of the contrast and saturation, and a little sharpening using masks for the zones in focus. I very rarely use square format in my work, but in this case I chose exactly this format, because of its specific suggestion.

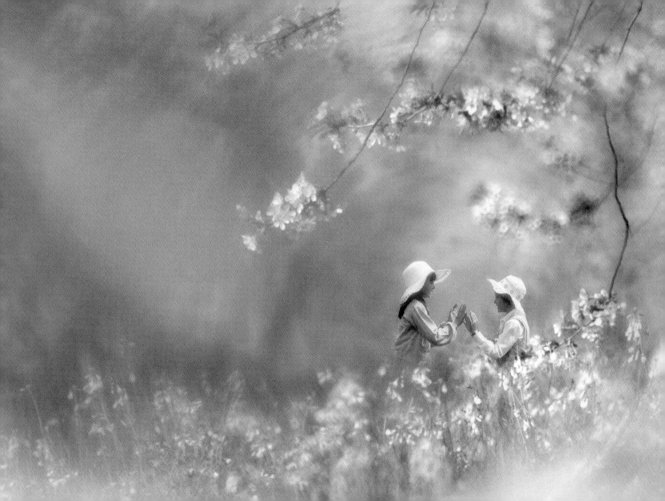

Let Us Sing

I like this image a lot. It's like a poem of nature, full of dreams. That is the feeling I want to convey through my images. The scenery around us is so beautiful; we just have to take the time to look and to enjoy it.

This image has a long history; it's a combination of two photos. Both are color slides, digitized by means of a scanner. The landscape was photographed on a spring day in 1991 with a 500mm fixed f/8.0 mirror lens, having a very shallow DOF. It was taken at ground level through low branches that were full of spring blossoms. The exposure time was 2 seconds. This created some blurry areas that impart the impressionistic touch, which is part of my vision of the beauty of nature. On the other hand, the blue area (the sky) invites you to enter the setting. I love to make this kind of image. I put them in files, which can later be a source of inspiration.

The second photo also dates from 1991. That shot was of two young girls (one is my oldest daughter), singing, full of joy.

I got the idea to combine both images and put the two girls in the blue spot of the landscape. I liked the result, but something was still missing. I wanted to extend the joy of the two girls to the surrounding landscape. So I created this partial rotation in the landscape, concentrated around the girls.

I am very satisfied with the end result. To me, this image perfectly expresses how young people enjoy life in their world, carefree and happy. I hope that viewers come away with the same feeling.

The most important aspect is to always be yourself. Photograph what you like and the way you like it. Do not imitate others or try to please a jury. Work, work, and work. Dream yourself, and let the viewers dream, too.

 Fernand Hick

I am a very personal and original Belgian photographer, trying to use my images to share the feelings I experienced while shooting. I am mainly an atmosphere photographer, and I wish to share this with all people looking at my pictures.

Feel free to visit me at http://www.fhick.be/.

All processing was done in Photoshop CS. First, the two girls were selected, copied, and pasted into the landscape. Then, I used the Transform tool on the layer containing the girls to create the right perspective and dimensions. I applied a mask to that layer and made final retouching with the Brush tool to create a perfect and smooth fit of the girls in the landscape.

To create the movement in the landscape, the layer was copied, a selection was made, and then feathered strongly. Finally, a radial blur filter was applied in "spin mode," making sure that the center of the rotation was the girls.

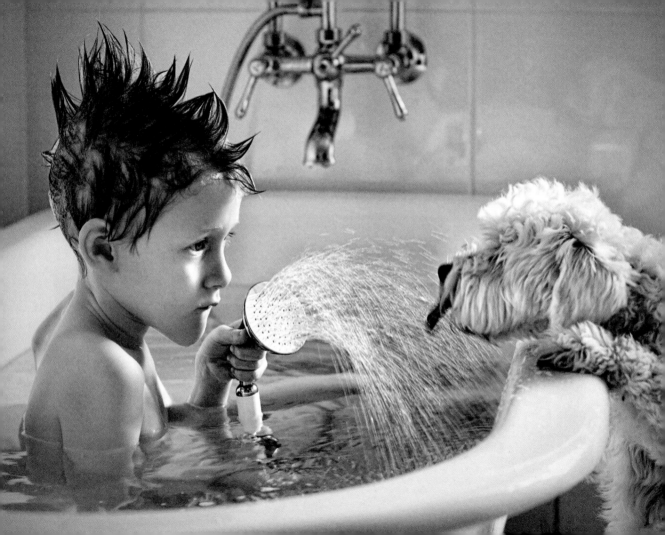

Showertime

My son was having a bath one night and I was washing his hair with the handheld shower. Our dog does not like to miss out on anything and was trying to get in on the action. I was watching them play together and thought it would make a great photo.

I grabbed my camera and flash but it did not really work out, because the lightning was just not right. I tried again with a tripod, but still it was not right.

The next day, around midday, I filled the bath and told my son to jump in so we could do a reshoot. Of course, the dog was more than obliging; anything for attention! This time the light was perfect, with the bathroom walls and floors reflecting the natural light coming in from the window beautifully. I sat on the floor to be at the same level as my subjects and positioned myself so that the viewer would also be able to see the faucet in the background. I had the camera set on spot metering and metered my son's face, focused on his eye, and thankfully, did not have to wait long before the dog jumped up and started to lick at the water coming from the shower head.

I like this photograph because it makes me smile. I love the interaction between my son and our dog, and the light was just perfect. The best advice I could give to anyone trying to shoot children or pets is patience. Thanks to digital technology, you can just keep clicking. Once the light metering is right, provided that the light does not change, you can just keep shooting if you are in manual mode.

 Niccole Goggins

I currently teach photography for "Photography Tours" in Brisbane, Queensland, Australia, and have a small photography business, specializing in family portraiture. My inspiration is and has always been my family.

This photo was processed by using Photoshop CS3. All I did was slightly adjust the levels so that the right pointer was on the edge of the histogram, merge layers together, copy the layer, and run it through a Topaz adjustment filter using "exposure correction." On the Topaz layer, I dropped the opacity back to 80%. I duplicated the layer and added a high-pass sharpen filter with Soft Light blending mode and the background masked out. Then, I used a small amount of dodge and burn on the water and shower head. A soft vignette was also added to help draw the eye in.

DOCUMENTARY is that which aims at recording reality, attempting veracity in the depiction of people, places, and events. However, the process of mediation means that this is something of an oxymoron, it being impossible to represent reality without constructing a narrative that might be fictional in places. Certainly, any images that are edited cannot claim to be wholly factual; they are the result of choices made by the photographer. Decisions made in post-production mean that actuality is edited, resequenced, and artificially framed. The documentary maker generally establishes a thesis before starting the construction of what he wants to document, and the process of documentary-making could simply be the ratification of his idea. Perhaps, to misquote Eco, the objectivity of the picture lies not in the origin but the destination?

The documentary genre has a range of purposes, from the simple recording of events (a snapshot or unedited holiday video) to a polemic text that attempts to persuade the audience into a specific set of opinions (*Bowling For Columbine*). Audiences must identify that purpose early on and will therefore decode documentary differently than fictional narratives.

Documentary can be so much more than showing reality. It is also art. There are different modes of documentary, such as the "poetic mode," "expository mode," "observational mode," "participatory mode," "reflexive mode," and "performative mode."

The photographer, the artist, is of course interacting but never creates scenes. Involvement in people's lives, partly living among them, can produce good documentary work. In any given situation, the photographer must respect the integrity of people and aim at presenting the reality in the form of art.

So much for the theoretical side, but when it gets to practice, some things are required.

The starting point is, of course, to find an interesting topic about which people are enthusiastic. It is hard to give advice about this, except "be patient." It is important to formulate the basic idea of what you want to document as precisely and clearly as possible. If you do not know why you want to make a documentary photo series, what it is about, and where the story is going, then it might not be a very good idea in the first place.

If you have not previously worked in the documentary genre, it is a good idea to find some examples that you can draw inspiration from before laying down the aesthetics and the method of your photo documentary.

Discuss whether you prefer to use television or film documentaries as your primary source of inspiration. If you do not lean toward television documentary, a library or a photo exhibition is the place to seek inspiration.

Find a good selection of documentaries and look for the quality and topic. This will give you a good idea about what you want to document and how to structure it.

As you have your idea, you need to find the right location and get the right information about the culture or place you want to depict. Explore the light situation and the habits and lifestyle of people. Employ a local guide who can help you to understand.

The camera gear plays a role: it acts on your behalf. Remember that the camera angles and movements are significant for the degree to which you express respect for, solidarity with, antipathy against, and so on the people in your documentary. Before the shooting starts, ensure that you have agreed on certain principles for operating the camera (this is of special importance, as fiddling on the gear instills no confidence in people).

It is a good idea to draw up a set of rules, some aesthetic narrative guidelines for what you can and cannot do. Never provoke a scene or set up a scene, and if you have to do it, take care that all is as original as possible.

The choice of lens is also important. The best is a 50mm prime or a 24mm prime.

And finally, you also need some good luck!

–Robert G. Mueller

Documentary

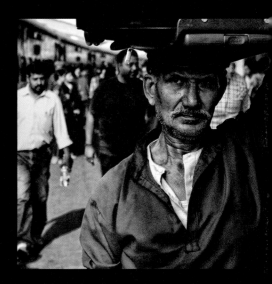

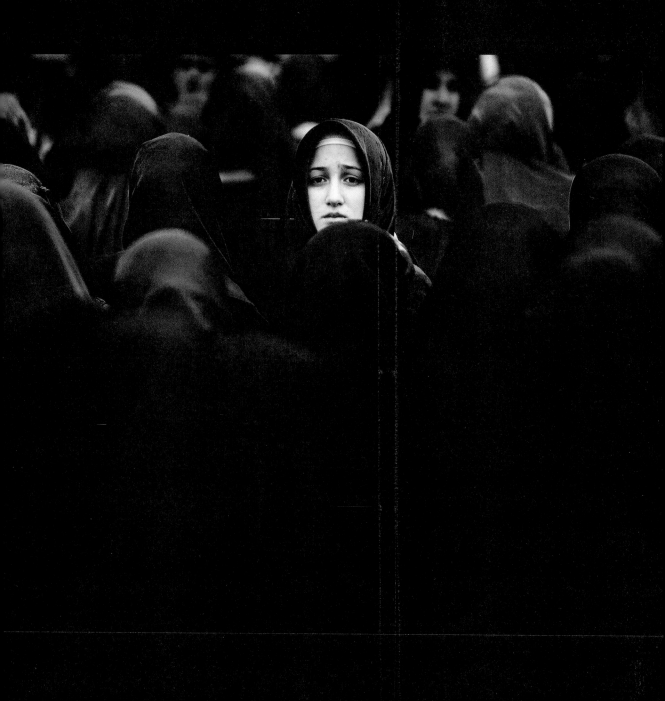

Where Am I?

This photo was taken on a mourning day for Hussein, an important figure in the history of Islam, who was killed in battle in AD 680. Hussein is worshipped as a martyr by some Islamic groups. Each year, worshippers gather together in a special mourning ceremony.

Such ceremonies also take place in my home country, Turkey. I visited the event for the first time in 2010. Planning to do some documentary work, I was looking for some general scene as well as for details in the crowd. Although the event lasts three to four hours, photographers are only allowed to take photos for one hour. So time is limited if you want to create a story, hoping for some great emotional moments. That is also the reason why I am planning to go back this year. During the ritual ceremony, the women were all looking in the same direction. I was hoping and waiting for one woman to look backward. Suddenly I saw this young woman, turning her head as if she were looking for someone. I was trying to find a good location for capturing her face, when she suddenly gazed at me for some seconds. I instinctively took two or three shots in continuous mode.

This photo is part of a series. In combination with other photos, it has become a real documentary story of this ceremony. While this single image speaks for itself, the impact of the whole documentary story becomes even more stronger.

The important elements that you must possess for this kind of image are patience, observation, and also some luck.

Yavuz Sariyildiz

I was a CEO for a leading financial group in Turkey. After 25 years, I retired to spend more time for my photographic passion. Today all my time is dedicated to photography. It became much more than just a hobby.

For this image, only limited post-processing was needed. Aside from some basic tone processing, I just cropped a little bit to better frame the woman. For the other woman looking in my direction (at the right), I did some tone burning to darken her face. Thus, all the attention remains on the woman in the center. All the processing was done in Photoshop CS3.

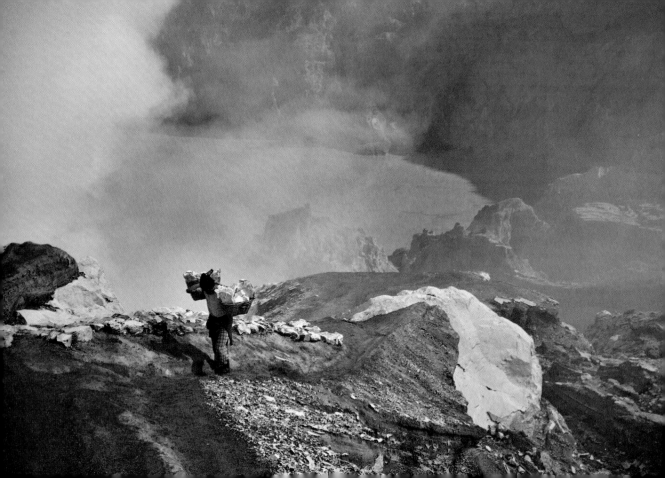

The Man and the Sulphur

As often as possible, I travel to other countries to discover different worlds, societies, landscapes, and people. This photo is from my trip to Indonesia. I have seen a lot of photos and documentaries from Indonesia, but the most striking images I saw were about Kawa Ijen, a Sulphur mine in an active volcano. It was then that I decided to go to Java and explore Kawa Ijen myself. This place really intrigued me.

 RomImage

I am 30 years old and have practiced photography for over five years. My main theme is travel photography. I am a traveller before being a photographer. I like to discover new places, thoughts, and ways of life. Photography is a filter through which I can explore and is also a good way for me to communicate with people I visit. My real job is also a passion—I am a researcher in math and I often find that science and photography share the same way of thinking (exploration).

This photo was taken in August 2010. I had been in Java for a week, and on each of the previous few days, I had been up quite early to catch the morning light. I had roughly four hours of sleep each night, so I was quite exhausted. Moreover, on this day I had a fever. I got up at three o'clock in the morning, and after about two hours of driving and one hour of climbing, I was finally on the summit of Kawa Ijen (not really in good health). I was there for only one reason: to climb down into the crater. But now the question in my mind was, "Do I have enough physical energy to climb down into the crater with the sulphur gas burning my throat and eyes, and after that, climb back up the crater and down from Kawa Ijen." After a few minutes I decided to do it, because after all, this was the initial goal of my trip. Quite surprisingly my fever disappeared completely during my climb.

I was looking for a strong photo, with the acid lake in the foreground, sulfur fog, and the surrounding environment. Finally, I found the right spot for my photo. I had the lake, the fog, and also a bird's-eye view, which gave the feeling of the crushing work and difficult conditions. The foreground is clear enough to lead the eye from the border to the subject, and the path behind the man suggests the hard walk he must take.

I found the right spot and waited for the right man, carrying baskets of sulphur on his shoulders. Workers on Kawa Ijen collect yellow lumps of sulphur. Once processed, the sulphur is used mainly to bleach sugar and make fertilizer. This man chose to work under such hard conditions. He gets five times the average salary in Java. Below the Kawa-Ijen, there are plenty of coffee plantations, but work there pays a considerably lower salary. Workers told me that they carry roughly 70–80 kg on their shoulders. They do around four descents into the crater each day.

In all of my works, I use RAW files. My post-processing is never a big deal. It's usually quite light and takes me no more than 10 minutes. In Nikon Capture NX 2, I modified local contrast, luminosity, and saturation, both around the subject and the subject itself. At the end, I did a global sharpening.

The most important preparation is to think in advance about the photo you want to take. When you are out in the field, you must have a clear idea of what to expect and what you are looking for. Here, we have a photo-documentary situation—through this photo you must show the hard conditions, the work itself, and the context. If you come without a rough idea of what you want, you risk having nothing good at the end. Having a clear idea for the picture and the story it should tell is, in my opinion, a good starting point for a successful photo.

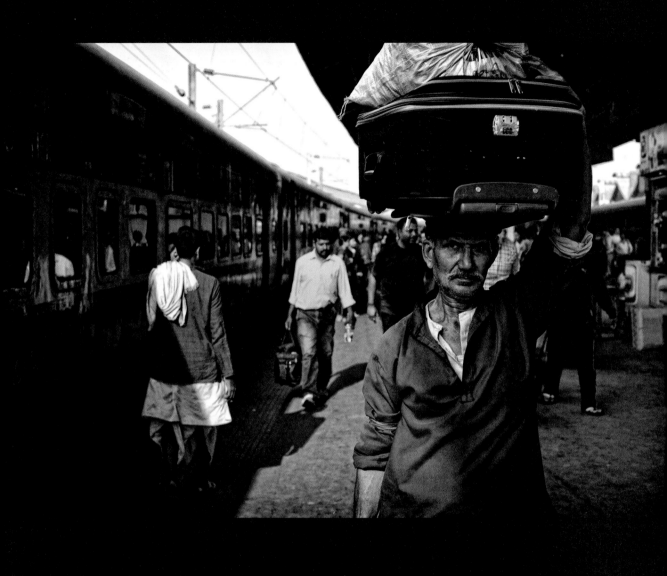

Nikon • Nikon 500mm lens • f/5.6 • 1/500 • ISO 400

Luggage Carrier

After I saw an exhibition with photos from India, one of which was a picture from a train station in Mumbai with a luggage carrier, I had an idea in mind to photograph the Howrah train station in Kolkata (Calcutta). I just wanted a typical scene from a train station; something not uncommon with a man carrying a suitcase.

I started by just hanging around the station and clicking all I could, and then look to see what was interesting and could be developed into a concept for what I wanted to show. Finally, I figured out the best light and location. Luckily, the train station is a terminus with a bend, so I did not need to worry about the compositional candy. What I needed was not much rush, an arriving train, and a luggage carrier. After a couple of Sundays, I finally got what I wanted—well, almost. As always for situations like this, I had to act fast and also be a bit lucky.

I always carry my favorite lens and camera: a Nikon full frame with a 50mm lens. This combination lets you catch the light very well. As a standard, I pre-adjust my camera to aperture 5.6 and ISO 400. I have programmed my camera with many different shooting modes. On my right shoulder I had my second full frame with the 80-200mm f/2.8, and on my left shoulder my 24-70 mm f/2.8. It was 6 am, and I decided to use the 50mm. I stood there on the platform with the train schedule. The train arrived and I started clicking and moving around till I got my frame with the best depth of field. That was it!

One important thing for pictures such as this one is that people around you need to get used to the camera. Situations like this also need time and luck. It might be possible to arrange such a scene, but then the picture is not authentic. I chose black and white because I feel that I can express more than I can with color. These pictures need a lot of patience and diligence. By just going somewhere and clicking, it will not be possible to get a "wow" picture. Of course, sometimes it happens, but if you have a concept and something in mind, you just need to work it out and the rest is easy.

Never hesitate to get involved and always try to listen to the people!

Robert G. Mueller

I am 41 and simply go by the name Robert from Germany. I build steel factories around the world and like to surround myself with people. I have been living in India for three years, and my passions are portrait photography, environmental portraits, and architectural photography. I have a great interest in foreign cultures. I love to walk in places where tourists typically don't go.

I developed the image in Nikon Capture NX 2, adjusted the levels, and saved it as JPEG with 100% quality.

Then, I opened it in Photoshop CS4. I played around with the colors and raised the global color contrast. For raising the contrast, I always try the black and white output to get a better feeling for the final contrast in my image. Next, I used Nik Silver Efex Pro to give the picture the last final tuning. Finally, I did a slight crop, and that's it. The total work time was about 10 minutes. For most of my pictures, I do not work longer, because I feel that if I work too long with it, the essence of the picture is lost.

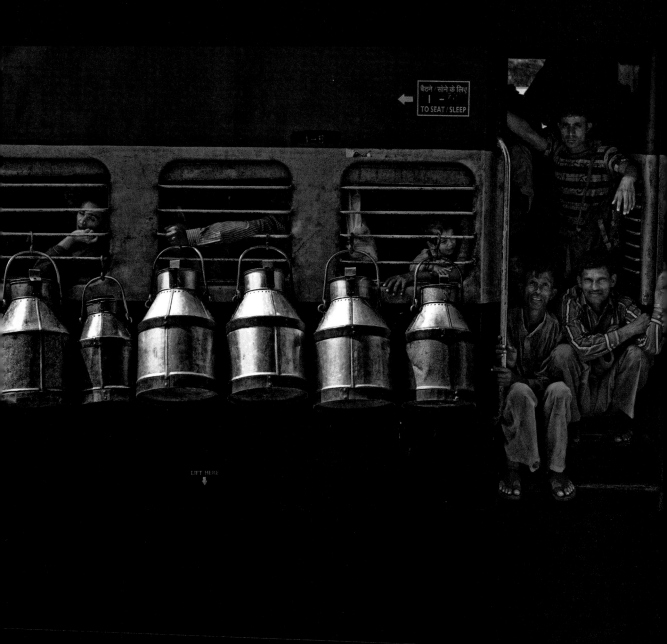

बैठने / सोने के लिए
1 - 7
TO SEAT / SLEEP

LIFT HERE

Nikon D700 • Nikon 24–70mm f/2.8 lens

Train

The train was already at the platform for quite a while, maybe for half an hour, so people were becoming bored and restless. There were some regular travellers in there, too, who brought milk to sell in the city. They had hung large milk cans outside the compartment.

It was the last major day of the Kumbh festival, which is held every twelve years in four holy cities in India—this time in Haridwar. It is a small town (by Indian standards) with around 800,000 people, but on this day of April 14th, 2010, more than 16 million people congregated to bathe in the river Ganges.

Since my photography is a lot about the life, trials, and tribulations of the people of India, it was very important for me not just to photograph such an event but to experience it, too.

India is heavily populated but nothing prepared me for such a surge of humanity. After taking pictures of people bathing, I went down to the city's railway station. It was an unbelievable sight. There were people everywhere. On the platform, inside the train, and even on top of it; many were fighting with the driver to let them travel in the engine itself.

I kept shooting. There were expressions to catch, moments to capture, scenes to preserve. Composition and comprehension both were intuitive. I had to look out for the high-contrast lighting. This was mid afternoon, and the sun was very bright, but inside the train it was quite dark, so creating a frame was a bit tough. I usually shoot full manual. For this shot I overexposed by one stop. When I looked at this compartment, I knew I had a good shot coming. The cans were a bit of challenge, because their reflective surface would blow the exposure, but to me, the expression of people inside was more important, so I overexposed, anyway.

The picture, is also allegorical. It speaks of monotony, of predictability, of patterns in a life. Still, for outsiders and observers, the monotony of others can make interesting pictures. To have a picture like this captured on a day that would not come around again for another twelve years was a bit ironic.

If you end up in a situation like this, get a good feeling for the place. Don't be a judge and do not pity. Just enjoy your presence and the opportunities. Shoot generously. Such situations are constantly changing. The right moment and the right emotions will be captured only if you shoot enough. Stay calm and keep a presence of heart and a presence of mind.

Prateek Dubey

I used to be a fashion designer, but now I am pursuing a full time career as a professional photographer. You can find more of my images at http://prottle.1x.com/.

I carried out basic tone level and color processing of the RAW files in Photoshop Lightroom, saving it as a TIFF file. Further processing was done in Photoshop. Layer masks were used to bring out some details in part of the image.

I used a high-pass filter to bring extra texture in the image (micro-contrast).

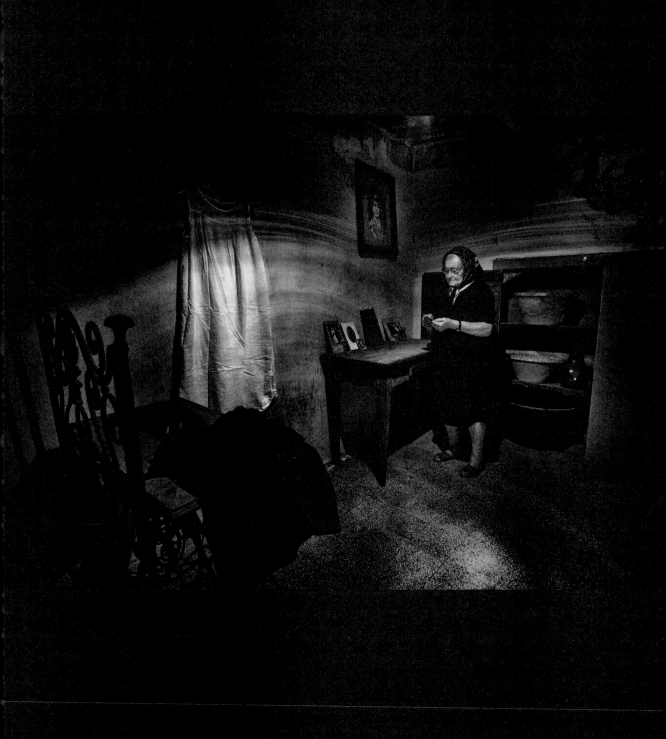

Nikon D300 • Tokina 12-24mm f/4 lens @ 12mm • f/4 • 1/20 second • ISO 2000 • RAW

Old Memories

This photo was taken at an event in the village of Mandia Ascea (Italy) called "The Feast of Ancient Flavours." I saw an elderly woman in a room, surrounded by the furniture and various antique objects that appeared frozen in time. I felt as if I were in a different era. I asked her (Elisabetta) to pose for me, looking at one of the old photos on the table, which she very kindly did.

I made a sequence of three hand-held shots (what I usually do for this kind of "moment" capture).

I only used ambient light (no flash) for a more natural environment

The purpose of this image was to recall the memories of the past and the living conditions in those days. I converted the image into black and white because I felt that it would make my message stronger. I received many very positive reactions, convincing me that my image apparently conveyed that same feeling to the viewers.

Here are a few of my personal recommendations:

Shoot in RAW mode. This gives you much greater possibilities and more flexibility during the post-processing.

Care for your composition and include as many elements as needed (but not more) to reinforce the message of your image.

For this kind of image, you can take a sequence of shots (at least three) to ensure that you get a good one.

Antonio Grambone

I am 45 years old and live in Rome, where I work in the military administration.

Photography is a hobby and a passion, allowing me to observe the world around me and the changes during the years.

You can find more of my work on my homepage at http://www.antoniogrambone.it/.

First, I optimized the white and black points in Adobe Camera RAW (basic settings tab). Then, I opened the image in Photoshop and made a copy of the background layer. I created an H/S adjustment layer and desaturated the image into black and white. Next, I opened a Level adjustment layer and optimized the levels in the dark areas. I created another Level adjustment layer and optimized the levels in the bright areas. I then put the "black levels" layer on top of the layer stack, activated the layer mask of it, and painted on it with a soft brush to reveal the bright areas of the underlying layer. Finally, I merged all layers and did a final levels adjustment.

The sharpening and the sizing for the web was done in two steps. First, I applied an Unsharp mask (amount 100/radius 0.6). I then reduced the image to 50%. A second sharpening (amount 60/ radius 0.4) and a final size reduction to the required web size finished the process.

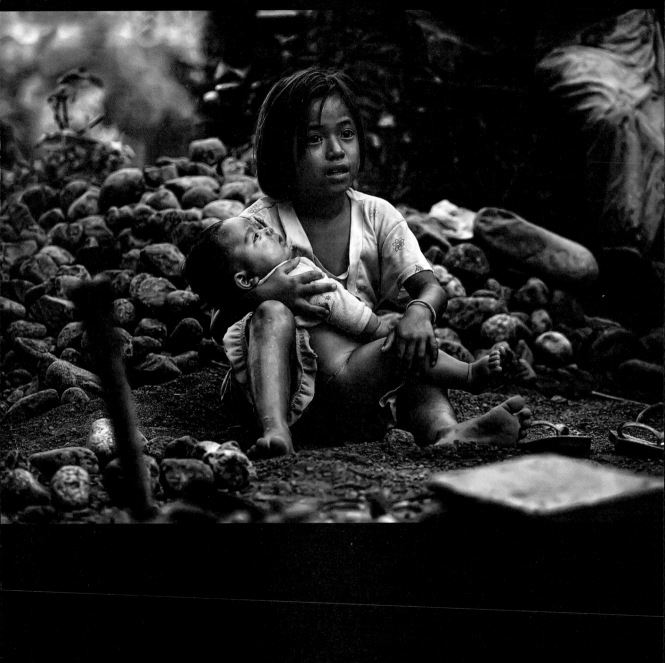

Canon EOS 5D Mark II • Canon EF 70-200mm f/4 L USM lens @ 109mm • f/4 • 1/60 second • ISO 400

Big Sister

I took this picture when on a bike tour in the mountains together with some friends. It was a full day adventure through villages and the countryside. I always carry a camera when I go adventuring or walking and take pictures when looking at beautiful scenery or meeting interesting people.

At the end of the trip, we had to cross the river where a car was waiting for us on the other side. But first, we stopped for a moment on the riverbank.

There were a few local villagers gathered—mostly women and children with hammer tools, baskets, and buckets, working hard to collect and break the stone to be used as building material. We rested and spoke to them. When we were going home, I saw a girl carrying her little brother. She sat down next to their mother, looking tired, with dirty clothes and body.

I immediately opened the bag and grabbed my camera. I only had a short time because the children would soon be gone. I could not imagine that I had managed such a good picture.

When I arrived home, I immediately opened the camera to view the pictures. I felt satisfied, happy, but very moved.

This image is a single shot. I took it from a distance of about 4.6 meters and the afternoon sun began to go overcast, so there was not enough light, but there was some reflection of the dim light that was of some help.

I hope this picture can be seen by many people and serves as a reminder that there are still poor families who need attention. This little girl should be at school or playing; instead, she had to spend her time taking care of her beloved brother because their parents had to work all day to meet the needs of their lives.

My wish is that through these photos, more people can be moved to love one another—watching, helping, having respect for others, so that life becomes more beautiful.

Adhi Prayoga

I was born in Mataram, Indonesia on the 22nd of February, 1971. I married Devy Darlota Salean and have three beautiful daughters. I opened a business trading spare parts and repairing Yamaha motorcycles.

I really like photography and am still an amateur. I started nine months ago. I hope that photography can provide additional income for families and that my work can make many people happy. I want to dedicate this to my beloved family.

This picture was processed in Photoshop CS5. I did some processing, such as conversion to black and white, levels, curves, contrast, and brightness. I also did a little burning and dodging, and then finally applied a bit of unsharp mask.

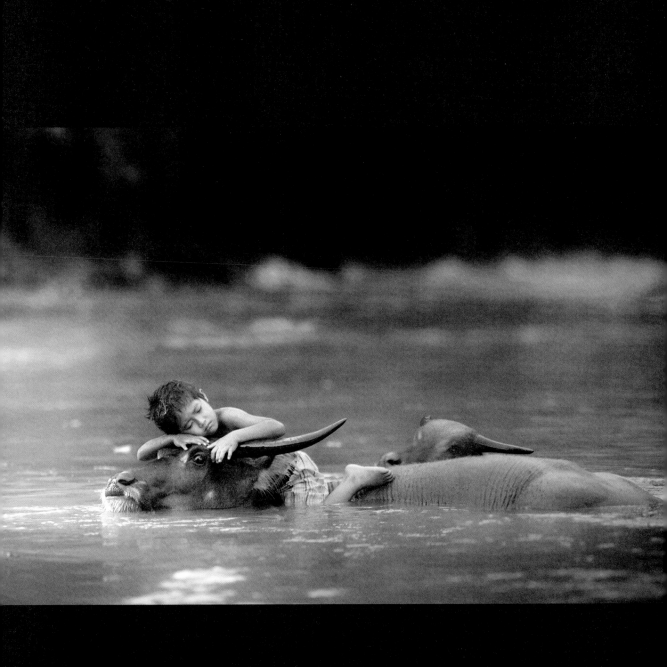

Canon EOS 50D • Canon EF USM 135mm f/2 lens • f/2 • 1/800 second • ISO 250 • flash

Sleeping Beauty

The photo was taken in a small river village in West Java (Indonesia). I was looking for a location for a wedding session. Suddenly, I saw these two buffaloes and a child playing in the river. At one point the child lay resting on one of the buffalo's head, making it a beautiful composition of tenderness and harmony between the child and the animal.

My main field is human interest photography. I love to catch scenes of our daily life. My heart beats faster when I see kids playing traditional games, with their innocence and free spirit.

My passion for human interest photography has to do with my own childhood. I grew up in a small mountain village in central Java with a strong Javanese tradition and culture. It was a sweet and memorable time, which I recall every time I take a human interest photo. My work *Sleeping Beauty* is one of my favorite photos because I feel a strong emotional attachment to it. It is a reminiscence of my childhood, which I, too, usually spent playing in the river with my own buffalo.

I hope that viewers living in the cities will also be impressed by this kind of harmony between people and the unspoiled nature around them.

Most of the time, I take pictures in the morning when the sun starts to rise. I walk around the neighborhood with the camera on my shoulder and try to find interesting subjects. At that time of the day, people are just starting their activities, and their energy is still fresh and high. We should more closely observe what is happening around us. There are common situations that often miss our attention but can become captivating feature photos with just the right time and angle.

I love improvising with shooting angles and available lighting. Using back lighting or side lighting can create more dimension than front lighting. Different shooting angles will create different emotions in your photos.

I try to make my subjects relax by having a chat with them. Natural facial expression is important to create a story-telling photo.

 A. Munasit

I am a freelance photographer and professional banker, living in the outskirts of Jakarta, Indonesia.

I performed the post-processing in Photoshop CS3. First, I copied the background and set the blending mode to Soft Light. Then, I applied Lighting Effects in the Render Filter, to adjust for the morning light. The next step was to create five adjustment layers with the following adjustments, respectively:

1) Selective color red (cyan +50).
2) Selective color yellow (cyan +60).
3) Selective color green (cyan +30). Further image adjustment with photo cyan filter.
4) Brightness/Contrast (brightness 10%/contrast 20%).
5) Hue/Saturation (saturation −15).

EDITING is done on most images, in one way or another. It could be basic adjustments of contrast and color, black-and-white conversions, and multiple exposures. But creating photo montages takes editing one step further.

Some people take photos, others make photos by using different images to synthesize creative compositions.

In fact, this is nothing new. A lot of amateur photographers and well-known top photographers such as Man Ray and Jerry Eulsmann did this many years ago in the darkroom.

In my opinion, editing an image is a step further in the broad world of photographic expression, where different photographic elements are used and brought together to create a new concept or to express an idea.

The difference between the darkroom era and now is that modern editing software affords a lot more creative possibilities and flexibility. It's easier than working in the darkroom. As a result, more and more photographers are tempted to do montages to express their creativity. Some professional, commercial photographers make a very good income from it, such as Tomas Herbrich.

The most important things to think about when making and editing a composite image are:

- The extraction of different elements should be as perfect and smooth as possible. It can be done with the pen tool, eraser tool, or with plug-ins such as MaskPro or Vertus. A well-defined object should be sharp at the borders of the image element. Soft subjects, on the other hand, should have softer outlines so that they don't look pasted in. A small (5 points) Blur tool in Photoshop is very useful when extracting objects from a photo.

- It is important that the light comes from the same direction in all elements of the image and that the colors of the added elements fit the colors of the background.

- When you have extracted the elements and placed them on a new layer, be careful to make the shadows as realistic a possible. Naturally, the shadows must follow the direction of the light in the image and they must have the correct perspective and toning. A good Photoshop plug-in for creating shadows is Perspective Shadow from Alien Skin's Eye Candy Impact (5 or 6).

Obviously, you need some knowledge and experience to achieve perfect control over all these elements. But Adobe and other software providers have created programs to make this work a little bit easier. Thus, Adobe has taken over from such former famous names as Kodak and Agfa.

–Ben Goossens

Editing

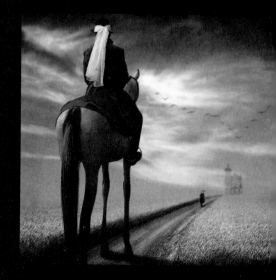

Canon 7D • Tamron 17-50 VC lens • 2 Canon 430 EXII flashes

Motion of the Runner

I always jog each weekend, to stay fit and socialize with my friends. This gave me the idea to make a rather unique photo of a runner.

I made this picture with a Canon 7D, Tamron 17-50 VC lens, 2 Canon 430exII flash with a homemade snoot, radio triggers, a tripod, lots of incense sticks, and black cardboard as a background to minimize shadows.

In total, sixteen RAW shots were made, including blurry shots to use for the effect. Fourteen pictures were selected. Those consist of the head, the body, the legs, and also the blurry motion effect. I used manual setting with three different apertures, f/5.6, f/7.1, and f/9.0, to control the depth-of-field of smoke. The hardest part was to blow the smoke and then shoot it. To get full control of the smoke, I blew it with my mouth and used a fan.

As for the light setup, I used two flashes, one to the left and one to the right. Homemade snoots were put on both flashes to keep the light balanced between the two sources. The essence sticks are the center subject. Each shot was made with different power output. At f/5.6, I used 1/64; at f/7.1, it was 1/32; and at f/9.0, it was 1/16. Both flashes were controlled manually via radio triggers. I ended up spending five hours to get this shot, without any assistance.

I tried to accomplish an abstract shot by using simple equipment. In this case, there are incense sticks that produce smoke. Many great photos have been made featuring smoke as a subject. It helps me to stretch myself to produce a great picture.

Blur is not necessarily bad in smoke photos. You can use it to produce a good effect.

Our imagination is the biggest resource. If you have an idea, write it down, and then develop it.

Smoke can be tricky to shoot. To control it, I use a cheap homemade mini studio.

First, I let the smoke flow freely and then I try to freeze it with my camera. Then I reshape it. I do not let the smoke flow freely again; instead, I control it like a wizard. A fan, blower, or something similar is very handy to keep it steady, as you want. Keep practicing and you will soon become familiar with it.

Tonny Liautanto

I started photography in 2009, when my neighbor introduced me to it. I am a hobbyist and am still learning. I enjoy photography very much as a relaxation after working six days each week.

I work with Photoshop CS3. First, I converted the selected pictures into black and white. From the 14 photos, 2 were made into the head section, 2 for the hands, 2 for the main body, 3 for legs, and the rest of them are blurry photos to create the running movement.

I combined all the selected photos together. The workflow includes cloning the legs, cutting unwanted parts, masking, and adding motion blur to create a more dramatic running effect. As a finishing touch, I used the high-pass filter (100 pixels) to sharpen details and remask it again for the blur and motion effect. Why 100 pixels in high pass? Well, smoke is unique. I need those pixels to make it sharp and clear. It depends on what you want to achieve. Those numbers are not absolute. It took 48 hours to do this job. If you know an easier way to do this, by all means, share it with me.

Canon 5D Mark II • Canon 24-105mm lens @ 24mm • f/4 • 1/5 second • ISO 800 • tripod

Me, Myself, and I

The whole idea of this kind of an image is fun, so your first job is to think of an interesting location and good composition. Depending on your retouching skills, you need to decide up front how much interaction your models within the frame will have.

Once you have chosen the location and decided on the right composition, you will start with positioning the tripod. Remember, this position *must not change* throughout the entire capture process! With the camera attached to the tripod, you need to establish a focus point. Remember to switch from autofocus to *manual focus*. And just as with the tripod position, the focus setting must not change at any point through the shooting.

In this case, the focusing point was the guy with the guitar (myself), because he is the main point of interest in the scene. It can be tricky to set the focus when you are the model. As a surrogate, I positioned the guitar roughly in the position where my head was going to be and focused on it.

With the tripod in the right position and the focus set, it was time to shoot the multiple images. I started with the guitarist. I used the self-timer settings on the camera—10 seconds was just about enough time to position myself into each shot. If you need more time than what the self-timer of your camera gives you (10 seconds is usually standard), then you will need a remote shutter trigger.

After every shot, I viewed the image on the LCD display of the camera so that I knew where to position myself for the next one. I also changed clothes between each pose so that the final image would look more realistic—as if there really were so many versions of myself. While viewing the images and changing clothes, you should be careful not to move the tripod or camera! Even the slightest change of the view can spoil the final result.

For a project like this it is easier to shoot indoors in artificial light—natural light constantly changes even on a bright sunny day (shadows are moving) so you might end up with different light/colors in the scene that will spoil the realistic look.

A good idea and a composition is more important than to just make many models!

 Stefan Babel

I am a photographer living in Orford, United Kingdom.

Once you have shot all the images, it's time to put them together in some editing software such as Photoshop.

To make it easier, work with only two images at the time. I started with the image of the guitarist and the man taking a picture with his phone. With both images opened, I dragged the guitarist on the top of the camera man, so the bottom layer was an image of the man with the camera and the top layer was the guitarist. I applied a layer mask to the top layer and started painting with black brush over the area where the camera man should be. Once I masked the camera man area out of the top layer (so he was visible), I merged the two layers together into a single layer that contained both the camera man and the guitarist.

Then, I opened the image with the fellow sitting to the left of our friend with the camera and furthest from my camera—let's call him Mr. B—and started the whole process again: I dragged the image with the guitarist and the camera man on the top of the image with Mr. B, applied a layer mask to the top layer (camera man and guitarist) and masked away the area where Mr. B was. Now, there were three figures in the image. I again merged both layers so that all three characters were in the same layer. I followed the same technique for the rest of the images until I ended up with the final frame, with all the models in the right positions.

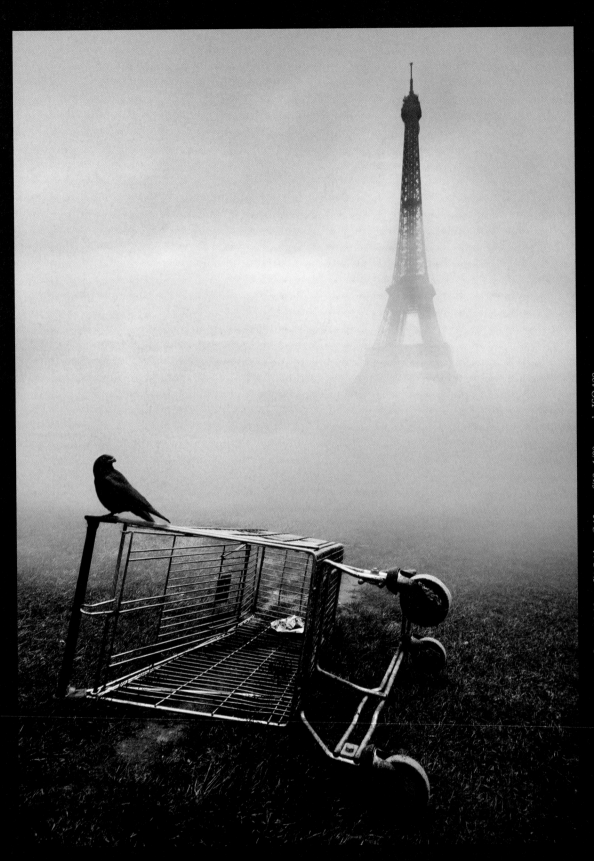

Tower: Nikon D7000 • Sigma 10-20mm f/4-5.6 lens @ 12mm • f/10 • 1/80 second • ISO 100

Crow: Sigma 18-50mm f/2.8 lens @ 50mm • f/4.5 • 1/200 second • ISO 100

Paris...

I was on a journey to Paris with my friend. While visiting the Eiffel tower, I saw the shopping cart lying in the grass. It gave me the idea to try a unique perspective of the tower, which has already been seen in so many different ways. It was just on a whim that I decided to make the of connection between the shopping cart and the tower.

The final idea for this image came to me when I was looking at my holiday photos and found a picture of a crow. From there, it took just half an hour to finish the picture.

The image is a composite of two photos, both taken in Paris within a half an hour of each other. The shopping cart picture was taken with a Nikon D7000 and a Sigma 10-20mm f/4-5.6 lens. The crow was taken with the same camera but a Sigma 18-50mm f/2.8 lens.

I wanted to create a unique view of one of the world's most photographed places. I also wanted to make the viewer feel like something dramatic was happening in that place.

I did not know if it would work in the same way for the viewers. But after receiving feedback, I felt like it really worked the way I wanted.

My advice for photos like this one is to first try to have an idea that stands out. Then, try to convey this special feeling to the viewer.

Processing is a key element for this kind of image. Make the viewer look at it even closer and speculate about what is real and what is not.

Mikko Lagerstedt

I am a self-taught photographer and graphic designer from Finland. I started photography in December 2008 and fell in love with it right away.

Contact information:

www.mikkolagerstedt.com/photography.html

www.redbubble.com/people/latyrx

I use Photoshop Lightroom 3.1 with Photoshop CS4 for processing my images.

First, I opened the tower picture in Lightroom 3.1 and brought back some shadow tones. I used an adjustment brush to make the sky slightly darker and to give a little more contrast to the grassy area. Then, I opened the image in Photoshop CS4.

I first removed all of the uninteresting objects in front of the tower and copied some of the sky to give it a more foggy feel.

I had an idea to add some drama to the image by putting a crow on top of the shopping cart. I opened the crow picture, cropped it to the required size, and then selected it by using the Path tool. After copying the crow into the tower picture, I positioned it on top of the cart and used the Brush tool to add some shadows, as if the crow was really sitting on the shopping cart.

Finally, I used a black and white adjustment layer for converting the image to black and white. After that, I increased the contrast with curves and added some blue and green tones.

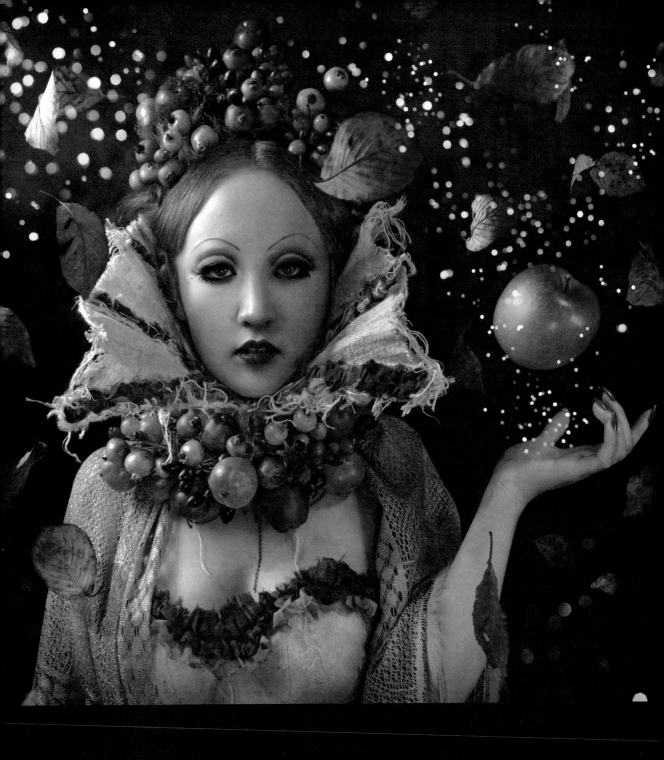

Canon EOS 5D Mark II • Canon 28-135mm lens @ 40mm • f/7 • 1/40 second • ISO 400 • RAW

Light: simple hot light, white board reflector, and ambient interior lighting

Magic of the Season

I find that I am often inspired by old paintings and classic films, and for this image, I believe I drew influence from the great Giuseppe Arcimboldo and Diego Velázquez.

It began when one of my friends showed me a dress she had created, and I really liked the unique fabrics and unusual design. A recurring theme in many of my works is the mixture of people and nature, and after seeing her with her dress, I felt inspired. I booked a meeting with a hair and make-up artist and began creating accessories using imitation fruits, branches, and dead leaves that I had raked up from around my house.

A key technique that I wanted to include was the shooting of the leaves and the apple in mid-air without using Photoshop. Many of the leaves used are actually "floating" by means of invisible threads; the apple is secured on a stick attached to the wall. The actual shooting took place in my friend's flat. It took a long time to prepare, but we had fun and really enjoyed the collaboration. I often find it more comfortable and inspiring to shoot on location than in a professional photo studio.

The image is a composite made from several photographs. I began by shooting the model with the apple and floating leaves. My concept also included random particles of light, so I shot several out-of-focus images of rhinestones on black paper. For the background, I prepared an out-of-focus image of trees.

I simply want my viewers to enjoy my work. It's very satisfying when someone derives pleasure from seeing something I have created from the world inside my mind.

When creating surreal images, I tend not to rely heavily on Photoshop. Even though I will eventually combine my images there, what counts most is what is captured at the click of the shutter.

Finally, I believe that it is very important to surround yourself with creative people and supportive friends with whom you can share ideas and find mutual inspiration and support.

Kiyo Murakami

I am a freelance photographer and designer living in Tokyo. After I graduated from art school, I continued experimenting with various art forms; illustration, design, music, and so on. I discovered that I was able to best express my myself through the world of photography. Much of my work is self-portraits as an adventure in self-discovery that often has the benefit of being "therapeutic," as well.

I carry out post-processing in Photoshop CS5. I used no special plug-ins, but I did use a lot of layers.

The original RAW file of the model was first converted to four JPEG images with varying exposure levels, which I then imported as layers to create my base image. The technique is a blending based upon masks that I created to expose or hide key areas of each layered image.

I also used intermediate layers to create "makeup" for the model's skin tones as well as layer masks to control overall saturation levels and color balance.

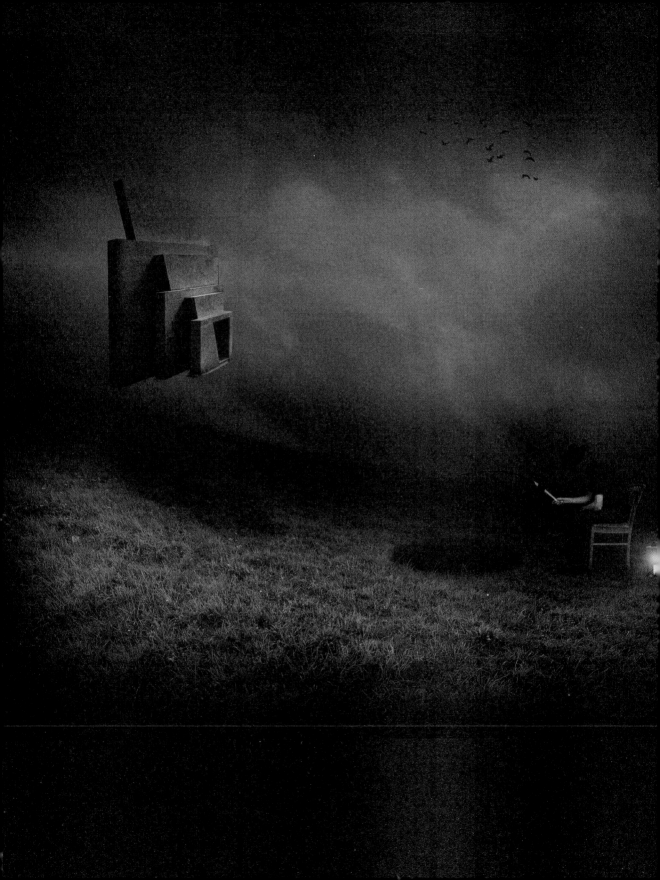

The Abyss

This is the first image in the series, Black Hole, *and it is my personal favorite, so far. It was made a while ago and is the result of a long process of different ideas and feelings, leading me to this (still unfinished) series. The creation itself was rather impulsive, made late in the night.*

It is a photo montage that uses different images to create the final composition at the end. This scene obviously never existed anywhere else than in my mind

I used two cameras to create the individual images, a Pentax K10D and a Pentax Optio. A tripod was used for photographing myself as the model in the composition.

It is with the entire series that I am trying to say something, not just with this specific image. But I tried nonetheless to give it a feeling of a secret—something unknown.

For me, the hole is empty. There is no fish there, but nevertheless the rod is bent, and that means there is some sort of a power—like gravity—that is pulling the rod inside; something invisible and untouchable but still existing.

The background idea for the image comes from some words of Friedrich Nietzsche: "If you gaze long enough into an abyss, the abyss will gaze back into you." I used the floating object as a metaphor for waiting and observing. Such a long wait, in fact, that it turns to stone, but it still exists.

The music I listened to while making the image was a song by the English Doom Metal band *Esoteric* (The blood of the eyes). It is very depressive, melancholic music, full of sorrow but noble at the same time. I was feeling the same as the music. Searching for something that cannot be found, but still aware that this thing has an effect on your mind. There is no head, because it is drowned into the nothingness. It has become nothing, because it looked too long into the abyss of nothingness.

I wrote the quote under the image and put the link to the song to make the message stronger, but I did not receive any feedback on these specific quotes.

This is my most viewed and popular published image on 1x.com. I did hope and expect that viewers would ask about the meaning and the message of the image.

Three hints:

For this type of work, you should think, feel, and be creative; think, feel, and be creative; think, feel and be creative.

 Kaveh H. Steppenwolf

My name is Kaveh Hosseini. Steppenwolf is my nickname (and has been for so long that many think it is my real name). I am 29 and was born in Iran. For the past ten years, I have been living in Germany.

The ground is a panoramic shot of a meadow land. The sky is a shot of a dark cloud. I added a layer mask to the ground layer and used the Gradient tool (with black selected) to remove the harsh horizon and make it more blurry. In Photoshop, I warped the ground with the Warp tool. Then, I painted with black and low opacity between the sky and ground to make the area darker.

To make the hole, I used the Elliptical Marquee tool to paint an ellipse. To add depth to the hole, I used a wall-texture. The grass around the hole was created by adding a layer mask to the hole layer and painting with a black "grass" brush.

The floating shape to the left is a stone statue that I photographed in a park. The shadow of it was made by duplicating the layer, filling it with black, and then blurring somewhat at the end.

I photographed myself as if I am fishing with a rod. The same process of selecting as before was used. I deleted the head by adding a layer mask and using a black brush.

I then adjusted the levels, converted the image to black and white and darkened the surrounding areas by painting with a very big brush size and low opacity.

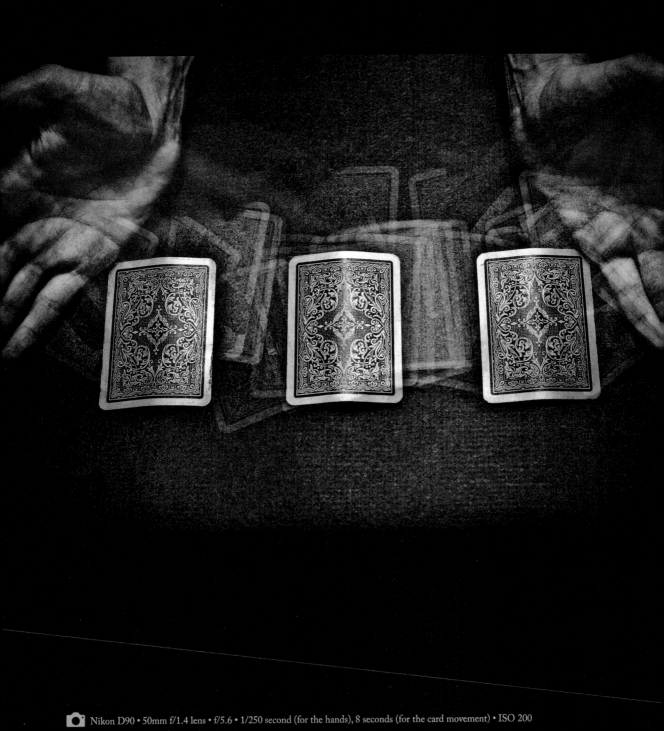

Nikon D90 • 50mm f/1.4 lens • f/5.6 • 1/250 second (for the hands), 8 seconds (for the card movement) • ISO 200

Choose Your Destiny

I have always loved cards. I have always been fascinated by both skilled magicians and street dealers whose means of living depend entirely on their mastery of cards. So, when the time came to start practicing my lighting skills, I had it clear that I wanted to do some light control exercises with a common and unifying theme: gambling.

In this picture, I tried to recreate the moment when the dealer is shuffling the cards, when everything can still happen, and you have to make the decision as to which card to choose—your destiny.

Therefore, I needed two shoots—one for the hands and the three cards that appear still and frozen, and another one for the movement of the other cards.

The first shot was quite straightforward. I used the camera's highest synch speed. A flash was placed above the hands with a sheet of paper as a softbox. The ambient light was reduced, both by turning off the room lights and by the short synch speed.

The second shot had to show the movement of the cards, so I had two options: either use available light or pulses of light from the flash. I opted for the latter, because the movement would be visible, yet the cards would be recognizable (and not just turn into a red blur), thanks to the freezing ability of the flash. The shot was 8 seconds long, and the flash fired every 0.5 seconds, so in total there were 16 pulses of light. The shot was repeated many times until I achieved a result that convinced me.

My idea with the picture was to invite the viewer to be part of the game, as if you could almost hear the dealer saying, "Now it's your turn. Pick up a card. Choose your destiny!" The hands in the upper part define the frame as well as the vignetting in the bottom. Thus, the attention goes exactly to the center of the image, where it should be.

For this picture it was really important to know the influence of the light: the effects of continuous light versus strobe light, the exposure time, the relationship between aperture and flash power, and the incremental effect of the light pulses in a long exposure.

You have to experiment. While creating this series, I failed several times, but failing is an important part of the process.

This picture was made the first month I bought my camera, and it's not much related to my present photography style. Nevertheless, I learned a lot about off-camera lighting which has made me more comfortable when shooting portraits as well as making me more creative (or at least giving me more technical knowledge) when planning a photo.

Javier Miqueleiz

I am a music promotional and editorial portrait photographer based in Guangzhou, China. You can see more of my work at www.efejotaphotography.com.

I processed the RAW files in PhaseOne Capture One Pro, matching them in overall brightness, correcting color deviations, and the histogram. Then, I opened both pictures in Photoshop CS4 and blended them by using layer blending modes (Multiply or Soft Light). Next, I merged the layers. The image had a lack of contrast that I fixed by using a curves adjustment layer. The blending mode was set to Normal, so it affected both the luminosity and the color of the picture.

The next step was to increase the contrast of the cards to emphasize their texture—dirt, scratches, and marks. I used another curves adjustment layer, masking away every part of the picture that was not the main three cards. I wanted a rather warm picture, so I created a couple of gradient map layers (round-sized gradient). The first one was a warm red/brown for the middle part (cards) and green (for the fabric). I masked the hands in this layer to avoid a greenish hue. The second one was an orange/yellow gradient that was meant to give the hands a bit more color.

Next, the vibrance of the picture was increased with a vibrance adjustment layer. Finally, I used a hue/saturation adjustment layer to make the picture a little bit warmer. I also changed the hue of reds so that the cards would not be intense.

Canon EOS 30 D

Silent Song

This is the voice of a marginal society that is constantly pushed aside by the greed of a civilization, and whose voices are unheard. They live in the trash left behind by the strong who always threaten the environment of the world. No matter how hard they scream and how loud they sing, they would never be heard. The only sound is that of damage that is growing into a bigger threat each day.

Seeing this reality fueled my imagination and gave rise to this picture. First I made sketches to translate the theme into visual form. Then I started to prepare for the shooting—everything from selecting the model, props, deciding the color tone, and so on. The chosen model is a child, symbolizing the regeneration of life that is threatening its own future. The megaphone represents the longing to be heard. The metal scraps and trash highlight the irony of a well-developed civilization that leaves behind a trail of destruction in its path.

All the visuals are captured with available light. The image of the child is taken on a terrace, the megaphone in an office, metal scraps in the junkyard, while the sky and smog are from stock photos I have made myself.

It took me about a week to create *Silent Song*. I worked on it in my spare time. I do not set a deadline or time limit for my personal work, what I set out for is to create an intensely satisfying result.

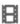

Final Toto

Final Toto is a photographer from Jakarta, Indonesia.

When all the visual elements were captured, I picked the final photos. Then, each selected photo was edited, one by one, using the Path tool in Photoshop. After that, I laid out each element according to my initial sketch.

When arranging the visual elements in the layout, I had chosen the color tone beforehand. In this way, the mood could be more controlled throughout the editing process and work out, as desired. For color tone, I used the filters color balance and color burn.

After the layout was ready, I did the detailed work on the photo. Sometimes I used an existing photo as a reference to make the editing as accurate as possible, whether it was about the lighting or depth of field. Finally, I set the brightness and contrast, by using curves.

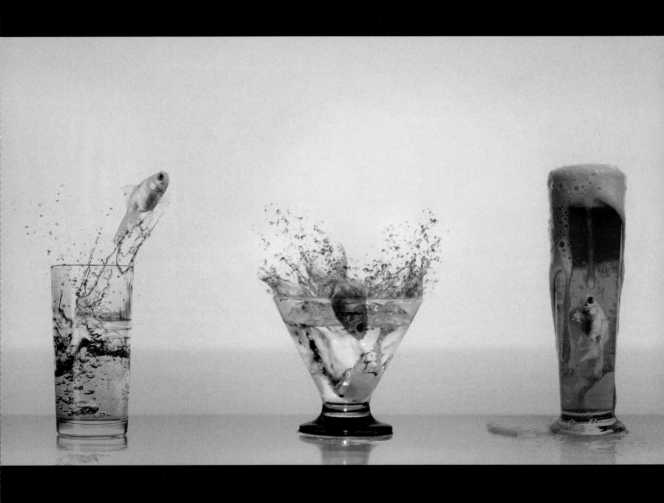

Nikon D90 • Nikkor 18-105mm lens • f/6.3 • 1/60 second • ISO 1000

Shot in natural light with a fill flash (Nikon SB 600 with a diffuse filter)

Get High and Fly

Looking through my photo archives, I suddenly got the idea to make some kind of "crazy image," with fish jumping around, in and out of the water, in several glass bowls. I gathered the images that I wanted to use and started working. The basic concept was there, but I had more ideas while working on it and trying different setups.

This image consists of several separate photos. Each glass was shot separately as well as the fish.

For the photographs, a Nikon D90 was used with a 18-105mm Nikkor zoom lens. All images are hand-held shots. As a background, I used a white paper with a silvery look.

I used a table and glued some white silver paper on the wall behind it. Next, I put the glasses with water on the table, one by one, to photograph them. To create the bubbles in the glasses, I threw transparent plastic balls into the water. This effect was later enhanced in Photoshop.

It was a lot of fun to create this. In a way, the fish jumping from one glass to the other stand for my own pleasure: first have a glass of water, then a Martini, and at the end, my favorite beer.

This image is one of my favorites. I like it because it's easy to read and to enjoy. Such images are also not too hard to make. You just need good ideas and some Photoshop skills.

I also think that the result creates some fun for the viewers. Anyway, I received a lot of positive feedback. It makes me happy to have accomplished this in a world with so many great photographers and so much creativity.

 Caras Ionut

I live in Iasi, Romania, and I am 33 years old.

Photographically, I prefer color work (as the world around us is in color, too).

I started with photography around 10 years ago.

For this image, I used Photoshop CS3 without plug-ins.

First, I opened the glass pictures and combined them into one image. Because they were shot against a silver white background, it was easy to select them. The edges were refined with a soft brush.

Next, I selected the fish by using the marquee tool. I first duplicated this layer and then applied a clipping mask. I erased the unwanted areas with the brush tool.

I created the water effect outside the glasses by using a Splatter brush in Photoshop. The Warp Transform tool was used to wrap the splashing water around the glasses to make it look realistic.

For color and level adjustments, I mostly used Layer styles in different blending modes (Darker Color, Color, Linear Burn...), depending on the effect I wanted to achieve.

Sometimes, I made a copy of a layer with the same settings to get a stronger effect (through an appropriate blending mode).

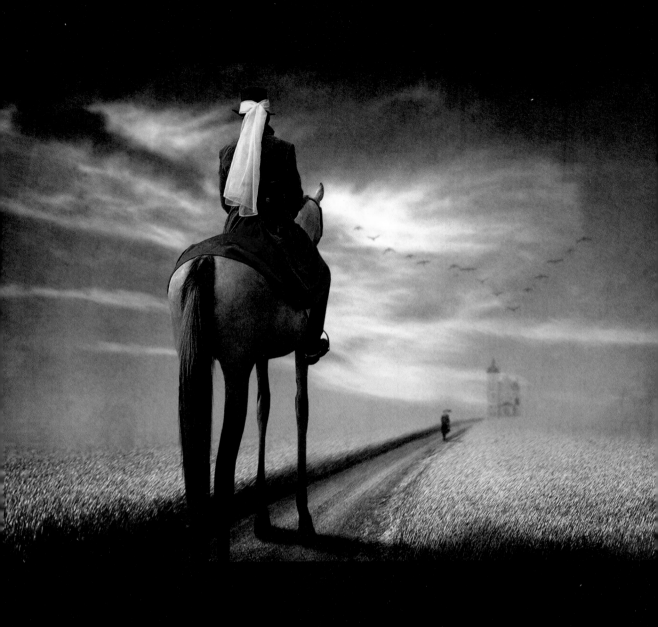

Nikon D300
AF-S Nikkor 16-85mm VR II lens • f/3.5-5.6
AF-S Nikkor 70-300mm VR II lens • f/4.5-5.6
SIGMA 70mm lens • f/1:2.8 DG Macro

Panasonic Lumix TZ7
iMac 27 Inch
Photoshop CS4

Her *Very* Highness Returns Back Home

Every year, there is an historical event at which I take many photos of the participants. One of them, the woman on the horse, inspired me to create this image.

It took me about six hours of post-processing in Photoshop to create this image. The following describes how I did it:

First, I extracted the woman/horse from the busy background of the street by using the Background Eraser tool. For the most difficult parts, like the horsetail, I used the MaskPro 4 plug-in. The rest of the background was deleted by using the Magic Wand tool.

Then, I created the background from a photo in my library of landscape images, which I have built up over the last 40 years. A cornfield photo was transformed by using a Warp Transform to create depth and improve the composition.

I used the Quick Mask tool and Gradient tool from the bottom toward the top and applied the Gaussian Blur filter to soften the horizon and create a fitting depth of field.

I then added a clear sky on top of it in a new layer, and a second sky with white clouds, using the Overlay blending mode at 100%.

I added the image of the castle on a new layer by using the Luminosity blending mode, at low opacity (about 35%).

The small figure of a man in the background was added and blurred with Gaussian blur at a 7% setting.

I added a photo of birds, after the birds had been extracted from the sky. I blurred them with Gaussian blur, at a setting of 6%.

Next, I added the previously saved woman/horse image to a new layer.

With the Rectangular Marquee tool, I transformed the legs of the horse, making them longer. Then, I darkened them at the bottom with the Burn tool, low exposure, until they were dark enough to create a "Dali-effect."

In the next step, I used a hair brush to retouch the tail of the horse and add more hair. This was needed because the extraction from the complex background was not perfect.

With the Perspective Shadow plug-in filter from Alien Skin Eye Candy 5 Impact, I created the shadows from the little man and the woman/horse, and used the burn tool where necessary to complete the shadows.

Finally, I added a plaster texture layer with Soft Light as blending mode (opacity depends how much texture is needed). The woman/horse was above this layer, so the texture did not cover them. On this layer, I painted some colors with a large soft brush at low pressure.

For this image, I also used color, light, and contrast adjustments.

Ben Goossens

I am addicted to surrealism and Photoshop. I have 40 years of photography and 20 years of Photoshop experience, but still I learn something new every day. I am now 65 years old and have been busy with photography for many, many years.

Worldwide, I am called the R. Magritte/Dali of photography, a style which has always been a must in my job as Art Director in advertising, where I made a lot of surreal concepts for international campaigns, using Photoshop. Today, my hobby is a logical follow-up on what I did in my professional life.

Nikon F80 • Nikkor 24–80mm f/3.5–5.6 lens • f/4 • ISO 400

Soul Mirror

This photo is a montage with an intentional set up (more or less a studio shot). It started out with the idea of using a mirror to demonstrate the hidden qualities of a person.

I did not use any flash but rather switched on every lamp in the room. This made the lighting a bit uneven, which was later fixed in post-processing.

I took many different shots for several hours, with different expressions, poses, clothes, and props. In total I used about three to four rolls. When I shoot film, I do not want to take hundreds of photos; instead, I plan them more carefully because of the cost of developing the film. I have put together several other montages of the images from the shooting. Some were planned from the start, some ideas came to me during the shooting, and some were put together afterward by combining photos in unexpected combinations. The camera is attached to a tripod and we were very careful not to cover the mirror in the shot with the person in front of it, because it would be too difficult to outline in the darkroom.

The idea of this shot was to create a contrast between the externally self-controlled businessman and the true inner person. Because it was taken in Japan, it is also a tribute to the Japanese samurai. In the late era before they vanished, the samurai became important public servants. I also like the contrast between black and white, where black represents the correct businessman, and white his dream or inner perception of himself. After making the shot, I realized the two persons are not looking into each other's eyes. This is a problem, because if it was a real reflection they would have exactly the same pose. The point of taking mirror shots is to make only small variations between the reflection and the real person noticeable only after looking at the photo for a while. The ideal is to only change one or a few things, like only the expression, the pose, or the clothes. In the end this did not turn out that bad, though. Because the samurai in the reflection is looking right in the eyes of the viewer and the businessman is looking to the side, it expresses the idea that the samurai is the real person, and the other person is just an observer, which was the intention of the shot.

 Ralf Stelander

I have been an amateur photographer for many years. I took a photography class while living in Japan in 2000 and won a prize at the school, partly thanks to this photo. I founded 1x.com in February 2007 together with my friend Jacob Jovelou.

Originally, the entire editing was done in a darkroom without any use of computer software. The two different shots were developed and the mirror was cut from the first copy with a razor blade and glued to the second copy. It was hard to make the outlines of the mirror perfectly straight. Finally, the result was photographed with ISO 100 film and developed. In this version, the negative is scanned with a film scanner. I used Photoshop to select, copy, and paste the mirror onto the second shot. I also removed some distracting objects, like an electrical cord, by using the Clone Stamp tool and fine-tuned the edges of the mirror, which did not come out just right in the original analog version. I used the Dodge and Burn tool and the Clone Stamp tool to fix some uneven lighting on the floor and at the top of the mirror. I also added some grain to get the film-look it originally had.

LANDSCAPE images can come in many forms and guises, from close up detailed shots of stones on a beach to wide open mountain vistas, and of course, everything in between. Images can be taken spontaneously to good effect, but a successful and pleasing landscape image has usually involved a lot of thought and consideration.

A good landscape image can often be partially created well before you have unpacked your camera and pressed the shutter. It is in the visionary phase where you can create your perfect image in your mind's eye and imagine every aspect and detail that you would like to capture; you can arrange objects for optimum balance, imagine the type of light you would like to compliment the scene, and even dream of the type of weather.

The natural progression from the imaginary phase is the planning phase. Once you have your image firmly lodged in your mind, then it's time to work out when, where, and how to achieve it. You might have a favorite beach or forest where you can start to plan the image capture; you might want to make some scouting walks to determine where and when the best chances of enhancing light will come from, or look for that composition that will satisfy your preconceived image.

Perhaps you will discover that the scene you have in mind will not work as well in the summer months but will be much more interesting in autumn or winter. Keep an eye out for the weather and how different it can be, because it might affect the subjects you have scouted. The weather and seasonal change are two of the most influential aspects that can dictate whether an image is merely average or great; it pays to tailor your planning to match your chosen scene with the most complimentary light and season.

After you have placed the bones on your image and formulated a plan, it's time to implement it. This is where your ambition and determination come into play; landscape photography can be frustrating at times because you are usually at the mercy of the weather and light, or lack of it. It can take repeated visits or changes to plans to finally achieve what you desire; this is where perseverance often pays dividends.

So finally, you are at a great location with good light, it's time to get the camera out and use your techniques to record your dream image.

This is where a good composition shapes and forms the elements in your frame to best accentuate the subjects and features. A good composition will show off your chosen scene to its best effect; a poor composition will only reward you with a lacking image after all the effort you have used to get to this point.

There are, of course, plenty of other aspects to consider while on location and in post production, such as focal points, depth of field, color or mono choice, and processing techniques, for which the following pages of tutorials will hopefully give you some insight and advice.

–John Parminter

Landscape

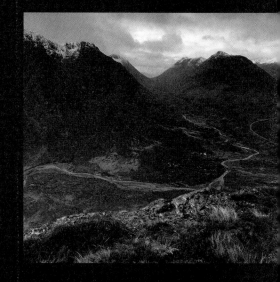

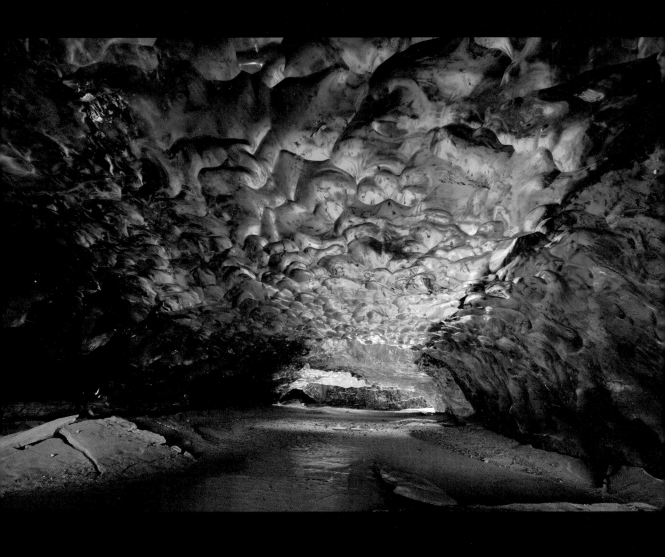

Canon 5D Mark II • Canon EF 16-35mm f/2.8 lens • ISO 400 • Gitzo tripod

Crystal Cave

I had planed a tour of Iceland in January, hoping to capture the frozen landscapes and the blue, naked glaciers that are visible during this time of year. As part of this trip, I had also hoped to photograph ice caves.

Shooting the ice cave was explorational. We did not know what to expect, what it would look like, and how shooting conditions were inside. I had been in ice caves before I took up photography, and I knew that they can be dangerous. Before entering, we had to assess if there was danger of a collapse. The extreme cold weather helped to keep the ice hard and reduce the risk of collapse.

Once inside, we were pleasantly surprised at how blue and transparent the roof of the cave was. However, this scene was too dynamic in the wrong places. The brightest part of the image was in the center, so I had to bracket three shots with one stop between them to contain the very dynamic light in the scene.

This picture was intended to inform viewers that most glacier ice is very different from what most people see on the outer surface. The weather and sun causes the outer surface of glacier ice to appear white. The real beauty of the centuries old compressed ice of a glacier lies underneath the damaged outer surface. Such ice can be seen in ice caves like this one.

I knew that the subject would be quite unique because this particular ice cave had not really been photographed before (it enters into a lagoon that must be frozen in order to access it). But how people would like my photo and editing was and will always be an unknown.

For success in landscape photography, you should learn about the places you visit and what they can offer for the particular season, time of day, and weather conditions. I study maps, sunlight angles, weather forecasts, and gather local updates on conditions for the locations I visit. Being at the right place at the right time is essential.

Be precise in what you do. Having gone through all the trouble of getting to the shoot location, nothing is worse than having too shallow depth of field or slightly off composition once you view your images on a computer screen at home.

Be efficient. Know exactly where you keep all your equipment and make sure that it is easily accessible when you need it. Searching for a filter hidden somewhere deep in your camera bag can cost you a shot of sudden brilliance.

Örvar Atili Thorgeirsson

I have been a mountain adventurer since my teenage years and like to document my trips through photographs of the mountainous regions of Iceland and of the rest of the world. It was a gradual transition going from mountain sports to photography, and the mountains are still my favorite places to photograph. Because making a living as a full-time landscape photographer is hard to do in a country of only 300,000 people, I still do software engineering as a main profession.

I used Canon's Digital Photo Professional for the RAW processing and Photoshop to edit the images.

The key to my processing is knowing what I want and visualizing the outcome of the processing before I start. I adjusted white balance, color saturation, and contrast adjustment while processing the RAW images. I output the three images as 16-bit TIFF files to Photoshop and then opened them as three layers in order of the brightest as the top layer. I used a technique called exposure blending to combine the images by adding a mask on each layer and masking out areas of the brighter layer where I feel the image needed less exposure.

I used some selective level adjustments to increase contrast in areas that were a little flat, such as in the shadowy parts of the blue ice. I did this by applying the Lasso tool with a large feather value on areas with flat contrast, and then adjusting the contrast by using Levels.

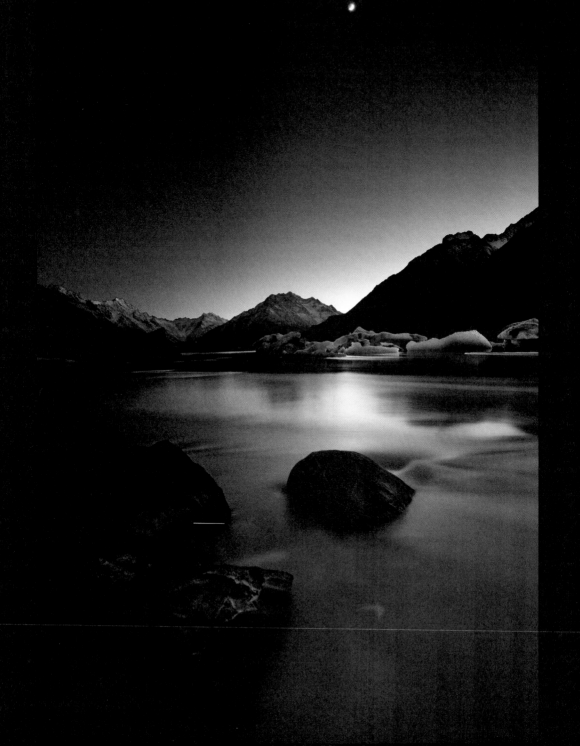

Canon 5D Mark II • Canon 16-35mm f/2.8L II lens • f/5.6 • 30 seconds • ISO 400
Tripod GT2531EX Gitzo CF6X Explorer 2 (BH-55 Ballhead) • RC-1 canon remote

Moonlight

This photo was taken in Tasman River, Mt. Cook, New Zealand in late April 2011. The location itself is full of interesting subjects: rocks, icebergs, snowy mountain backgrounds, and a river.

We stayed two days in Mt. Cook, and my first day of photographing this place was not successful. On the second morning, we arrived at about 6:40 am; the moon was still in the sky and the sun was just about to rise. Compared to the previous morning, this time I was very impressed with the moon and its reflection in the flowing water of the river. I decided to take a portrait frame in order to exclude many unwanted rocks in foreground.

To balance the light between the sky and dark foreground, I used two filters in combination: a Singh Ray 3 f-stop Reverse GND and a Lee 2 f-stop GND (soft), which made the foreground rocks quite visible while still keeping the sky exposed correctly.

This is a single-shot image. I was satisfied with the final image after processing. I felt that I captured what I actually saw in the scene. In some sense, this image presents a mysterious and tranquil place on this planet, which reminds us to preserve it.

I didn't have much time to take the shot because the light was changing quickly during the twilight period, so I could not try different compositions and make multiple shots. Under circumstances like this, personal intuition is the only factor for making a successful image. For me, the most distinguished subject at that moment was the moon in the sky and it's reflection in the river.

I think that simplicity is always a key to achieve a better composition. It is also a good idea to preview your photography procedure one more time before you arrive at your destination.

 Yan Zhang

I am a Sydney-based Australian university professor, specializing in Artificial Intelligence. I started digital photography in 2007, which eventually changed my perception about the world. Now, my passion is landscape photography.

The post-processing was a bit tedious. Although the two GND filters had made the foreground rocks quite visible, the two sides of the mountain backgrounds were still very dark and lacked details. I opened the RAW file in Camera RAW of Photoshop CS5, lifted the Fill Light bar a bit, and then turned over to CS5. There, I used Tony Kuper's mask luminosity technique to precisely isolate the two side mountains by five times of Darks Pixels, and then lifted the curve to make them brighter. Quite interestingly, some details on the mountains were revealed.

However, one side effect of "lifting dark pixels" was that it also affected other parts of the image, and the entire image became too bright. This was easy to fix. I added one layer mask, and painted both sides of the mountains to reveal the effect of the previous action, leaving the rest of the image unchanged.

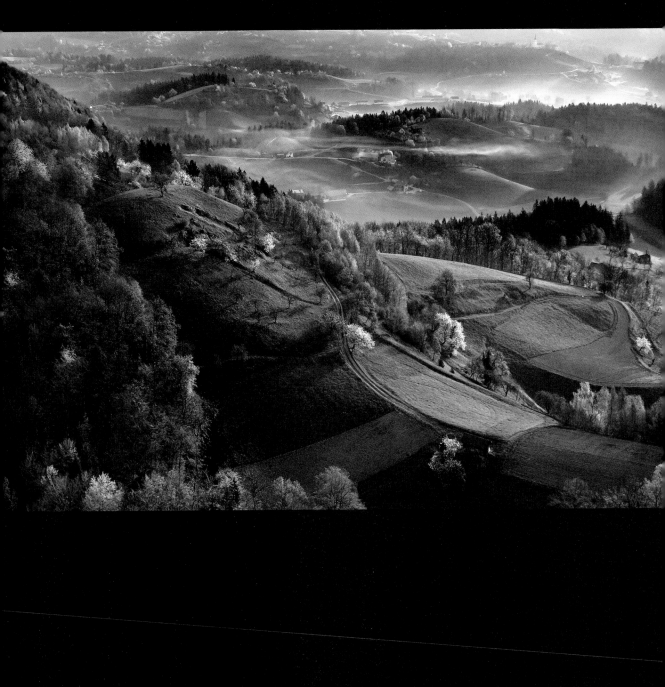

Canon 5D Mark II • Canon EF 24-105mm lens @ 35mm • f/4 • 1/395 second • ISO 160 • Exposure compensation: −0.7EV

Cherry Trees

I was high up in the mountains overlooking the Logarska Valley in Slovenia, checking out the area for another photo that I planned to take in the future (The Point). *It was Easter time, when there was still some snow left on the higher peaks, and the weather was forecast to be calm and favorable for flying.*

 Matjaz Cater

I am a forester, working as a researcher at the Slovenian Forestry Institute. Hang-glider competition flying has been my life's imperative for the last 20 years, but now I also like to share life's other pleasures with my family and people around me. When you can share these things, the joy becomes multiplied many times.

The photo was made in early April, about 30 minutes after sunrise, when I was descending from the peaks above Logarska Valley. I was amazed by the contrast of the blossoming cherry trees amongst the green beech trees that were just starting to develop leaves at the beginning of the spring season.

I set up my hang-glider and prepared for takeoff; the conditions were perfect for flying. The view from the hill was incredible, like a fairy tale misty landscape. There were just enough details, textures and tones in the scene for me to be able to capture this beautiful morning, the opportunity was simply too good to be missed.

When airborne, I took some photos to check how they would display on the camera's LCD, and subsequently adapt minor settings. Usually, I set the camera in advance. The camera hangs from my neck on a neoprene strap, and is secured with an additional link, which allows for some movement. No special attachments are used. Shutter priority mode looked like a good setting for the aerial shots in order to get sharp photos. The lens was set to Image Stabilization to help combat any camera shake.

The photo was made approximately 150 meters above the meadows. The sun was still at a low angle to my side. My lens hood did not extend far enough to avoid the flare, so I shaded the lens with my hand.

I decided to descend lower and then noticed the randomly spread cherry trees. The light still wasn't quite right, but finally I found my best composition of the trees on the sunny side of the slopes.

When I took this shot, I thought it was one of my average ones, and so put it aside for a while before doing anything with it. Once I decided to display it, I was very surprised at the attention and positive feedback it received. I am still surprised, even now.

I processed the image in Photoshop CS4.

I cropped about 25% off the lower-left side to get a better composition and to reinforce the diagonal line of the trees from the top-left down toward the bottom-right. The lower-left part of the photo—the tree area—was adjusted separately from the upper-right section. I reduced brightness and increased contrast by approximately 15%.

No matter how crazy your ideas might seem, try to make them come true. It is worth it. If nothing else, slight insanity is a good excuse for being in the air at sunrise and photographing the spectacular scenery that many others do not have the chance to experience.

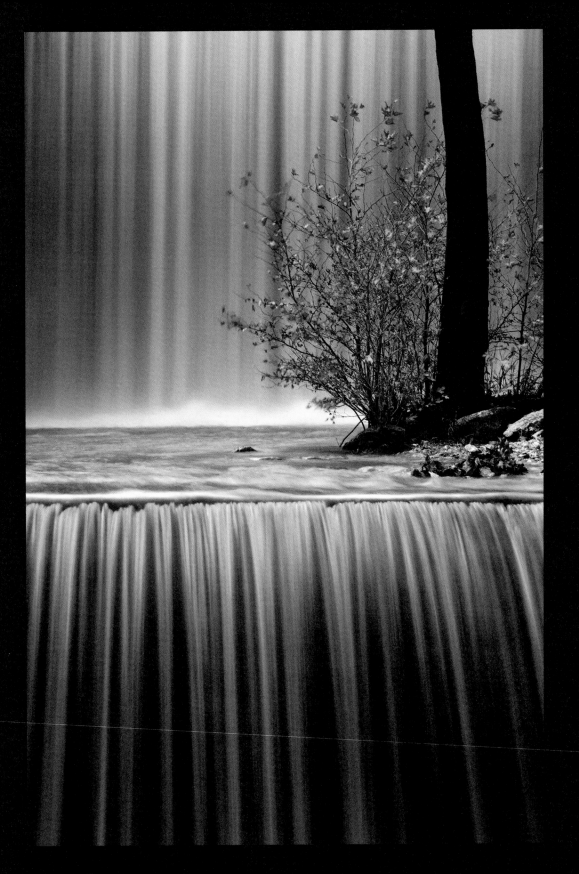

Nikon D300 • Nikkor VR 18-200mm lens @ 80mm • f/16 • 1 second • ISO 200
Hoya Circular Polarizer • Singh-Ray Color Intensifier

Autumn Interlude

The place where this image was made had it all. There was this quite unique double waterfall, a beautifully built stone bridge above it, and the surrounding trees dressed in their best autumn colors.

I love nature in all its forms, in almost all kinds of light and seasons, and places we visit while location scouting. But when it comes to choosing a place with the potential to give a great image, very few locations make it into the list. Before we pick up the camera, we need certain requirements to be met: a strong subject, good or exceptional lighting and weather conditions, angles that offer a clear, unobstructed view of the subject, and sometimes the right season and the color scheme it offers.

My initial impulse here was to try to take everything in, so I started with a wide-angle lens and tried different perspectives to capture the big picture. But gradually my attention was drawn to a detail: that small bush of golden leaves in the middle of the waterfall. Suddenly everything else started to look like a distraction from what appeared to me as the most important detail of the scene.

I got closer and zoomed to 80mm to flatten the scene a little and bring the rear waterfall closer. I used a polarizer to remove most of the reflections and glare from the water and the leaves, to make the colors richer. I also used a color intensifier filter, which yields a richer blue on the water and brings out the yellows even more. These filters cut out a bit of light, so I did not have to use a neutral density filter to smooth the water flow. I did not want to blur the water completely but rather get a curtain-like texture, so stepping down to f/16 gave me the 1 second of exposure I needed for the desired effect.

I have always admired the ability of some photographers to say so much while showing so little. The images that stay in my mind are those intimate landscapes that rely more on form, contrasting tones, and the associations the subject brings to mind rather than on colorful skies and impressive views. I have read the term *visual haiku* and I think it describes those kinds of images perfectly. What I wanted to create from that scene was just such an image. I was delighted to see that wherever I uploaded it, the response was overwhelming, very warm, and enthusiastic.

Most photographers agree that "it is all about the light," and they usually mean that you should make good use of the golden hours light. Most often that is the case. But there are certain subjects that can greatly profit from overcast days, too, such as rivers, waterfalls, flowers, and autumn scenes.

Mary Kay

My real name is Maria Kaimaki, and I am from Greece. I am a teacher, a perpetual student in all things that interest me, and for the past three years, a landscape photographer by passion. Photography changed my life in more ways than I could have imagined, it opened a door to a whole new reality, a new way of seeing and appreciating the world around me.

I used Nikon Capture NX 2 for the RAW conversion, and most of the post-processing was done there, as well. I tweaked the white balance a little to achieve the blue I wanted without losing the golden hue of the leaves. I used a minimal amount of contrast because I wanted the scene to maintain a soft look and feel to it. In Photoshop CS5, I applied a selective noise reduction only to the water and a color balance adjustment level to give a final tweak to the blues and yellows. Finally, I used a black and white copy of the image made with Nik Silver Efex Pro with the following settings: neutral, brightness 0%, contrast 12%, structure 21%. This was placed on a separate layer over the color version and set to luminosity layer mode with 50% opacity to bring out the texture of the water even more.

The links that follow will bring you to photos of the big picture that I shot before deciding to concentrate on the bush:

http://justeline.daportfolio.com/gallery/13630#5

http://justeline.daportfolio.com/gallery/13552#9

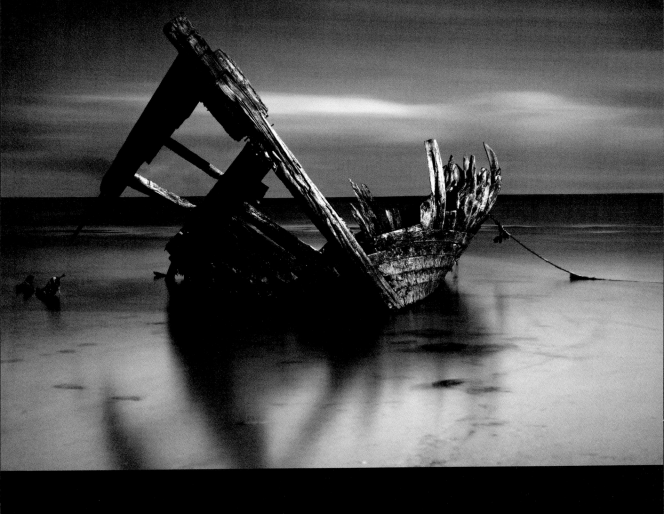

Canon 1ds mk111 • Canon 24-70mm lens @ 65mm • f/16 • 267 seconds • ISO 50 • filters: Hoya ir 72, Lee 0.9 soft grad

The Court of Heaven: "A Galley's Last Stand"

 Mal Smart

Lives in York, United Kingdom.

I had taken a two week touring vacation to the north of France in June 2008. We arrived at around midday to find this scene. The immediate possibilities were obvious but the conditions were poor; the tide was out with the boat beached upon uninteresting sand with harsh, unforgiving and unattractive light. Still it was a scene that excited us greatly, and we knew that there was potential here.

We calculated that the tide would be at its height at around 8:45 pm that evening and planned to return at around 7 pm to check out how the conditions and light would develop. When we returned, we were not disappointed. The light was good and the tide had returned to engulf the lower frame of the boat's hull.

My first instinct was to photograph the boat from a different angle, more to the right of this particular image but when I did, the results were not as good. No matter how I composed the scene, there were extraneous and distracting elements in the view. I realized that the boat needed to be photographed head on, giving it full prominence in the scene rather than being but an element in a scene. In my mind, I had already committed to a very long exposure type of image. I wanted to make use of the flattening of the lapping waves and extensions of any cloud cover that the scene might produce. I therefore set the tripod some 4–5 meters in front of the boat and composed to suit my eye. I fitted and adjusted a soft grad 0.9 Lee filter to reduce some light from the sky as well as a Hoya ir72 filter. I calculated that a 200 second exposure would be required but after three exposures, I adjusted it to 267 seconds, which is what this exposure used. The extended exposure time did not really need to be this long and could easily have been achieved with a less opaque filter than the ir72, but I did not have other filters with me at that time. I used a cable release device (TC80-N3) manually to determine the exposure with the camera set to bulb mode.

I am not really sure if I wanted to say anything with this image when taking it. The title came a lot later and is perhaps a bit pretentious to the casual observer, but it is deeply personal. I tried to expand upon the emotion that the shot gave me at a later date and hope that it gives the viewer a slight insight into the "other world" type of feeling that the image gives to me.

I took the RAW image into Photoshop CS2 (the RAW file is completely red due to the ir72 Hoya filter) and converted to black and white by using the Gradient Map feature. I used the dodge and burn function to highlight/darken localized areas that required attention. Some minor dust spots required removal, also.

I had initially visualized this photograph as a pure black-and-white image. The more I looked at the shot, however, I started to see the potential in adding a tone. I therefore started to experiment with tonal variations. I settled upon a tone curve of pushing the highlights of the red and green channel curve and pulling down the blue highlight curve.

1) Plan, if you are on a tour or just visiting, find out about the location: information is king.

2) Do not expect every location to yield instant results. Be prepared to wait for the right time and conditions, be patient, and prepared to return when the time is right.

3) Often I will view a location with blinkered thinking or a fixed idea of how the scene should look. Be prepared to adapt and alter your approach to suit the scene. Do not try to manipulate the scene to suit your approach.

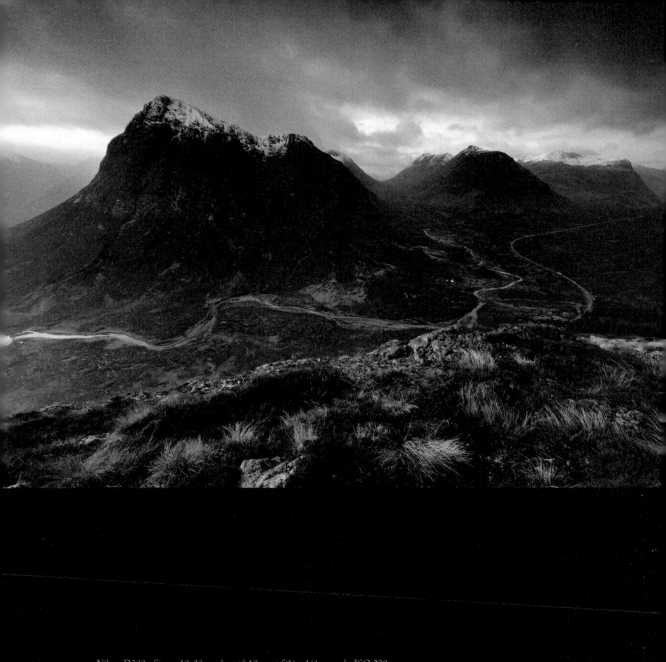

Nikon D300 • Sigma 10-20mm lens @ 10mm • f/16 • 1/4 second • ISO 200

Lee 0.6 and 0.9 ND graduated filters • polarizer • cable release • tripod

Guardians of the Glens

This mountain has been photographed by me and many others thousands of times before. It is the definitive and most iconic mountain in Scotland, the subject of postcards and calendars, and it seems to be on everyone's list of landscapes to photograph.

I had decided over a year before taking this image that I wanted a different perspective of it, something a little unusual; an image that doesn't isolate it too much but puts it into context of it is surroundings.

I have driven past this mountain many times and always thought that a higher viewpoint looking onto it would be best. After much studying of the terrain and a map, I decided on a location from the opposite hill at a height of about 600 meters, looking across to it. I stayed in the glen overnight and woke early to see what the weather conditions were like. I was hoping for more snow over the tops but the skies were fairly clear, even though it was still dark, so I set off up the hill to get in position before sunrise.

I spent 20–30 minutes wandering along the edge of the hill trying to find the best vantage point. I wanted foreground to anchor the image, midground scale, and then leave the rest to the main subject. I chose this particular location mainly because the small ledge I was on fell away very suddenly into the glen and left a sharp line between the foreground and the rest of the image. I like this distinct portioning of the image and I usually look for a strong foreground. I think the foreground colors are important here.

I tried to include as much scale in the midground as possible by means of the river that runs through the glen. Although I think I have cut a little off one of the corners and it annoys me a bit, I feel the road is also an important element.

The main subject is self-explanatory, really. It is the reason for the shot, but I did try to include the two other significant mountains as well, to give a pleasing three-item theme.

The light was not really as I envisioned. I was hoping for the sun to rise a bit more eastward and to shine down the glen a bit more but this was taken in January and the sun rose further around behind the facing crags. Even so, I am now happy with the results, in spite of my initial annoyance when I stood there.

John Parminter

I was born and brought up in the English Lake District and spend most of my spare time walking, exploring, and running over the mountains and through the spectacular scenery that the UK has to offer.

Not much processing was done as this was pretty much how it came out of the camera.

In Photoshop Elements 5, I selected the foreground with the Lasso tool and increased the vibrancy of the colors and contrast with levels by moving the shadows slider into the histogram and doing the same for highlights. I would have moved the midtones to about 90, as well.

I selected the midground and did the same thing, increasing contrast with levels.

For the sky I selected a few areas with the lasso and altered the contrast very subtly in certain areas to give more depth. I usually spend most of my time and attention to skies, as these can often make or break the dramatic effects of an image.

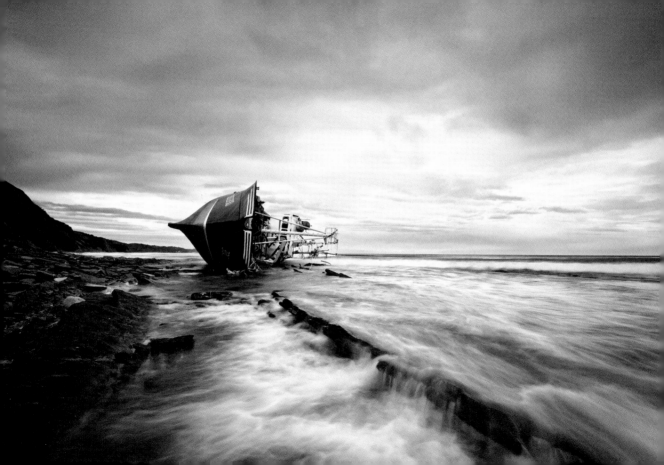

Defeated by the Sea

This ship sunk on November 4th, 2010, on the coast between Zumaia and Deba, two villages of Guizpuzcoa, in the North of Spain. This coast was declared a protected Geopark By UNESCO because of its geological and archaeological importance.

Inigo Barandiaran

I am an amateur photographer, born in San Sebastian (Spain) in 1976. I started taking photos six years ago. Since then, photography has become an important part of my life.

The picture was taken around midday on a cloudy morning. It is a single shot. I used a Hoya ND400 filter to decrease nine stops of aperture, allowing me to use a slow shutter speed. Using this type of filter is mandatory for shooting at slow shutter speeds in strong light. In combination with the Hoya ND filter, I used a Lee gradient neutral density filter for decreasing two additional stops of aperture in the upper part of the image. I also used a Manfrotto 055xPRO tripod.

This combination of filters allowed me to shoot at f/11, with 0.8 seconds of exposure and ISO 200. I did not want to shoot at slower speeds (two seconds or more), because I wanted to keep a bit of movement in the water.

I decided to put the ship almost in the middle of the image and used some rocks from the bottom-right corner of the frame to guide the eyes towards the ship. In this way, I think that a strong connection between the sea and the ship was created.

In addition to the technical gadgets I used, maybe the most important equipment that day were some big boots. The tide was rising, and I placed myself just in front of the ship when the water was at my knees. A solid and sturdy tripod, well placed among the rocks, was needed to avoid camera movements caused by the waves.

With this picture, I wanted to capture the power of the sea. I wanted to give the message that the sea is stronger than humans and will continue independently of any kind of human aggression. I wish that all of us could be more and more aware of nature and try to protect it as much as possible.

I think that the most fundamental step to obtaining really great pictures is to look for interesting/strong subjects. In addition to the subjects, light is also essential. In the case of this picture, it was only the third time I went there when the conditions, the sky, and the light were perfect for shooting. The final message is that if you find an interesting subject, you should go there again and again until you find the right conditions. And don't be frustrated if you don't obtain the desired result immediately.

And last but not least, invest in nontechnical equipment such as some big boots.

I started in Adobe Camera RAW by adjusting White Balance, Exposure, and Blacks to maximize the dynamic range. Then, in Photoshop CS5, I used two black-and-white adjustment layers with layer masks to apply different parameters (black-and-white conversions) to different zones independently. Next, I collapsed the layers. I created individual adjustment layer folders for the coast, the sea, the ship, and the sky. With curve adjustment layers, I increased the contrast of every part of the scene. I then applied a duotone conversion by using brown tones to midtones, and lights and greens to shadows. I used a curve adjustment layer, applying different contrast curves to each RGB channel. Above this layer, I placed a Hue-saturation adjustment layer and got different duotone combinations by modifying the Hue slider. Then, I added a new layer filled with 50% gray and blended using the Soft Light mode. I applied some soft brush strokes of dodge and burn to darken and lighten some areas. Finally, I added a bit of local contrast by applying an Unsharp Mask filter with values of around 10 to 20 for amount and 70 to 110 for radius. I adjusted the opacity of this layer to reduce/increase the effect.

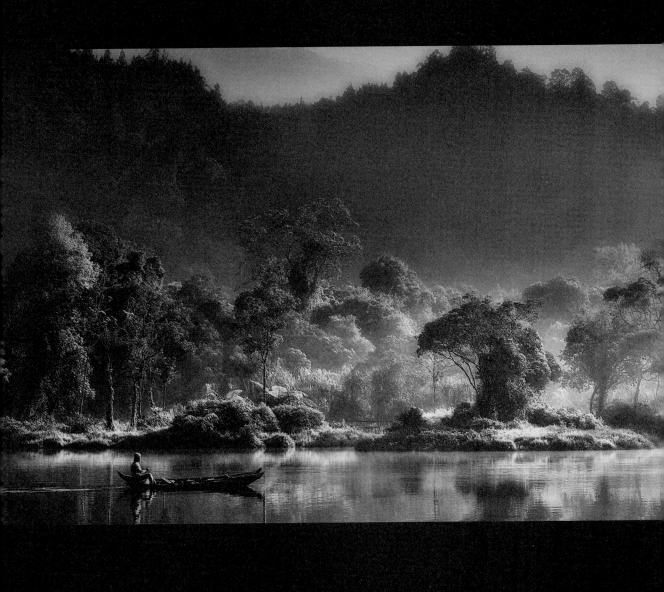

Nikon D3s • Nikon 70-200mm VRII f/2.8 lens @ 70mm • f/4.5 • 1/125 second • ISO 200 • RAW

Painting of Nature

This image was taken in a place named Situ Gunung. In the Indonesian language, situ *means lake and* gunung *means mountain.*

I wanted to take some photos there, showing the beauty and the tranquillity of the Indonesian landscapes. Driving and looking around, this place seemed perfect for what I was looking for.

From other people, I learned that the best time for taking pictures there was around 7–9 am. Just after daybreak, the rising sun shining through the morning fog provides a very beautiful light, rendering all the magic of this landscape. For me, this image encapsulates perfectly the beautiful scenery of the Indonesian countryside.

It still is my most popular image on 1x.com (almost 200 favorites). I am, of course, very happy with this appreciation.

For taking pictures such as this one, first look for the ideal light. In my case, the early morning light was key to the image. If I would have taken it in harsher light conditions, it would have lost a lot of its magic. Also look for the right moment to take your picture; for example, special composition or scenery. Try to photograph with your heart and catch moments of beauty and emotion.

 Hardibudi

I live in Jakarta, Indonesia. Professionally, I run a company that creates art in glass.

Photography has been my passion for five years, now. I can express what I see and feel through my viewfinder.

I used Nikon Capture NX 2 and Photoshop CS3, with the Nik Software Color Efex plug-in.

First, I opened the RAW file in Capture NX 2. I did some exposure optimization and tone controls, by using eight color control points (six at the background to give the image a more three-dimensional look, and two at the boat).

Next, I opened the file in Photoshop and adjusted the curves. I also sharpened the image slightly by using Unsharp Mask (20/20 settings).

The Nik Color Efex plug-in was then used to apply a better color tone contrast across the image. This was done via the bi-color blue & yellow setting, creating a gradient of colder tones in the upper part of the image and warmer tones in the lower part. I then reduced the opacity of this effect to 50%, creating the final tones and color settings.

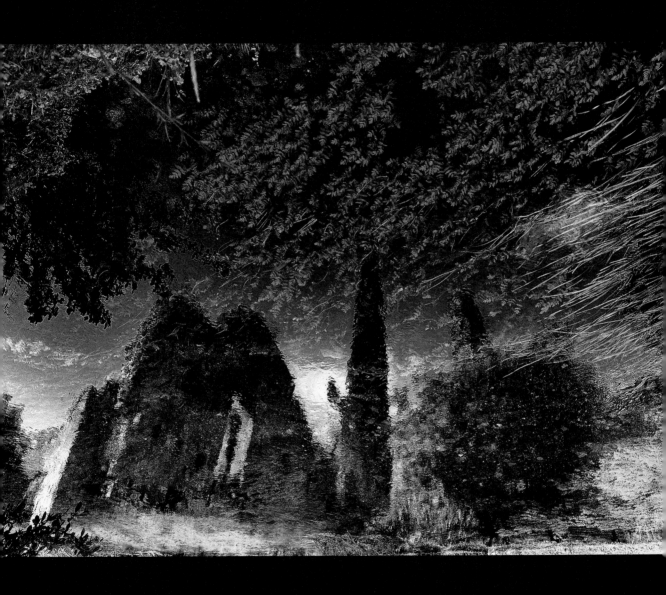

Nikon D3 • Nikon 12-24mm f/2.8 lens @ 24mm • f/2.8 • 1/500 second • ISO 250
Exposure compensation: +0.3

Reflected Ruins

This photo was taken in the Gardens of Ninfa, owned by the Caetani family. The garden is located in an area where some medieval churches and castles once stood surrounded by gardens full of rare plants from around the world, creating a particular and unique environment. A stream of clear water runs through the garden.

During my previous visits, the river attracted me because of its transparency, but I never found the right light conditions. On that particular afternoon, however, the atmosphere was right, and the bright sun lit up the water. Moving toward the exit of the garden, I noticed this beautiful reflection in the water.

This is a single hand-held shot out of several similar ones, differing only in focal length. All of the shots were made with the expectation that the picture would need to be reversed. I therefore tried to align the horizon very precisely to use the captured frames optimally.

Given the extreme transparency of the water, my concern was to avoid that the viewer would think that the image was the result of a combination of two shots.

In the processing of the contrast and the colors of the single shot, I therefore tried to combine the tone levels of both the water part and the reflected elements in such a way that they looked fully natural. The presence of a warm and indirect light helped me there. The result is an image in which the clear surface of the water returns all details as if it were a mirror.

The image was very positively received by the members of the site. I also felt that I succeeded in making the desired impression.

For making a picture like this one, first ensure that you have a well-aligned horizon to allow for the image to be reversed. Avoid direct sunlight. You might risk some gray areas, but that can be corrected later on in post-processing. Also, look for harmony between sharp edges and water movement.

Fulvio Pellegrini

I am a sociologist teaching economic sociology at the University of Rome, La Sapienza.

Photography is a passion, sometimes a job, but always a way to express myself additionally to the writing in my work.

http://fulviopellegrini.1x.com

http://www.fotoblur.com/portfolio/fulviopellegrini

http://www.monocromie.com/fulvio-pellegrini/

All post-processing was done in Nikon Capture NX.

I used nearly the full image size; I just cropped a little bit off the edges.

Next, I optimized the colors and the contrast in the image in such a way that both the brilliance of the reflections and the transparency of the water were maintained as much as possible. I gave special attention to the detail in some shadow areas (for example, the algae in the water).

No parts of the image were cloned, except the deletion of a piece of red fruit. It happened to be in the water and was disturbing the uniformity of the overall colors, which are focused on blue and green.

Finally, I increased the sharpness slightly.

Engulfed

I was in the San Francisco area for some training. I wanted to take a shot of the bridge. My friend who lives there said the fog would be rolling in by the time we got there and it probably wouldn't be a good photograph. I insisted.

We arrived at the top of a spectacular vantage point overlooking the bridge just as the fog was about to complete its path across the bay. The fog came in very low and left the skyline basking in the sunlight. A ship was heading out from the fog, coming toward the camera.

I set the camera on a tripod and took a couple of full-frame, bracketed exposures. After a couple of sequences, the ship was completely obscured by the fog. I zoomed in to 100mm (200mm equivalent on full frame, 35mm). I panned left to right, overlapping the image area, knowing that I was going to stitch them together for a panorama. I took several passes of four to five frames for each sequence.

What I ended up with was a wide view image with stunning detail throughout. I have a 36" (1 meter) wide print that looks as if it were taken with a large-format camera. Also, the combination of the skyline bathed in the evening light and the rolling fog with the ship emerging from it makes for a unique image of one of the most photographed scenes on earth.

Olympus E-PL1 • Olympus 14-150mm f/4.0-5.6 lens
M.Zuiko Digital ED @ 100mm • ISO 125 • f/8 • 1/50 second • RAW

**David
Scarbrough**

I live in Houston, Texas, but travel the world in my work as the Global Systems Architect Manager for a fortune 500 energy services company.

My photography background is in photojournalism. I worked for the Houston Post and AP as well as several magazines and periodicals.

I brought the images into Photoshop CS4 and combined them by using the Photomerge tool. I chose the Autolayout option and merged the four images. When I shot the series, the ship was already gone. So, I copied it from one of the full-frame images and pasted it into the same position in the panorama. I did some clean up around the ship so that it blended in naturally. I worked the color of the fog quite a bit. It was pretty pink and I tried to keep that without too much of a pink cast overall. The whites in the clouds in the background were a little hot, so I spot edited them to bring down the highlights. I applied some spot sharpening on the buildings.

1) Do not be afraid to take photos of things that are frequently photographed. You might get something special, anyway.

2) Be ready to set up and shoot quickly, as the situation can change in matter of seconds. The ship was in view for less than two minutes after we arrived.

3) Do not be afraid to merge elements from several frames, as long as you stay true to your vision. Some might have an issue with the way the ship was placed in the image. I am fine with it because I did not change the essence of the image. I simply reconstructed a higher quality image that I saw and captured in a single frame by using multiple frames.

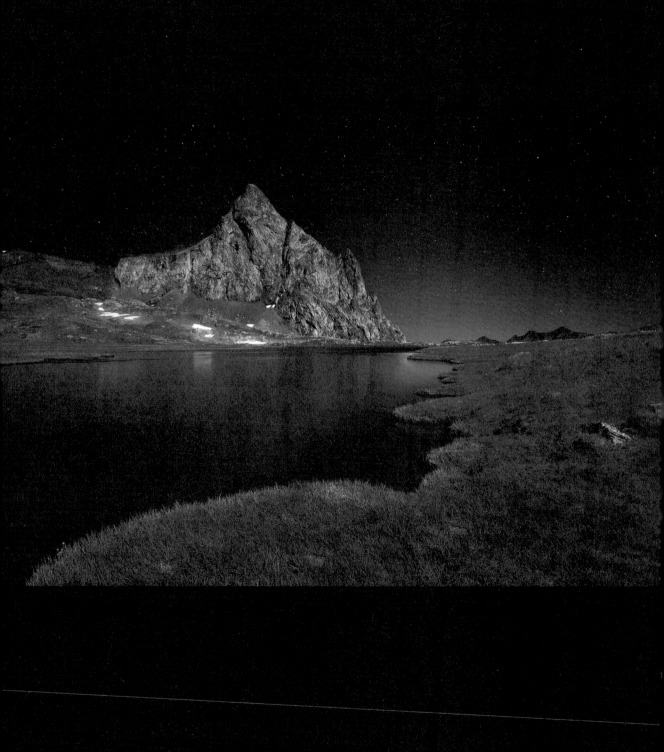

Nikon D700 • Nikkor 24mm f/2.8G ED AF-S lens @ 14mm • f/2.8 • 30 seconds • tripod

Glacier Anayet

This photograph was made in the mountain lakes of Anayet in Huesca, Spain, which is a high mountain area located in the Aragonese Pyrenees, the top of the Formigal ski resort.

Night photography is special. It is curious to see how a landscape changes with the light of the evening. I always plan my night shooting in advance; I find out about weather conditions (high or low clouds), size of the moon and its position in the sky, and time of sunset and sunrise. There is a program called The Photographer's Ephemeris (TPE) that informs you about all these things.

For this type of photography it is essential to use a tripod, remote cord, stopwatch, and a good flashlight.

This photo was shot at 2 am. You have to calculate the exposure time for stars not to blur. To calculate this, divide 400 by the focal length used, which in this case was 400/14mm = 28.52 seconds. I then put the camera in manual mode and adjusted the ISO and aperture to achieve the desired exposure that I was looking for. For this shot, it was ISO 1600, f/2.8 and 30 seconds. You can also get creative by playing with the white balance. At night it is difficult to focus, so I focused on the hyperfocal and passed the focus to manual. I usually like to overexpose these kind of photos in order to avoid noise at ISO 1600.

I am very happy with the image, I've managed to convey the nightlife of the location and the grandeur of nature. I wish for all of us to be able to care for these environments.

Again, it's very important to plan nocturnal sessions. If possible, be on site in daylight to find frames and ensure that there is nothing dangerous nearby.

 David Martin Castan

I am a photographer living in Zaragoza, Spain.

I use Camera RAW and Photoshop CS5 for the post-processing.

In Camera RAW, I adjusted the exposure of the land area, to prevent noise that could be generated at ISO 1600. I adjusted the black to gain dynamic range and the white balance.

In CS5, I selected the sky and applied a mask layer to increase blue saturation I added another S-curve with the power that obscures the stars and the blue sky, inverted the selection and applied a layer mask with warm photo filter (85) for the land portions, with an opacity of 50%. I then flattened the layers and created a new layer and fill (50% gray), put it in Overlay Mode with the Dodge and Burn tool using a brush with an opacity of 10–15%. Next, I painted in the highlights, midtones and shadows to add volume and light where I wanted. I applied another curve of contrast and played with their opacity.

In a new layer, the Noiseware plug-in was used to eliminate noise in the sky using a layer mask. The image was flattened and sharpened using the smart sharpen filter. Halos were removed using the clone stamp tool in darken mode with low opacity.

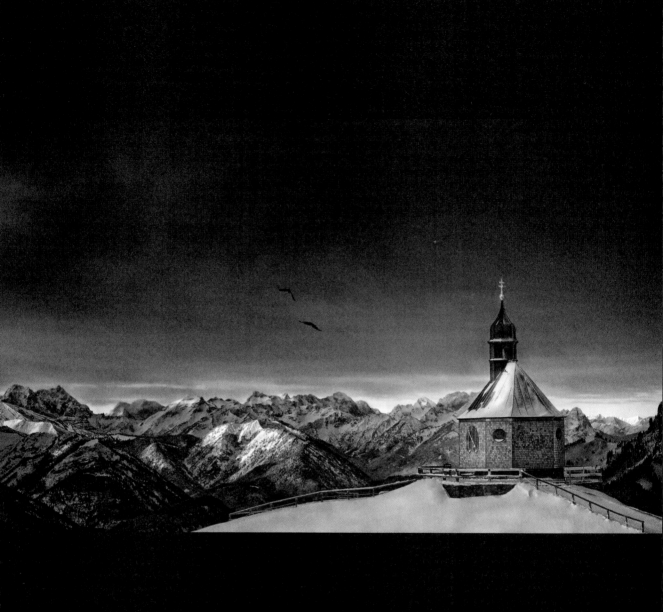

Nikon D700 • 80-200mm AF-D f/2.8 lens @ 92mm • f/9 • 1/200 second • ISO 1000 • RAW
Lee Polarizer • Lee NDGrad soft 0.9 • Lee NDGrad soft 0.6 • tripod

Wallberg Chapel

The idea for this photo came about in 2009 when I first travelled to the Tegernsee, an area in the German Alps. I climbed from 700 meters, the level of Tegernsee with its lovely villages, Rottach and Bad Wiessee, up to the summit of the Wallberg at 1,800 meters. Just before the peak, at 1,700 meters, there is this wonderful chapel.

My idea was to show the dignity of this chapel, emphasizing its height. It was obvious that it needed the morning light. It takes about two and a half hours to get up there, so we awoke at 3:30 am. In full darkness, we made our way up the mountain with head lamps and equipment, through wonderful, fresh snow.

When we arrived, we saw an enormous flock of mountain jackdaws flying around. So, I decided to change my position to get them in frame, without loosing the overall impact. I thought this would fit with what I wanted to say with the picture.

The light was not very good so early in the morning. It would take another hour and a half for it to warm up and get brighter. That gave us some time to change our clothes and adjust the equipment.

My distance from the chapel was about 50 meters, which meant that I had enough room to adjust the depth of field.

I took a large series of images, when suddenly, the sun broke through the clouds, while at the same time, the birds were in the right position. It took some time, but I'm a patient guy, and it all came together in the end.

What I think is important for landscape shooting is organization. I have to know what I want to show, why, and how. Planning is everything. When and where will the sun rise, what will the wind and clouds be like?

I do not think one should stick to the plans too rigidly, though, because circumstances change, such as with the birds in this shot. Flexibility is necessary, especially in landscapes. There are too many factors that cannot be altered. But I can relax a bit more when I know that I am prepared.

It's also very important to be prepared with the right clothes, especially in the mountains.

 Cristoph Hessel

I am 47 years old and married to the wonderful photographer, Marei. I work as a self-employed lawyer. Photography helps me to be creative and to "decompress." I would be honored if you would visit me at http://www.christographics.de.

I use Photoshop CS5 and do the RAW processing in Adobe Camera RAW.

In Camera RAW, I adjusted the white balance a bit toward cloudy and added some warmth. I also did a soft noise reduction and increased clarity a bit.

In Photoshop, the first thing I did was to clone out some footsteps in the snow.

To increase the impact of depth, I needed to increase the contrast and details. I did so with a layer using a high-pass filter in Blending mode overlay. To boost the color contrast, I converted to LAB color space. Then, I increased the contrast with Gradation curves and left brightness untouched.

The rest was only small alterations. I brightened the horizon with an empty layer, in Soft Light, and painted with a soft bright brush and about 10% opacity. I did the same with the cross on the chapel tower.

I finally reduced the image size and sharpened it, by making a selection of brighter areas and by using an Unsharp Mask set at 125, 1, 3.

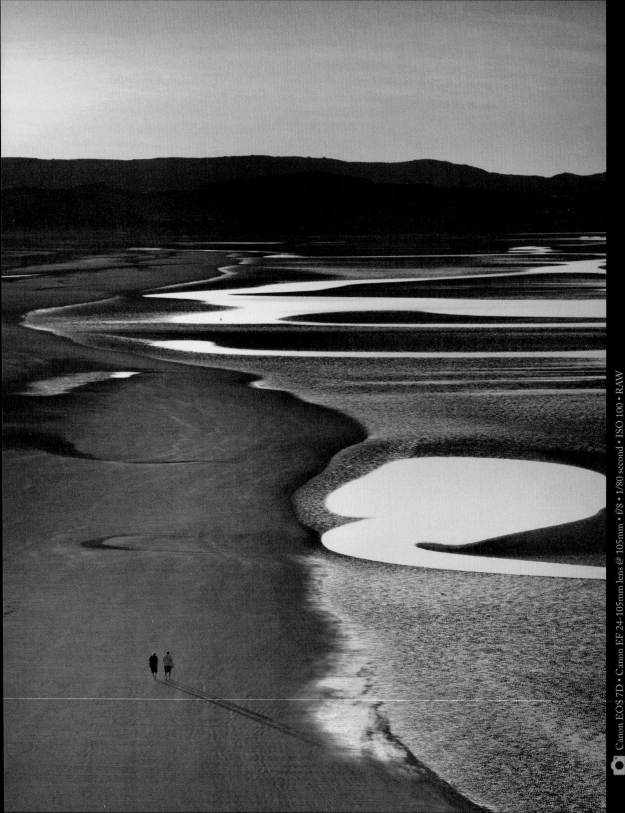

Canon EOS 7D • Canon EF 24-105 mm lens @ 105 mm • f/8 • 1/80 second • ISO 100 • RAW

Settlers

I was on a week-long work trip in Point Samson (Australia), which is only 10 kilometers from the old abandoned settlers town of Cossack. I had been to Cossack briefly, six months earlier, and had seen this shot then. The backlit hills, textured sand and mudflats, low-tide pools. So, understandably I was keen to capture it this time around.

I travel quite a bit by motorcycle, gear in my backpack, tripod strapped on the back. This time was no exception. When I rode over the last hill to the desired location right at sunset, I noticed a couple walking along the beach. Gone was any chance of a thoughtful setup.

I walked toward the edge of the hill while setting up the camera. White balance is almost always on around 4850K (I find it a happy middle ground). Luckily I had the 24-105mm lens on the camera, because there was no time to change the lens. I like to keep my camera on manual and would rather be frustrated with myself for messing up a shot than blame the camera.

Once I found my place and composition, I spot metered the scene through the lens. My first setup was a little dark, so I dropped down to the settings listed here. I always shoot RAW, especially for scenes like this where there was a huge variation between the exposure of the sky and the ground. The calculated exposure had the sky reading 2 steps up and the ground around 2 steps down; I knew I could pull them into line later, but at that moment, I really just needed to get these people before they left that sweet spot.

I was focused on the couple, and I knew that they needed to live in a cleanly framed landscape. The choice to shoot this landscape in portrait was made as I felt this was where the details were. Australia is such a flat country over in the west, so the details are in the land, not the horizon.

I hoped people viewing the image would be touched by the human element and the couple's intimate connection to the landscape, which gives the scene scale, and highlights how empty the beach really is. So far, most viewers have had a similar reaction as my own, which makes the dash to catch it in time all worth it!

Side and back lighting highlights detail, shooting with a low-angled light will bring your landscape to life. Lighting is the key, and it's where I've had most of my fun throughout my career.

Learn the limits of your gear and know how far you can push your RAWs. The more you know about how your camera creates an image, the more freedom and choice you'll have to express yourself. You don't need good gear, you just need to know how to use it.

 Chris Mitskinis

I am from Broome, Australia. I was working with video, but since I bought my first dSLR in 2011, I have hung up my video hat and haven't looked back. I love the challenge to convey the same emotion and story in a single frame that I used to tell in a scene.

I use Photoshop CS3. The first step was to sharpen and remove any fringing. I then created layer masks with three exposures and painted away the parts of the layers that were either over or underexposed. Then, by dropping the exposure on the sky, I had introduced a green tint in the center up to the top. To remove it, I created a new layer, and with a very soft, large brush, painted a red spot right over it, changed the composite mode to Soft Light, and dropped the opacity on the layer until it was no longer visible. This created the consistent yellow across the sky. Next, I created a levels adjustment layer, crushed the blacks and painted away where I didn't need it. This is how I "burn" without using the Burn tool; I can work faster and need not worry about running out of undo's because it is a mask and is non-destructive. This step was used to darken and add contrast to the mudflat detail, hilltops, and so on. I then created another levels adjustment layer and bloomed the mids to paint in my highlights. Here, I picked up the sand to balance the brightness of the sky. Lastly, I created a final levels adjustment to do an overall contrast and drop my blacks a little, and some minor normal burning and dodging on the base layers to increase detail in the sand.

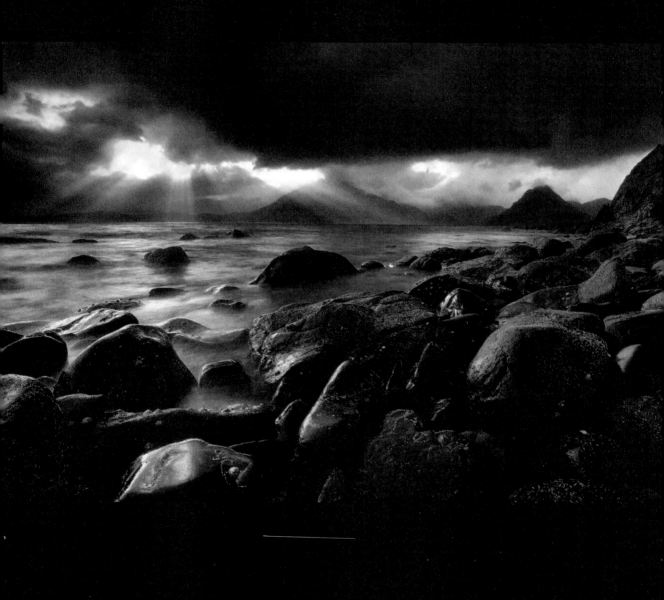

Nikon D700 • 21mm lens • f/22 • 2.5 seconds • ISO 200
Nikon Sb800 flash mounted on the camera

Skye Island

This picture was taken while on a photographic tour that I made to Scotland, along with two friends. I am very attracted to nature, especially the northern landscapes. That is how I found Elgol on Skye Island.

When I shoot, I just try to get the best from the landscape. I am always attracted to wild nature and the kinds of landscapes that remind you of how the earth probably was, long ago.

When on a vacation, you generally do not have much time to spend in every location, so it's important to know in advance what you are visiting.

A good way to study a place before visiting it is by using Google Earth. Take a look there, spend time to see photos by people who visited the place before. Panoramio.com is also helpful for this purpose. This is exactly what I did before going to Elgol.

This is a single shot. To light up the stones I used an SB800 flash with low sync. The camera was in manual mode.

First and foremost, you need a good tripod. It's best if it's a bit heavy (no wind problems); otherwise, you can always hang your backpack on it for ballast.

Instead of taking many shots with different exposures, you can preserve the highlights by using filters. For this photo, I used three filters in combination: Hoya polarized filter, Cokin Z ND +8, and Cokin Z ND graduated.

Polarized and ND were needed to obtain the long exposure effect (smooth water). But the most important filter for this picture was the Graduated ND, which is the only one that gives you the correct exposure on the entire image. The choice of the neutral graduated filter (light, medium, strong) depends on the condition of the light. If the contrast between sky and land is very high, you need the strong filter. Because digital images allow you to see the result immediately, you can start by trying them all.

You must have a lot of patience! When you find a good place, always try to go there as many times as you can. Take a look at the location and find the best angle so that you don't waste time looking for locations once the weather conditions are good.

When you find the right angle, take as many shots as you can, playing with filters, different angles, and all the equipment you have. This shot took me about 80 minutes.

I chose the wide-angle lens to obtain a deep image, including elements very close to you and also very far. I wanted to give more importance to the stones, so I put the camera on the tripod at about 50 cm off the ground (very close to the water, so pay close attention!).

Andrea Auf Dem Brinke

I was born in 1982. I am an amateur photographer who has been practicing photography since about 2001. I never attended courses; rather, I've learned and gained what experience I have, picture by picture. I like to take photos to express my mood.

I did very little post-processing on this image. It pretty much came out as you see it now, thanks to the filters. I essentially adjusted the contrast, lights, sharpness, and did some noise reduction.

MACRO photography is the art of capturing the tiny world that surrounds us.

There are different approaches in macro photography, starting from close up landscape (magnification ratios from 1:1 to 1:3) to high magnification ratio macro (from 1:1 to 5:1). A magnification ratio of 1:1 reflects a size of the subject on the sensor that is equal to its actual size.

Close up landscape photography shows the subject in its natural environment, using a large framing, whereas high magnification ratios are used to make pictures that reveal minute details of the subject, such as its eyes. These two approaches require different lenses and equipment.

There are also different philosophies and schools of thought.

On one side are those photographers who use only or mainly natural light and make their pictures in a natural environment; on the other side are those who use multiple lighting systems, and capture their images in some kind of studio that simulates a natural environment.

Other fields include macro photography of objects and high-speed photography, such as the collision of liquid droplets, for example.

Macro photography is one of the fields that requires a strong knowledge of the gear, and a strong technique. In most of the cases, this generally requires that you set all the parameters manually, especially focus. Indeed, depth of field obtained with a macro lens (also a function of the working distance) is very tiny (less than 1 cm). Therefore, you have to decide where the focus point has to be. Generally, exposure should also be set manually. However, when beginning in macro, aperture priority mode can be used in some cases and still yield fairly good results.

Lighting and background are highly dynamic in macro. Change your position by a mere 5 cm, and the picture could be completely different. That's why you need to check the histogram and adapt gear parameters very often, as soon as you change your point of view.

Whatever the kind of picture you like to make, as with any other category of photography, the key points to capturing a good macro shot are composition, light, sharpness, and background, also called *bokeh*.

The most important thing aside from the actual subject that you want to photograph is to evaluate its position relative to the light and its closest environment, depending on which elements you want to include in your composition. Each situation is different and requires this evaluation.

Take several pictures of your subject, varying settings (mainly to adjust depth of field) to get the required sharpness, but without degrading the bokeh. Depending on the distance between the subject and the background and the type of picture you want to create, you can get a structured bokeh or a quite uniform, soft, and blurry one.

If you only use natural light, you should tend toward early morning or late afternoon of a sunny day. This will give you the best soft light. If you use flash units, this requires a strong knowledge and a lot of practice to get a picture that looks natural.

Well that's it.

To conclude, my last advice for those who want to get into macro is to turn your computer off, go outside, and shoot, shoot, shoot. Nothing is better than practice.

And of course, enjoy this close relationship with nature. Even if you don't achieve the expected results at the beginning, you will feel better in your mind and in harmony with our mother nature. And finally, you will learn patience.

–Fabien Bravin

Macro

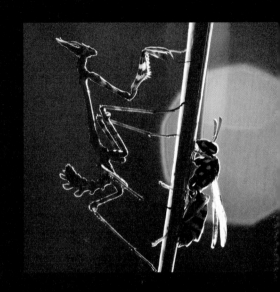

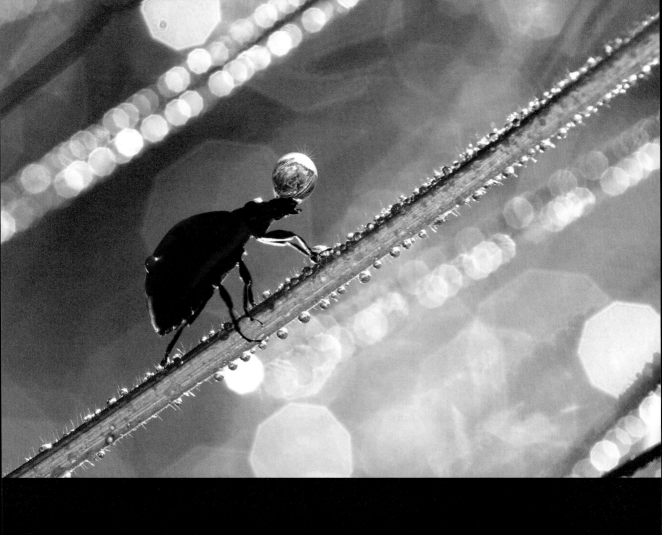

Canon 7D • Sigma 70-300mm lens (with Raynox DCR 250 macro converter) @ 70mm • f/9 • 1/800 second • ISO 400
Exposure compensation: −0.33

The Optician

This photo was taken in March, on an early morning macro shooting session. I was watching this ladybug in the dew of the grass; she was very active, which is rather unusual at that early morning hour. I sat down and started to follow her movements through the viewfinder of the camera. It was a beautiful morning mood, especially as the ladybug was back-lit against the strong sunlight. She climbed to the top of a blade of grass, looked for the large drop of dew, took it between her legs, made a half turn, and then carried the drop down the blade and disappeared!

I took a dozen pictures of the scene without really understanding what happened. I am very happy with this one, in which she is balancing the droplet on her head.

The Canon 7D is really quite good at capturing a wide dynamic range with plenty of colors and contrast.

I had no intention to make a message with this picture, at least not initially. I was fortunate to be at the right place at the right time to enjoy a rare scene, although I still do not know why she did this.

In a way, I think she laughed at me, showing me the purity and simplicity of her own magnifying lens in the water droplet compared to my Sigma 70-300mm plus Raynox DCR 250.

Since I made the image public, I have noticed that many people do not understand what is really happening in the picture. Some think that I waited in the rain for one drop to fall and touch the ladybug; others do not see that the image was flipped vertically, as the reflection of the drop betrays. But, then again, I don't think the viewers really care about all that. I think when it comes to macro they want to see something new and interesting.

Here is my advice for getting pictures such as this: wake up early to catch unusual activities that can happen at these hours. Do not be afraid to get yourself or your equipment wet. Be lucky!

 Waugh

I am a thirty-year-old French art director. Professionally, I am involved in print, web, motion, and 3D.

Since I was young, I have been passionate about insects. In 2007, a company that I worked for bought me a Canon EOS 400D dSLR to make texture stock for a 3D project. Of course, I took the opportunity to shoot insects with that camera, and since then, I've never stopped.

The post-processing was done in Adobe Camera Raw and Photoshop. I did minor adjustments to the Curves, Levels, and image sharpening, flipped the image vertically, and a made a 5% crop to get the composition just right.

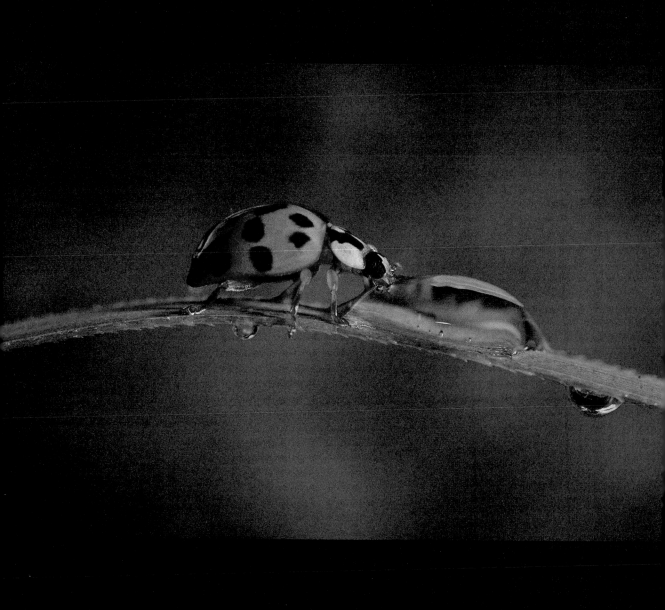

Nikon D70S • Micro Nikkor 60mm f/2.8 lens • f/18 • 1/250 second • ISO 200
Nikon SB-800 flash, off-camera and hand-held

Thirsty Ladybug

I was taking pictures of water drops on a leaf when suddenly a ladybug walked into view and stopped at the drop to have a drink. I thought the interaction of the ladybug and water droplet would make an interesting image.

The ladybug came to the water drop several times to take a drink, so I took the opportunity to capture it just as it started to take a sip. It was fascinating to watch the scene unfold, and I took quite a few shots to ensure that I got a pleasing one.

I was quite surprised by the actions of this ladybug; I had never seen one approach a water droplet before and then see it drink from it. I think that most viewers would have the same reaction seeing this for themselves, so from that point of view, I think it is a unique moment and picture.

For macro photography, I think that the most important facets are patience, a steady hand, and proper exposure settings. Another important aspect is to try to learn how insects behave and live. The more time you spend studying and observing them, the more you will have valuable information and experience about their behavior and what they are likely to do.

I prefer not to use a tripod when taking macro insect shots because I can move faster between places, which affords me far more opportunities to capture pictures of fast-moving insects. Also, when using a tripod, you can easily disrupt the insect in its environment. Macro images generally look better taken in natural light if it is possible, but if I have to use flash, I use a hand-held, off-camera, externally. For this shot I used my external flash. However, I tend to avoid using it as it can create disturbing highlights on reflective surfaces such as wings and insect shells, for example.

 Lifeware (Jeanette)

I am a photographer living in Assen, Netherlands. My three photographic passions are macro, portraits/models, and photo-manipulation or creative editing using Photoshop.

When I started taking macro images about six years ago, I had no idea that there were so many different insects and how interesting and fascinating their little world is.

I performed post-processing of the image in Photoshop CS3.

I saturated the colors a bit with the option via Hue-Saturation.

I also clarified the picture more by using the Exposure option, in which I just used the exposure and the gamma correction.

I sharpened the image in the following order:

First, I made a new layer from the background layer by using Duplicate Layer.

Next, I set the blending mode for this new layer to Soft Light, and then used a high-pass filter.

I set the radius to 0.9 pixels.

The Background copy is now colored gray.

If necessary, this layer can be copied again, just to avoid sharp edges created around the insects.

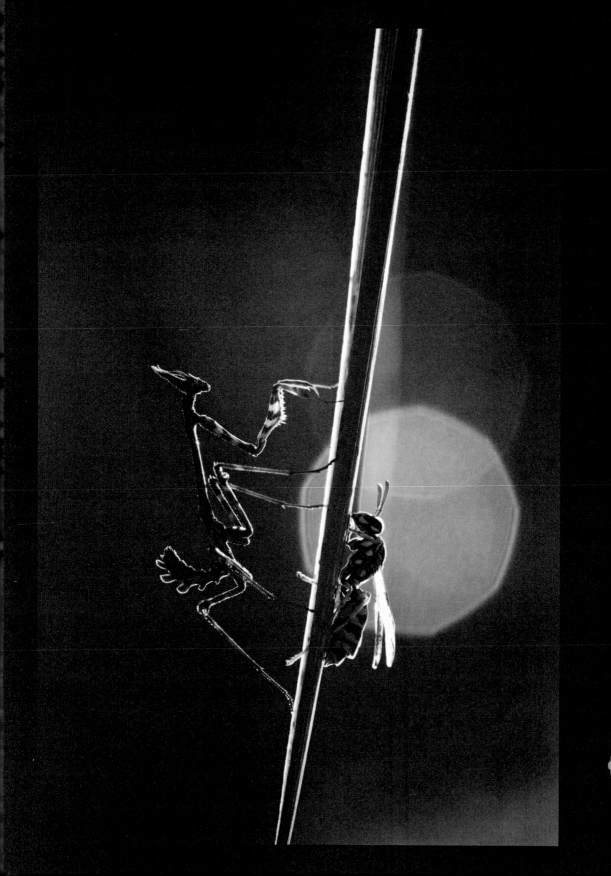

Canon 7D • Sigma 180mm f/3.5 macro lens • f/9 • 1/320 second • ISO 320 • RAW

On the Other Side

I was in my backyard. The wasp was in a tree, just waking up and warming itself in the rays of this early spring morning sun. Its wings were still wet, so it couldn't fly.

The immobilized wasp presented a great opportunity, because I knew that it would be still for a while. A few meters away there were some praying mantises in the dried grass. I lifted one and coaxed it to climb on the stalk where the wasp was sunbathing. They both just stayed there for a while. I enjoyed having these two different species co-existing so close to each other.

The light and the angle of view were perfect for me. I love this kind of backlight. After making some backlit shots, I decided to reverse the angle of view to see how the bokeh evolved. To my surprise, many colors appeared instead of this warm, golden light. I think this can be a good reminder, that by changing viewpoint in an image like this, it can turn out completely different.

Fabien Bravin

I am 38 and live in Toulouse, France, working as an aeronautical engineer. I started photography three years ago when I bought a Canon 400D.

As I like to spend time in nature, I soon became attracted to macro photography.

I used Photoshop Lightroom 2.6.1 to process my RAW files. No particular improvements have been made except for a little fill light in the shadows, as far as I can remember.

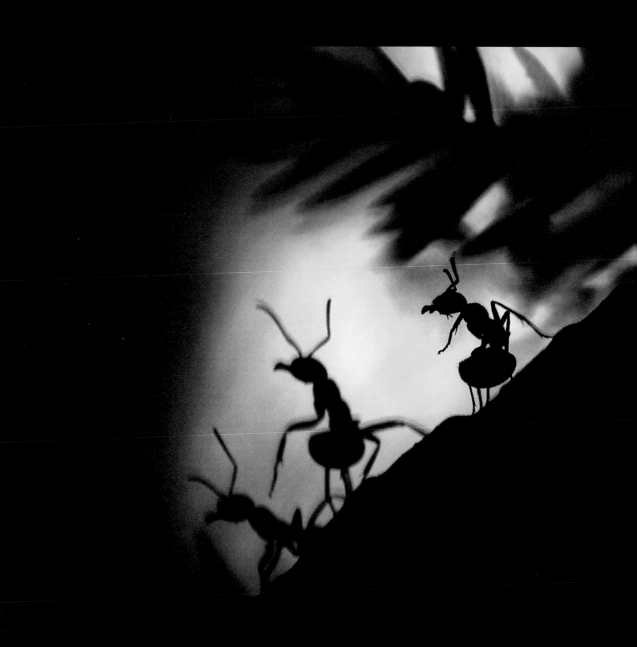

Canon 350D • Canon EF 100mm f/2.8 USM lens • f/2.8 • 1/125 second • ISO 100 • RAW

World of Ants

For me, one of the most enjoyable things to do is to take photos of ants. It all started one day a few years ago when I walked past an anthill in the woods and stood there looking, fascinated by how hardworking they are.

Wondering if it was possible to shoot them there in the ant hill, I leaned down and zoomed in on them with the lens, and a whole new world appeared to me. It was absolutely fantastic, and I was enchanted by these incredibly industrious little insects.

There, in the viewfinder, I quickly realized that they were aware of me and perceived me as an intruder, which of course, I was, although I was motionless and extremely careful not to disturb them. They ganged up and sprayed their acid at me. Some of them ran up with open jaws and waved at me, as if to warn me, "If you come any closer, you are history." I was completely knocked out by their extraordinary attitude and body language; to me it was like entering a fairy tale that suddenly became real.

While the light was bad in the woods and I did not want to increase the ISO, which would add noise, I chose to go down on my knees and point the camera upward, catching the light falling through the trees and the ants in

silhouette.

I chose the aperture f/2.8 to keep a shutter speed no less than 1/100, because I had no tripod with me. I used manual settings.

This was my first picture of ants, all because these lovely little models with so much character caught my interest. I was happy when I saw the result, because the entire image captures their attitude: "small but tough"!

If you want to try ant photography, first find a good view where the ants are and where you can get the light and the background to harmonize with each other. Decide if you want to catch a silhouette or something else and do some tests to try out the lighting and background.

Ants are fast. You barely have time to adjust focus before they're gone. So just shoot away; don't just sit and wait.

You get the best silhouette photos in the evening when the light is warmer, and most ants calm down a bit in the evening.

 Tammy Bergström

My name is Tammy Bergstrom, and I am from Sweden.

Ever since I was a child, I wanted to capture the beautiful eyes of an animal. I often borrowed my mom's camera when she was not looking. When I was 15, I got my first analog camera and started to take pictures of my dog and any other animals I came across.

I have always had a desire to show others that every life has a value, even the smallest animals, and how important it is for us to creatures that.

Could I capture the personality of the smallest creatures? Was I able to show that even a ladybug has dreams? Would I be able to capture her personality so that my picture tells her story and is not just viewed as a art portrait of a ladybug? Could I show that a little ant has so much personality—that he has a job to do and a family to support? Could I show that other living creatures have feelings just like us—that they are not much different from us, even though we humans usually consider ourselves to have the greatest right to this planet and think we can do what we want with it?

To show the love I feel for animals and nature is my ambition with my pictures.

I cropped one side of the image with Adobe Photoshop because there was nothing there that added to the picture. I also increased the contrast and added some sharpness on the ant that is in focus.

NATURE photographers have very little influence over their subjects compared to other photographers. Landscape photographers can only hope for good weather, great light, and spectacular skies. In wildlife photography, there is the additional problem of having to deal with subjects that don't show up when the conditions are perfect, or if they do, they rudely present only their backside. Luck is an important factor in nature photography, but it is certainly not a lottery, and there are many things you can do to get the results that you're after. Here's my top ten:

1. Preparation is the key to success. Search the Internet for images that have already been shot of your subject so that you, a) know what the possibilities are, and b) what you don't have to shoot anymore because it's already been done. Find out what the best season is, check sunrise and sunset times, and maybe even the moon phase and tides. If you're going to shoot wildlife, learn about their behavior—you don't want to be waiting for an animal that has just gone into hibernation.

2. Be patient; be very patient. The longer you wait, the luckier you get. Really.

3. Experiment. Those who try the absurd will achieve the impossible. Try a different technique, a weird angle, anything you normally don't do. Experimentation is not only great fun, it can lead to surprising results.

4. Knowledge is power. When photographing abroad or in unknown territory, using a local guide that knows the area and/or the species you want to photograph is often the most efficient way to work, especially with wildlife.

5. Scout before you shoot. Visit the location and then analyze it. What is going to be lit by the sun, is there anything that can block the light? How will the shadows move over the earth? What is the best position or angle to shoot from at any given time? You can use information such as this to better plan your shoot and avoid frantically running around when the light is great, searching for a good spot.

6. Explore. If you stay on the beaten track, you're going to get the same shots everybody else has.

7. Previsualize. Think about the subject and the location, and try to imagine the image you would like to create. It's amazing how much work you can do inside your head without having to move an inch. It will save you time on location, because you already know what sort of shot you're looking for.

8. Be ready. When something spectacular happens in nature, it's usually not for long. Make sure that you don't have to fiddle around with your camera settings when that quadruple rainbow appears or those polar bears start dancing.

9. Go back. Don't expect to get that award-winning shot after just one day of shooting. You can do better than that. Go back and try again. And again. And again.

10. Forget the rules. Photography is art.

–Marsel van Oosten

Nature

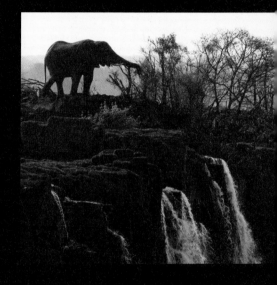

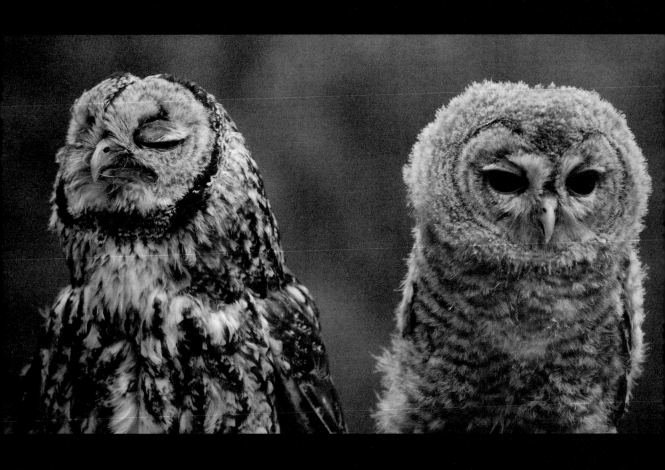

Nikon D40X • AF-S Nikkor 55-200mm f/4-5.6 G ED VR lens @ 125mm • f/5.6 • 1/640 second • ISO 200 • JPEG

I'll Never Speak to You Again

In Vila Nova de Gaia, a neighboring city of Porto in Portugal, there is a park that, among other things, is dedicated to the conservation of some birds of prey. They breed eagles, falcons, hawks, kites, vultures, and owls. It was there that we were introduced to this charismatic couple.

A few Tawny Owls were born recently at the park and the trainer wanted to show the audience the difference between a baby owl and an adult. So, he placed those two on his arm, providing us with a great opportunity to take some unique photos of this night creature, grabbing two stages of its lifespan at once.

Fortunately, the owls were nicely lit by natural light and the vegetation behind them provided a beautiful background. We moved in as close as the trainer allowed, trying not to startle the them, and the shooting session began. It ended a few shots later because the older owl was starting to drive its claws into the trainer's skin.

The photo was shot at eye level, because the intention was to have a classical portrait, with no distortions caused by viewpoints that are either too high or too low.

This was a hand-held shot, with no use of flash or burst mode. Because the owls were constantly moving, the speed was set to 1/640 to assure a shake-free photo and to freeze an eventually interesting moment. The aperture was the largest possible (f/5.6) in order to blur the background. A focal length of 125mm was enough to fill the frame at it's largest width. The ISO was set to 200.

The original purpose of the photo session was mainly to record two stages in the life of the Tawny Owl. However, thanks to the almost human expression on the owls' faces, it became a photo of two estranged friends. Viewers reaction to it was marvellous, and it went beyond our most optimistic expectations. It provoked smiles and laughs, and comparisons with daily life occurrences abounded. Someone wrote that it was "a shot about modern families," and someone else was more personal: "Just like me and my wife."

 Adrifil

We are Adriana Marques and Filipe Azeredo (Adrifil), a Portuguese couple living in Vila Nova de Gaia, Portugal. We are clerks in our professional lives, but we escape from it whenever we can to practice our common passion for photography.

From macros to landscapes, we love to record scenes that appeal to our senses. Flowers, insects, animals, castles, old churches, people—all these themes are targets for our lenses.

The editing was minimal and very simple. A copy of the original JPEG image was post-processed in Photoshop CS3 in the following steps:

A small crop of the upper and lower margins of the photo was made by using the Crop tool to enhance the owls in the frame and give the picture it's wide format.

We removed a distracting small blue blur on the upper-right corner with the Healing Brush tool.

The photo was slightly lightened with Curves.

Finally, we resized the photo and applied an Unsharp Mask of 50% (Radius: 1; Threshold: 0) only to the owls, after selecting them with the Magic Wand tool.

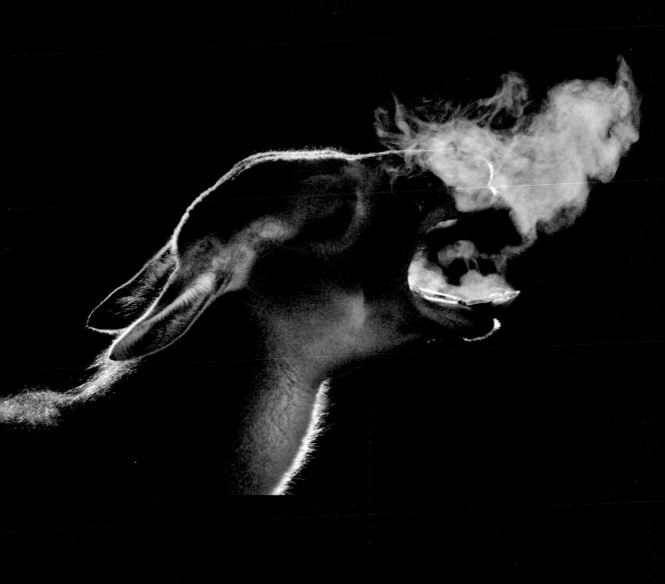

Sony A700 • Sigma 50-500mm lens • f/8 • 1/320 second • ISO 800

Breath

I took this picture on a very cold December morning. I think I was one of the first visitors that morning as I saw this llama yawn. The breath was illuminated by the sun in front of a dark background, and I saw this perfect backlight.

At this point, I still had my camera and lens in my backpack. So, I had to be very fast to be ready for a second chance. Just as I was ready, the llama started yawning again. I didn't have the time to control anything, but my standard camera setup is f/8, auto ISO, up to three pictures/second, and spot measurement. I pressed the button and captured ten pictures. Most of them are not sharp because the A700 autofocus is very slow in cold conditions. Only the last three frames were perfect.

I made this and all other pictures in my series, *Animals*, as a part of a concept governed by strict guidelines: all photos should be in landscape format, black and white, black or dark background, and high contrast. The project was for a calendar and an exhibition. The calendar was fundraiser for a "gorilla garden" in a small zoo near my hometown. I chose black and white to reduce the printing cost (and I really like black and white).

For my series, I try to show a wide range of animals. Llamas are not really photogenic, but I think in this case, most people will take a closer look.

Some hints for animal photography:

- Always be ready—a standard setup on you camera body can be very helpful. Do not watch your photos on the camera LCD during action (very often, I have seen photographers watching their photos while the action was still going on).
- Watch the expression of the animals; sometimes the position of the ears or the way they are looking can make the big difference.
- Use an angle finder to get a lower perspective to the animal (don't buy it from your camera manufacturer—for example, Sony sells one that is more expensive than most, and it's only a single lens with a prism, covered in black plastic). An angle finder saves your back. I try to use a camera position equal to or lower than the eyes of the animals. Always watch through your viewfinder so you can quickly react to a good expression; sometime eyes and ears are moving around very fast and might only be in a good position for a second.

Wolf Ademeit

Lives in Enschede, Netherlands. He is a teacher of mechanical engineering at Twente University.

For processing my RAW files, I always use Photoshop Lightroom. I do not use the standard black-and-white conversion; every picture has it's own unique character and curve. I also used Lightroom to make this black background (very rare in combination with Photoshop). By working with backlight, all animals have a fine and light aura around them, and it is very easy to distinguish them from a dark background.

Nikon D300 • Nikkor 600mm f/4 VR lens • f/4 • ISO 200

Who Are You?

I have always been fascinated by waders. There's something special about their long legs and beaks. I wanted to create a picture of one in its natural habitat, focusing as much as possible on the bird, while keeping the surroundings calm. That is not always easy to do, because there is often something in the way to draw the attention away from the bird. The location where I shot this picture is nearly ideal, though. It is a long stretch of mudflats along the shore with small ponds and lots of birds.

This picture was shot from my favorite spot in that place. I lay down behind some rocks under my bag hide, wondering if this would be my lucky day. The weather conditions were perfect—the sun had just risen over the horizon behind me, and there was no wind at all.

This picture was a single shot, without any artificial lighting. I used a Nikon D300, Nikkor 600mm f/4 VR lens, and a Gitzo tripod in split mode. The key piece of equipment, though, is the bag hide. Without it, there would be no picture. I used a blanket with plastic coating to lie on and then covered myself and the camera with the bag hide. This makes very good camouflage. I have even had birds land on my back.

To get the most out of the blur around the bird, I used the largest aperture my lens can manage, f/4. Large apertures are a bit risky with close ups, because you get a narrow depth of field. If you want to get closer, you might have to stop down to f/5.6, or even further. As my camera is rather noisy, I always try to use ISO 200, if possible. Vibration reduction (VR) makes it possible most of the time, as long as the birds stand still. When I took this picture, there was enough light to use the settings I wanted and still get a very sharp image.

I am very pleased with the result. I managed a long series of pictures of this particular Greenshank. I like the reflection and the calm background, which put the focus on the bird, without distracting too much. There are pictures in the series with sharper reflections, some in which you can't even tell which one is the "real" bird. But I think that this picture had something more to say. The name *Who Are You?* came quite natural. For me, the bird is looking at himself wondering who it might be looking back.

 Olof Petterson

I am a 34-year-old software engineer from Gothenburg, Sweden. Nature has always been a part of my life, and I picked up photography a few years back as a reason to get more out of it. I like spending time out in the wild waiting for that special moment. A lot of fascinating things happen in the world around us, and all we have to do is look for them.

Post-processing is the part I like the least with photography. I use Adobe Photoshop CS5, Bridge, and Camera Raw. I adjust the white balance and make other color adjustments, and that's usually it. Sharpening might be needed for printing but when downsizing for the web, the pictures are often sharp enough, anyway.

1) *Hide yourself.* This is the most important advice there is. Most birds are quite shy, and a good camouflage can get you within a few meters from them and let you witness their natural behavior.

2) *Get close to the ground.* Shooting from a low angle, makes the picture more natural. Due to the low angle, the reflection might stretch over a couple of meters of water, though. This make it even more important that the water surface is perfectly calm.

3) *Patience.* It can't be said enough. You can't remote control birds; thus, you have to wait for them to be in the right place, at the right time, and in the right light. You might be lucky and get it right on your first try, or you might have to wait for a lifetime.

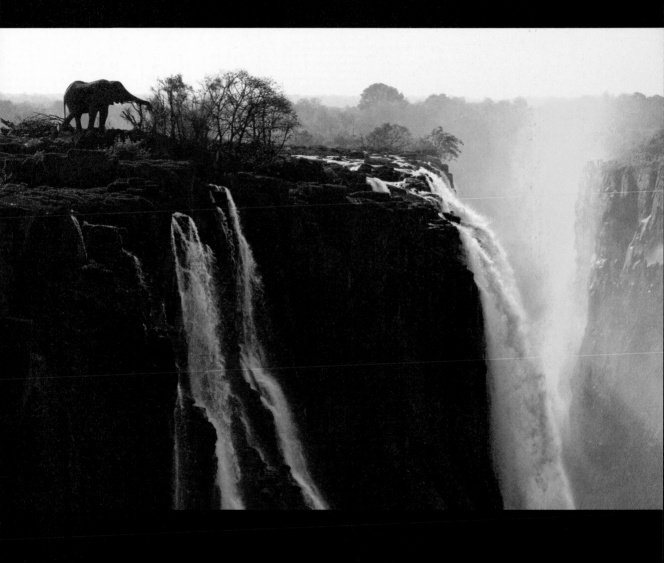

Nikon D2X • Nikon AF-S 28-70mm f/2.8 lens @ 70mm • f/13 • 1/160 second • ISO 200 • RAW • tripod

The Edge

The course of the Zambezi river is dotted with numerous tree-covered islands. As the dry season arrives, the islets on the crest become wider and more numerous, and when the water level drops, previously submerged walkways and fresh foraging possibilities appear. This elephant was apparently aware of this.

When I visited Victoria Falls, I spoke to some local people who told me that they had seen a bull elephant crossing the Zambezi river the day before. I had never seen any images of the falls with an elephant in it, so I decided to stay a few extra days and try my luck.

On the third day, I left early in a small boat. I continued to the falls where I took some sunrise shots. Half an hour later, the elephant approached. I moved toward the edge where the water plummeted into a 360-foot chasm so that I could include as much of the falls as possible and make a composition.

Luckily, the position of the elephant could not be better. The nice thing about backlighting, especially in foggy or misty conditions, is that you get a layering effect into the shot, adding lots of depth and mood. The elephant really stands out in the image, even though he is comparatively small in the frame.

I only wanted a hint of motion blur in the water, so I stopped down to f/13 to get 1/160 second.

Early morning light loses its warmth very quickly, so I set my white balance to cloudy to act like a digital warm-up filter. I tend to often change my white balance to get a feel for the different possibilities.

I always try to shoot both horizontals and verticals. There are always situations for which it can be useful to have a vertical version, as well. I actually ended up using the vertical frame on the back cover of my book on African safari lodges, *Wild Romance*.

If you want to create a mood like this in your images, you must look for the conditions that you need for it: mist, fog, haze, dust in the air caused by animals kicking up sand or by the wind. Place the sun behind the mist but just outside your frame if possible. Otherwise, you end up with a large area that is blown out. You can also hide the sun behind a tree or a rock, for instance.

Try to prevent flare. Even if you keep the sun outside your frame, it can still hit your lens and cause flare and reduced contrast. When shooting from a tripod you can easily block the sun with your hand or stand in the shade yourself.

Marsel Van Oosten

I am an Amsterdam-based, full-time professional nature photographer from the Netherlands. My images are featured in galleries and museums, and are used worldwide in advertising, design, and magazines such as *National Geographic*.

I live with producer and videographer, Daniëlla Sibbing. Together, we organize specialized wildlife and landscape photography tours and workshops for small groups of all experience levels to spectacular locations, worldwide.

For this image, I used Photoshop Lightroom as RAW converter. I fine tuned the white balance first (warmer), made tiny adjustments to the exposure, added some fill light to get more detail in the dark rocks, and then I used the recovery slider to get some of the color back in the sky.

In Photoshop, I made some contrast adjustments with one of Tony Kuijper's Luminosity Masks and dodged the water to make it slightly brighter.

I always work in layers, so all the adjustments I make are on separate layers. In that way I do not destroy any pixels permanently, and I can always go back to the file later to make small adjustments. From experience, I know that I often revisit my images to make small adjustments, so it is important to keep all the layers intact.

I only sharpen when I have to resize an image to a specific size.

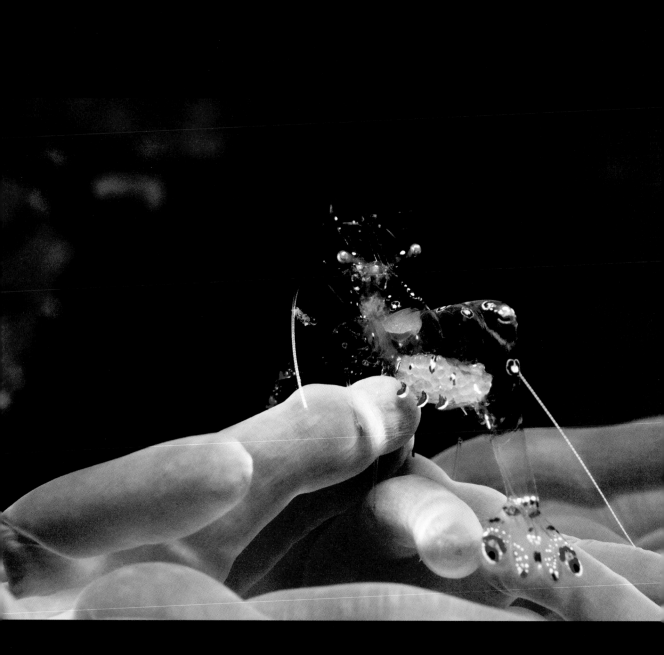

Nikon D100 DSLR • Nikon Aquatica underwater housing • 60mm f/2.8 macro lens • f/29 • 1/60 second • ISO 100

Anemone Shrimp

Underwater photography is hard to plan because you do not usually know what opportunities you might get during the limited time of a dive. An average dive normally lasts 45 minutes to an hour, so it cannot be compared to other types of nature photography, for which you can sit in a blind for hours or even days. It has it's advantages though: you can hover weightless over your subjects!

The reason I take underwater pictures is very simple: I just like the beauty of the underwater world and want to show it to others.

The following is what I usually do when I shoot images like this:

I do not use manual focus. I set focus on automatic to the distance I expect to use and then lock it. Auto focusing does not work very well with macro, because all too often the focusing will hunt and run straight to infinity before it goes back to close focus. In my experience, it never works.

I had only one strobe with me on this trip, a Sea & Sea YS300. It is quite a big and powerful strobe, which is not an advantage when photographing small underwater creatures. My preferred setup for macro shots is two small YS110 strobes, because you have to get very close, and it can be hard to place the strobe correctly without getting light into the front glass of the housing port. I use Ultralight arms to mount my strobes to the side of the camera and place the strobe at an angle

as close to the front of the camera as I can. The trick is to use the edge of the light without getting too much light on the water between the subject and the camera. This is to avoid light on particles in the water between the camera and the subject. But because of the transparency of these shrimp, you need an angle that creates the right reflection to separate it from the background.

I set my strobes to manual and find the correct exposure via test shots. The histogram is one of the best tools for underwater photographers because you can instantly evaluate and adjust exposure as necessary. TTL metering is very unreliable underwater; there is often a very dark background that fools the metering into overexposing. Bracketing is not an option, because there is just too much movement in the subject.

The next thing to do is to find a plot of sand where you can support yourself without creating any disturbance. The best is usually to point the camera and wait. In this case, I was just sitting still there, waiting for the shrimp to appear.

 Lars Grepstad

I was born in 1956 and took my first photos when I was 12 years old, which were black-and-whites that I developed myself at home with very simple equipment. At that time, I made contact copies because I had no enlarger. Photography has always been my hobby but still I did not take it seriously enough to really learn a lot about it until 1986.

That year, I worked for seven months on Jan Mayen, an arctic island north-east of Iceland. I had plenty of spare time on my hands and there was a darkroom at the station, so I rediscovered my passion for photography, and after a year, I had registered my own photography business.

I started diving in 1989, mainly because of the photographic opportunities that could be discovered underwater. I was very inspired by the underwater photography of David Doubilet and the images he produced for the *National Geographic* magazine.

The processing on this shot was very basic. I cloned away some disturbing particles in the water. I cropped the image a little at the right. Then, I adjusted it with curves for contrast and sharpened a little with the Unsharp Mask. My processing skills were quite basic at the time, and I am sure I could do it better today.

Canon 7D with Canon BG-E7 • Canon 300mm f/2.8 L IS USM lens • f/5 • 1/500 second • ISO 400 • RAW

Panning

"Eagle's coming! Eagles coming! Yeah... rock 'n roll, eagle!" That's what our guide and driver of the boat, Ole Martin Dahles, yelled when he saw it. I spotted the eagle in the viewfinder, followed it, and waited for it to dive for a fish, which Ole had thrown out. Here, it dives with an enormous power and speed. I hear the shutter sound from my own camera and from other photographers around me. I shoot 20 images in 2.5 seconds, and then it is over. I check the display on the camera, and yes, I got it just the way I wanted it. I'm a happy man!

The scene is Flatanger, Norway. I had rented space in Ole's boat for three days in the summer of 2010. Oles place in Flatanger is very famous, and photographers from all over the world come here to get images of white-tailed eagles grabbing fish from the surface of the water. You get quite close to the birds in these "eagle boats."

This image was captured on my last trip. The weather had been sunny, but on this trip, it was dark and cloudy. Instead of using a rather high ISO (800 or 1600) which normally is required to get a fast shutter-speed in such conditions, I kept my settings at ISO 400. I thought that I would try to get some powerful panning images with movements in the wings at a lower shutter-speed, while the head would still be sharp enough to get a nice, impressive image.

I was continuously checking the shutter speed to see if it was fast enough for such action images, which means that it should not be slower than 1/1250 second, and it's of course better if a faster shutter speed can be achieved.

I was using aperture-value priority and didn't actually regulate the shutter-speed through the ISO value to get a fast enough speed, it was done through the aperture-choice and just a little bit through the ISO. If aperture 4 wasn't enough to get a shutter speed at the preferred 1/1250 second or faster, I used ISO 500. To measure the light for a correct exposure, I used center-weighted average metering, with an EV at −0.33, and in bright sunlight minus −0.67, so as not to burn the highlights on the white head of the Eagles.

A camera lens with fast Autofocus properties should be used. A 300mm lens on a crop camera or a 400-500mm lens on a full-frame camera is perfect. Even a 300mm lens on a full-frame camera is good. A 500mm lens on a crop camera is actually not recommended, because you'll likely get many shots with only half of the eagle's wings in the frame.

Henrik Just

My name is Henrik Just. I was born in Denmark in 1967. In my professional life, I am a schoolteacher, teaching math and biology. I am an amateur nature photographer, and that is the only kind of photography I do.

I take photos of a variety of natural subjects, but as the years have gone by, I find myself mostly taking photos of birds. I am especially fascinated by birds of prey. I only take photos of truly wild animals in their natural habitat.

I use rather simple post-processing for all of my photos, generally not more than ten minutes work on my PC.

I used Adobe Camera RAW to crop the image a tiny bit at the top and the right side for a good composition, and then added some contrast. Finally, I adjusted the levels and added some sharpness in Photoshop. That was actually all the post-processing I did to the image.

Canon 5D Mark II • 70-200mm f/2.8 IS L lens

How to Eat a Raw Worm

To me, the most interesting subjects to be photographed are birds, especially birds that are in flight. First I tried with relatively large size birds such as herons near mangrove swamps around Jakarta. When I felt a bit used to capturing such big birds, I started photographing smaller birds in sanctuaries, such as parakeets, parrots, sparrows, (known in Indonesia as the Terucukan), and Finch Birds (Kutilang).

At the sanctuary, I observed the feeding habits of the birds, especially at the location where they were being fed. I found two kinds of birds—a kind of Swiss Annacis and Finch Birds—who joined the group at that spot, flying from one tree branch to another and catching the worms that were being thrown into the air.

I asked a friend to help throw out the worms into the open space nearby, and I tried to keep a distance of about 3–4 meters to the target when shooting.

Based on several trials, I found this to be the optimal camera setting: Tv-mode at shutter speed 1/1250 for freezing the bird in the air; ISO 800 to secure f/2.8; Partial Metering, EV –2/3 AI Servo AF; Continuous shooting; and focal length at 200mm.

Because it was a bit of a random shoot, I had to stop once in a while, review the result, select the useful images, delete the unnecessary frames, and then take another series of shots.

 Hedianto

I started with amateur photography as my new hobby in July 2010. I chose it because I had learned to appreciate art previously, especially painting and music, because as an engineering student (30 years ago), I found that it balanced my mind.

I used mainly Canon DPP RAW to process the image. Because it was a relatively a small object, I had to crop the frame up to about 80%. The next steps were to review and reduce the noise, increase the sharpness, adjust the brightness and highlight, and resize.

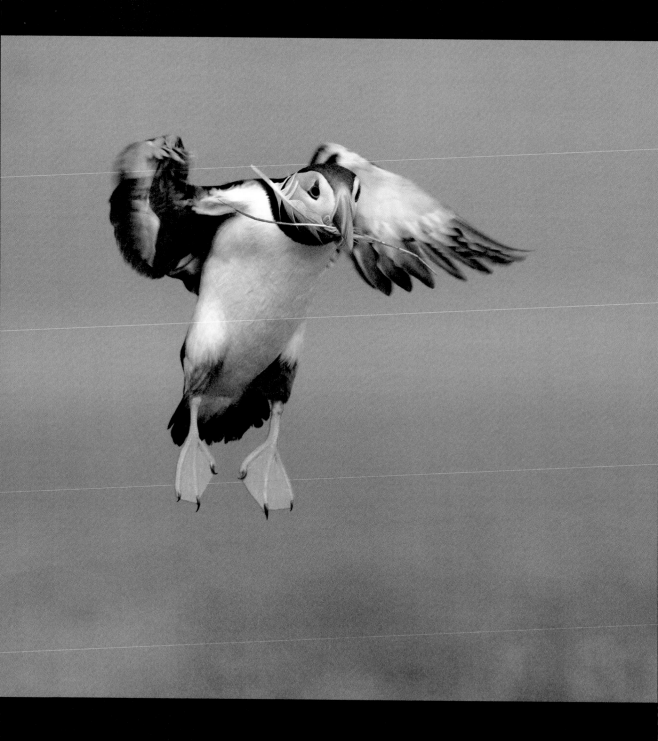

Nikon D300 • 200-400mm VR lens @ 400mm • f/5.0 • 1/1250 second • RAW

The Feather

A lot of puffins gather together on the Farne Islands (England) every year, and the intention of the trip was to get as many good shots of the birds as possible. The hardest thing was to capture them in flight because they are as fast as rockets.

This picture was taken on July 3, 2009. All of the puffins were coming in with food for their chicks, but this one seemed to be a little confused and came in with nesting material.

I took the hand-held shot with a Nikon D300 and 200-400mm f/4.0 VR lens. It was the third shot out of a series of five, taken at eight frames per second. No special settings were used because the puffins come flying in from everywhere and things happened too fast to do so.

The post-processing was minimal and I did not have to do anything to make the image stronger.

I never think much about how other people like my images. I upload pictures that I like the most and am often surprised, sometimes negatively and sometimes positively, at the outcome.

I am very happy with this shot, especially the locale that allowed me to capture this puffin in flight.

 Harry Eggens

I was born on the 10th of January 1953, raised and still living in Groningen, a town in the northern part of the Netherlands. I started serious photography in 1990 with a Nikon F801.

The original is a RAW file, which I opened in Nikon Capture NX 2. Later, I made some smaller adjustments in Photoshop CS4, such as levels and contrast. I generally do not process an image that much, because if its not good enough coming right out of the camera, at least for me, it will never be good enough to publish.

For sharpening, I used Nik Sharpener Pro software, which in my opinion is the best there is for sharpening an image.

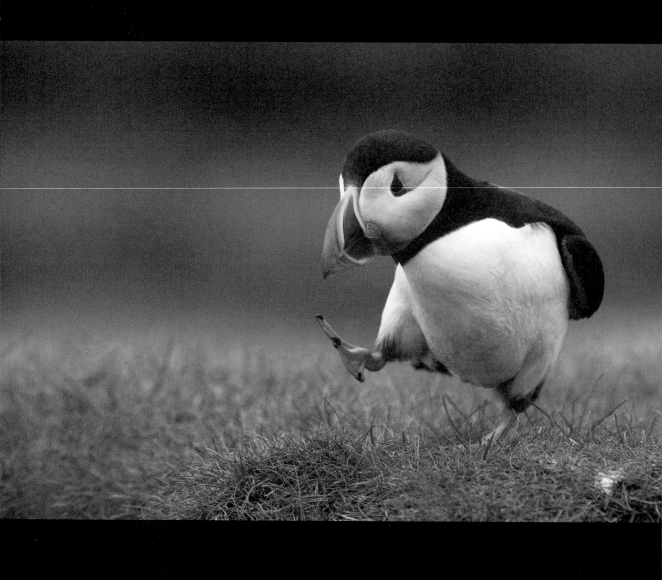

Canon 1D mark II • Sigma 120-300mm f/2.8 lens, with a 1.4x converter @ 327mm

f/5.6 • 1/1250 second • ISO 320 • Automatic white balance

Silly Walk

Originally I wanted to take a classic "fish-in-mouth-of-puffin" picture. I knew there were lots of puffins on the island I was about to visit in Scotland. This shot was taken on an impulse; I had been waiting for about two hours, but puffins with fish in their mouths were moving too fast, and I could not get a good picture. Finally, this puffin suddenly walked toward me, and I took about four shots in quick succession. One of them captured this silly walk.

Everything was happening so fast that I couldn't get a good in-camera composition. Besides, the AF was set to continuous focus, so if I had chosen another composition the puffin would have been out of focus.

I lay down on the ground in order to get a better perspective of the puffin. The weather conditions were very good; it was sunny, but the light wasn't very harsh.

I wanted to give the viewer a funny and happy feeling. Although the bird might not look very happy, it is still a funny photo, in my opinion, and I hoped viewers would think the same.

After publishing, I was amazed at how many people liked it—it was beyond my expectations.

My advice for pictures such as this one is to first of all be patient! I waited two hours for this shot. It could have been a lot longer.

Try to capture a special moment. It doesn't really matter what the subject is or if it has been photographed many times before—it will have that something special.

Be prepared. If that special moment arrives, you must have your camera (settings) ready. Usually, you will only have mere seconds to get the shot.

 Andreas Mulder

I am 19 years old and studying for a degree in urban design. I live in the Netherlands and have been into photography for four years. I like to capture beautiful nature shots; that's why photography is important to me. In the last six months I have also started architectural photography.

I used Rawshooter Essentials 2006 and Photoshop CS3 for post-processing.

Because I am not very good at Photoshop, I only use its basic tools. First, I increased the contrast in Rawshooter and added a little saturation.

Then, I exported the photo as a JPEG and opened it in Photoshop CS3. I used the Clone Stamp tool to remove some dust spots and disturbing brown grass in the foreground.

Finally, I cropped the photo to position the puffin off-center with more space on the left for him to "walk" into. I used the Crop tool and scaled it to a ratio of: 3 width to 2 height (so it would have the same proportions as the original file).

NIGHT and darkness has both fascinated and intimidated humans for millennia; darkness fascinates and frightens because it deprives us of one of our most important senses: sight. To see, our eyes need light, and preferably lots of it. Night photography or low-light photography is all about generating light from the darkness; the light that gives the right mood and the right details. But it is all about seeing the possibilities in the dark. A landscape or a location is dramatically changed when the light vanishes. Some things disappear and the color changes, whereas other things become more clear and beautiful. Just think of how a forest changes when darkness falls and the moon rises over the horizon. This beautiful, lush landscape, usually so alive with color, changes to an almost inanimate, colorless ghost landscape. This is when a good photographer sees possibilities, not limitations. It just takes the right knowledge, and to a lesser extent, the right equipment to create a stunning low-light image.

However, there is some equipment that is important when it comes to capturing light in the dark. A mandatory accessory that you need for night and low light photography is a sturdy tripod. When you let the shutter stay open for a long time, the camera needs to be kept rock steady; otherwise, you end up with blurred images. Another important piece of equipment is a remote: even the slightest touch of the camera during the long exposures can cause shaken pictures. The camera and lenses are obviously also important. You need a lens with a large aperture if you want to freeze motion in the dark, and it is also important that the camera can handle high ISO values and long exposures without creating too much noise. Other important non-photographic equipment includes a flashlight so that you can navigate in the dark, a spirit level so that the horizon is straight, and a good thermos for hot coffee or tea. One last very important item: a stopwatch. It doesn't matter whether it's your phone or your wristwatch, it's just important that you have the ability to manually time the long exposures.

When photographing in low light, you have two options. You can either freeze the moment or create an image with a certain degree of movement. When photographing people and wildlife in low light, you often want a sharp picture without any shake or motion. In such a situation, it is all about increasing the ISO and opening the aperture as much as possible to ensure that the shutter speed is fast enough to capture any movement of the motif. For landscape photography in low light, you often attempt to create drama and movement to make a more dynamic image. For this type of shot, a long shutter speed is advantageous, which is best achieved with a low ISO value and a small aperture. With this technique, you can create motion in the sky or milky water. But as mentioned earlier, it requires, a good tripod and a remote control. With this type of photography, it is important that you play with shutter speeds and aperture; a small change in shutter speed can often create a very different image. Generally, it is always a good idea to take many pictures with different aperture values and shutter speeds, because the motif often changes beyond your ability to see it with the naked eye. One last little trick. If you're are photographing cityscapes, use a small aperture; it imparts all the strong light sources (such as street lights) a beautiful star effect. Just remember to experiment, learning by doing is often the best way to become a good night and low-light photographer. Enjoy the night, and be careful out there in the dark!

–Niels Christian Wulff

Night

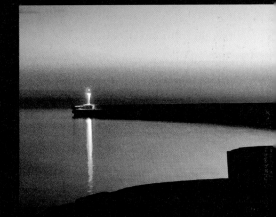

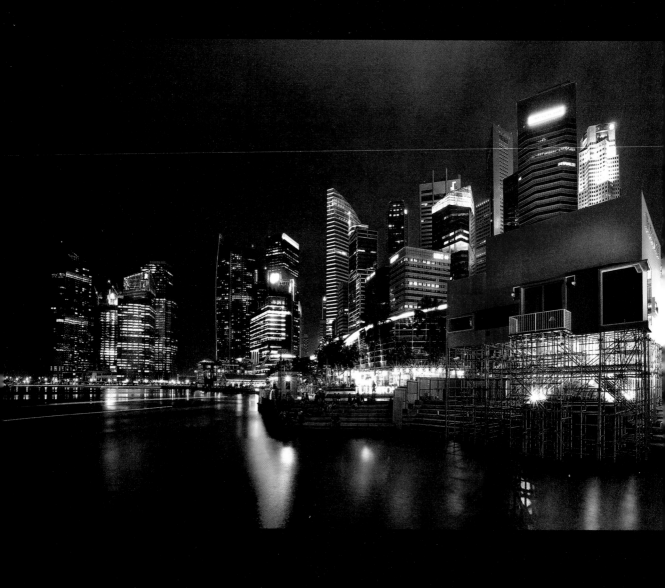

Canon 5D Mark II • Canon 16-35mm f/11 lens • 10, 20, and 30 seconds • ISO 100 • RAW

Singapore, the City of Lights

Merlion Park is one of the best places in Singapore for night photos. After noticing that the Merlion statue (the mascot of Singapore) was covered by a red construction scaffold, I was inspired to capture this rare moment. I waited until it was dark and the lights were turned on. To give more color and texture on the river, I waited for the moment when the boats were crossing the river.

To show the Merlion's "cage" in the near distance as well as the buildings in the background, I used an ultra-wide lens at 16mm with a full-frame camera. I used a tripod and a cable release to avoid any shaking. The flash was turned off.

I used ISO 100, aperture 11, and automatic white balance. I took at least three shots at 10, 20, and 30 seconds. The 10-second shot was for the building to avoid too much light while the 20 and 30-second were to capture the movement of the river and the boats. I always check the result on the LCD and take other shots with slower or faster speed, if necessary. Focus was set manually.

I'm satisfied with the technical quality of the image, which is very important for me. Good technique or tricks while taking the photo and creativity in sharpening or manipulating the lights during the post-processing is the key to a successful photo.

For an image like this, first try to be creative and look for an angle or story behind the picture that other photographers might not have seen. Of course, it's important to use good technique and equipment to create a great effect and quality picture. Another important thing is, of course, good weather and good timing. For instance, try to shoot during weekdays instead of the weekend for more lights on the buildings.

Sebastian Kisworo

My name is Sebastian Kisworo. I'm a 40-year-old Indonesian, living in Jakarta. I am a serious amateur photographer, expecting to become a professional. I work at an agrochemical company as an IT manager.

For post-processing, I used Photoshop. First I increased the shadow and brightness. I opened the three files as different layers. Then, I removed undesired parts by using a layer mask with black brush, merged all, and saved it.

I straightened out the horizon by rotating the image, and then reduced distortion by using skew.

The image was copied to a new layer to keep the original and sharpened by using the Unsharp Mask (amount 150, radius 1). A desired area of the sharpened image was isolated by using a layer mask, inverting, and finding edges by applying the stylize filter. Finally, the level was adjusted to extremely black and white. The effect applies to the white area only.

Similar steps were done to soften some parts by using a Gaussian Blur filter with a radius of 1, and to remove noise in the sky and other parts.

A new brightness/contrast layer was created to brighten the image. Brightness was set to 46 and contrast to 0. The layer was inverted and white spots were created by various brush tools on desired areas to make them brighter or create a shiny effect, such as on the lights on the building and in the reflection.

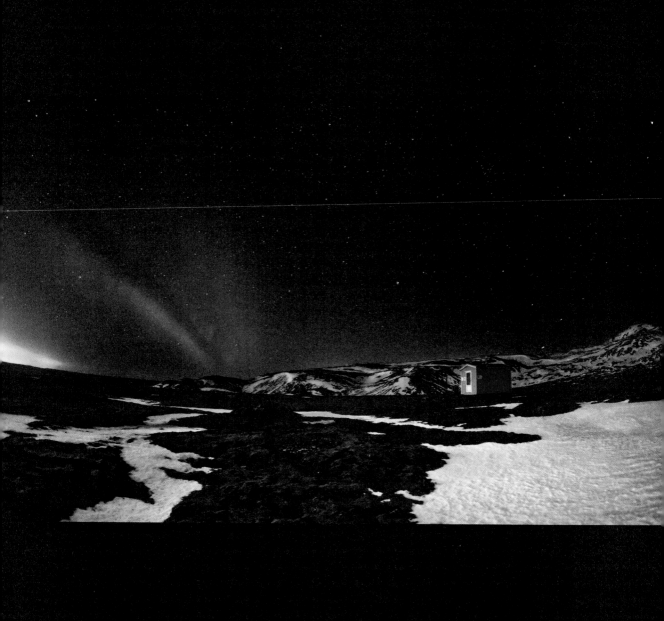

Sony Alpha 900 • Sony 2.8/16mm lens • f/2.8 • 96 seconds • ISO 1600 • tripod

Midnight

This night, after having looked at the weather forecast, I had expected to see the northern lights. I drove half an hour to this location in the southwest of Iceland and waited for some time for the northern lights to appear. They were not very strong this evening, but I found another source of light that I thought might be interesting. I knew about this small orange hut and thought that it might be a good foreground for this light.

This image is a single shot with an exposure of 96 seconds. The exposure for the nightly sky was limited to 25 seconds. This was achieved by using a black cloth that was held over the upper part of the lens—the "magic cloth technique." The light at the left is from the city of Reykjavík.

I had some expectations to see northern lights that evening. Well, I got lucky that night with contrasting effects of snow, green moss, northern lights, and a night sky filled with stars. This landscape and light is spectacular, but it was the orange mountain house that made the difference. The name

Midnight indicates dark and silent circumstances but this picture is full of light, colors, and movement. Still it is something you can expect to see when you go outdoors here in Iceland during long winter nights. Seems like a fun place to be, doesn't it?

My general advice for taking photos like this one is to first use your imagination and be open for experiencing new things. Then prepare and be on the watch for good light. Do not forget to bring warm clothes for a cold evening like this. Know how to handle your equipment and it's capabilities before you enter the scene.

 Raymó

Raymó (Raymond Hoffmann) is known worldwide for his magnificent landscape photos. In the last couple of years, his career as a photographer has taken a leap forward as he has been awarded internationally for his extensive work. He is originally from Germany but moved to Iceland six years ago. His choice of living and working in Iceland is for a good reason: the beautiful and dramatic landscape of Iceland is an endless resource for one who is always searching for exceptional landscapes and light. Today he works as a nature photographer as well as a photo tour guide in the Nordic countries.

I converted the RAW file by using the Sony Image Data Converter SR software. The only additional adjustments I made were level and contrast corrections. A bit of sharpening was also done. No special effect filter or tone mapping was used here.

Canon 5D Mark II • Canon EF 24–10mm lens @ 47mm • f/5.6 • 1/2 second • ISO 800

Pick Me Up

This photo is part of a series project that's centered around a nostalgically dressed travelling couple, who end up in various, sometimes bizarre situations but always retain composure.

The series, called *On the Way*, is a conceptual project by fellow photographer, Uta Schönknecht, and myself, who are also the protagonists in the series. Their outfits appear somewhat formal and nostalgic, particularly with regard to the unusual situations in which they continually find themselves. Every picture is meant to work like a short movie in the mind of the viewer and should be open for different interpretations.

The settings were always chosen in scouting visits (at least one of us) prior to the final shooting. This was also the case for the night car scene for *Pick Me Up*. Of our available cars, my Alfa Romeo GT was chosen because its fold-away back seats allow placement of a camera in the luggage compartment, behind the front seats.

The camera was placed on a tripod in the luggage compartment of the car and operated by a programmable interval self-timer. The outside light comes from the headlights of the car, and inside, from an LED flashlight clamped to the right headrest and aimed at the driver. After the start signal to Uta, ten shots were taken at an interval of five seconds. This was repeated twice. While I tried different poses to ensure that my face was visible in the mirror, Uta was moving back and forth and changing the orientation of the suitcase. The final image is a montage of two images, because she looked better in one photo, and I looked better in another one.

I wanted to create a mysterious night scene, reminiscent of a crime movie. We wanted to portray a lonely, empty road and a driver who stumbles upon a travelling woman, alone in the middle of the road, lit up by the headlights of his car.

The overall reaction to the photo was quite positive and met my expectations. When the photo was shown on our recent exhibition, people were captivated by it and attested that it stays in the their mind.

For an image like this, first find the optimal setting by scouting and taking test images prior to the final shooting. Then plan the optimal light situation for the shooting. In this case, it was the combination of warm light from the car and cold, blue light from the LED flashlight.

If there is nobody behind the camera to direct the models, as was the case with this shot, take many images, with different poses. If there is no single photo that meets your expectations, you can then make a montage of two pictures, as we did with *Pick Me Up*.

Photography is my medium to act out those of my creative talents that I have to neglect at my daily work as a cell biologist. You can view this project at http://traveller.finegallery. You can find my other photographic work on my website at http://graef-fotografie.de.

The two original images were developed in 16-bit mode in Adobe Camera Raw. The montage was done in Photoshop CS5. The two images, which differed only slightly in the poses of the models, were placed in two layers. Then a white mask and a soft black brush was used to replace the woman in the upper layer by the woman in the lower layer. After flattening the image into one layer, low tone values were brightened up with level adjustments. Next, a few disturbing elements and reflections were removed by using the touch-up tool in the content aware fill mode. Noise was removed by using Nik Dfine 2.0, and the image was sharpened by using Unsharp Mask at 50% strength, radius 0.5, and a threshold of 0 steps. Finally, the image was cropped on the left and right to achieve a 4:3 aspect ratio.

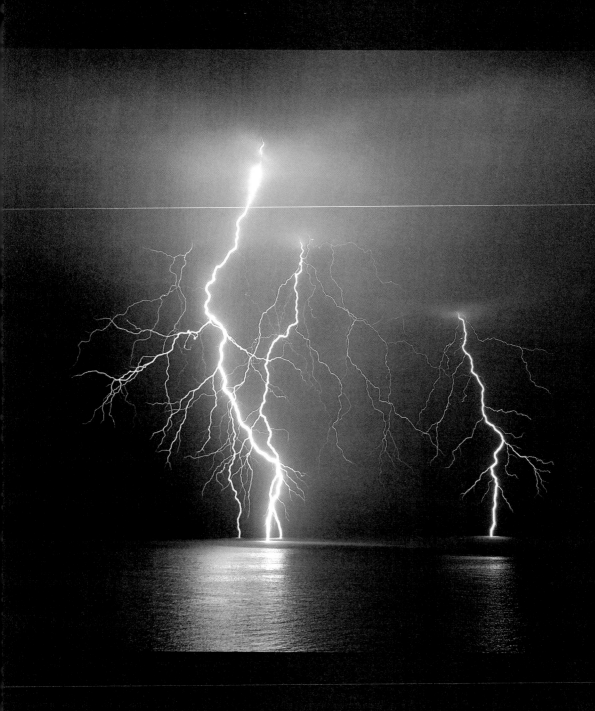

Canon EOS 40D • 18-125mm lens @ 38mm • f/5 • B (bulb setting) • ISO 100 • JPEG

Thunderbolt Over the Sea

Nini Filippini

Nini is a photographer who currently lives in Paris, France.

Catching lightning by night is quite an easy thing to do once you understand the simple technique behind it... and are also lucky enough to witness a strike.

Here, I was facing the sea from the terrace of my father's house. I was trying to shoot some distant lightning with my lens set on 125mm, when suddenly the lightning struck just in front of the house. I turned my camera toward it, reduced the focal length (here, 38mm) and caught three thunderbolts, including this one.

To take a picture like this one, you need (apart from a dark night with a thunderstorm) a place with a wide view that is sheltered from rain, a tripod, a remote, and a camera with a B (bulb) setting.

You point your camera toward the place where the lightning has begun to strike and open the shutter with your remote (press and hold the trigger), leave it open until lightning strikes. Then close it (release the trigger) and open it again right away and wait for the next strike.

If nothing happens in front of your camera, you can close it and re-open it at once. With digital cameras, you do not need to care about how many shots you waste. Here I had to take 100 shots to get 3 good ones.

This shot was taken with 20 seconds exposure, but I have another one taken a few seconds later, just as beautiful as this one, with only 2 seconds exposure, because the lightning struck almost as soon as I re-opened my shutter. The exposure is exactly the same because my background was completely dark. The only source of light was the lightning itself.

I personally do not use the automatic noise reduction for long exposures. That function keeps your shutter closed for as long as it has been opened, which means that catching a bolt of lightning relies on pure luck. So, I prefer a little noise in my picture with beautiful lightning than a perfectly dark image.

About the background, in this case the sea, the lightning illuminated it sufficiently to make it perfectly visible, so choose your backgrounds well. If you are in a place with a brighter background (in a city, for example), see Frank's tutorial at http://1x.com/tutorials/27462/ride-the-lightning.

Now you just have to wait for the right moment!

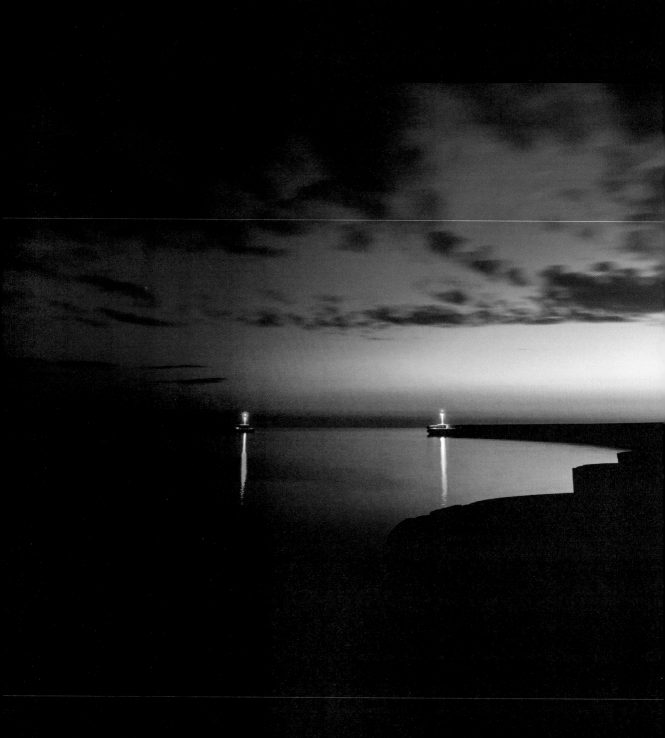

Canon EOS 40D • Canon EF 17-40mm f/4 L USM lens @ 17mm

f/9.0 • 25 seconds • ISO 100 • RAW • Exposure compensation: –2/3

Midnight Blue

The town of Hanstholm in Denmark is one of my absolute favorite places when it comes to coastal motifs—just look at the rest of my portfolio. The only problem with it is that it is often windy and rainy, and such conditions are not so good for night photography. But on this particular evening, I was quite lucky. It was one of those nights I dream about all winter: almost no wind and with a fantastic sky. In fact, I have to thank Mother Nature for this picture, and not my own abilities behind the camera. It really was a fantastic evening.

 Niels Christian Wulff

My favorite subjects are night and coastal motifs, which is pretty obvious from my portfolio. And when I can combine the two, as with this image, the result is, in my opinion, gorgeous.

The RAW file was processed in Lightroom 3, where I adjusted the colors and the contrast to give the picture a little extra impact. I also removed some noise, though there is not much noise at only 25 seconds. I always do so with night shots. The only other adjustment made was optimizing the curves in Photoshop CS5.

For night photography at the seaside, you must have a solid tripod because it is often very windy. I have a Velbon Sherpa with a ball head that makes it easy to adjust, which is an advantage in the dark. Otherwise, I always use a spirit level to ensure that the horizon is perfectly straight. When I had found the place where I wanted to be, it was just a matter of waiting for the light to be just right.

I took around 50 pictures from this location, using different shutter speeds and aperture values to make sure that I had something to choose from later, when I got home. This picture is the one I liked most. In my eyes, the light, the colors, and the sky is perfect.

When doing night photography, I always take many pictures of the same subject. It often happens that the scene changes imperceptibly. It's always a good idea to have many images from which to choose.

I am quite happy with this image, especially the colors and the sky, which I think work really well. Personally, I would like to see some stars in the image, but unfortunately it is hard to capture stars on a bright summer night.

A good tip for night photographers is to bring a powerful flashlight, for painting with light in places you would like to highlight. A regular flashlight with a red light is also useful for working with the tripod and camera (red light does not decrease your night vision).

Be patient! Patience is paramount for this type of photography. The sky, clouds, and light change frequently, so be alert and take advantage of the opportunity as it appears.

Safety is also very important in a place like Hanstholm. There are often waves several feet high that hit right where I stood that night. Always keep your eyes open when you walk on piers and along the coast.

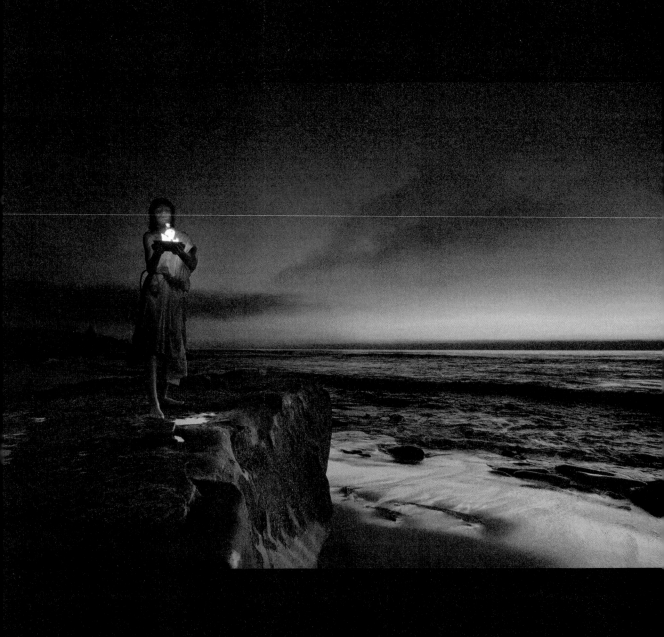

Nikon D700 • Nikkor 20mm f/2.8 • f/5.6 • 1/125 second • ISO 400 • RAW

Prometheus

I am lucky to live in beautiful San Diego, because a great combination of water, earth, and air is always there for me. All that was missing was fire. So I just needed to bring fire to the beach, right? At this moment it struck me: "Prometheus! This will be my story." Recall that, Prometheus is one of the mythological Titans whose claim to fame is stealing fire from the gods and giving it to the humans.

Most of my photos do not need a tutorial. They are the result of my walking down the street, seeing something interesting and being able to capture it. This photo is one of few exceptions—it is obviously staged. It was engaged in a photo challenge with the theme "all four elements," meaning earth, water, air, and fire. I always try to tell a story with my photos, and for some reason I thought about the beach.

I immediately visualized the image in my head as someone looking as a Greek god (a titan, to be exact) who just descended from the sky, standing on a cliff overlooking the ocean, holding a bowl of fire. This would indeed have earth, water, fire, and air, all in one shot.

Nick, the 14-year-old son of our friends, agreed to play the part of Prometheus. For the bowl of fire I poured some kerosene in a metal can, soaked a piece of paper towel in it, and placed the can into the bowl. That would make a nice, relatively safe and cool flame. For the Greek tunic, we used a white tablecloth and a piece of rope for a belt.

The real challenge was the lighting. In daylight, the flame would not stand out as the focus of the composition. I actually wanted it to light the face of Prometheus, and that would not happen in bright sunlight. On the other hand, it could not be the total darkness, as the ocean would not be visible. So, it had to be twilight, when both the light of fire and the remaining sunlight would be nicely balanced. The actual time slot for this is only a few minutes, so we had to be ready when it happened and didn't have time for many shots.

We arrived at least an hour before sunset. When the time came, I lit the fire, passed the bowl to Nick, who was already in position, and started shooting. The fire glow on Nick's face was still not strong enough, so to amplify it, I had his mom throw additional light on it with a flashlight. Two minutes were quite enough to capture the image I wanted. The balance of light occurred when it was already somewhat dark, and I needed a short exposure and a sufficient depth of field.

 Lev Tsimring

I was born in Russia, where I spent the first 32 years of my life. Since 1992, I have been based in San Diego, USA. I am a physicist by profession. I started photography in my youth, working in traditional 35mm format and printing in my own darkroom. Now, I shoot mostly with a Nikon FX digital system My photographic interests range from abstracts and landscapes to studio portraits and candids. Above all, I like it when my image tells an interesting story, either real or imagined.

In my usual workflow, I pre-screen RAW images in Photoshop Lightroom, in which I also make basic global adjustments and cropping. After choosing the picture I like best, I save the parameters in the .xmp file, which I use when I import the image into Photoshop CS4 via Camera Raw. In this particular case, I imported the RAW file twice with two different exposure levels as two layers. Then, I merged them manually by using a mask to bring out the texture of the rock (it was very dark relative to the sky and the ocean) while keeping the rest of the image normally exposed. I cloned away a few minor distractions, ran it through the Topaz Adjust plug-in to further amplify the texture in certain areas, and applied the Imagenomics plug-in to filter out some noise. Finally, I applied some dodging and burning, resized, and sharpened.

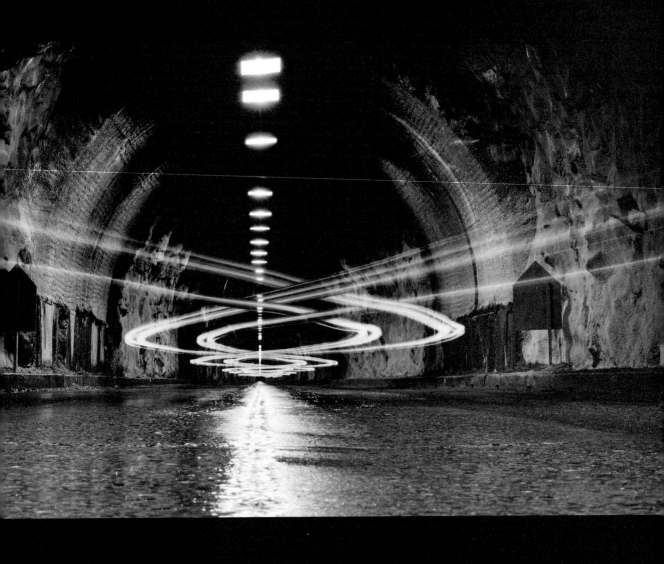

Nikon D3 • 80-200mm lens @ 80mm • f/22 • 20 seconds • ISO 200 • tripod

Convergence

Having been to Yosemite Valley many times in my life (I have always lived no more than a five-hour drive from there), I have been through the Wawona Tunnel many times. It opens up to that iconic view of El Capitan, Half Dome, and Bridal Veil Falls and the valley floor. It is called Tunnel View.

My wife Jan and I decided to stay in the valley for a couple of nights, and my intention was to get some night images. The first evening, we took a drive up Highway 140, and there was another tunnel, so we stopped. I set up my camera just to try my luck. It was a shorter tunnel, and I shot without vehicles in the image.

My creative juices were flowing, so I decided to go over to the Wawona Tunnel on Highway 43 and try some other options. We drove to the west end of the tunnel (it is over a half mile long) and I had the idea to capture the car weaving across the double-yellow line.

My desire to extend the possibilities of this type of image led to another shoot over a year later. Not only did I want to change my viewpoint for *Convergence*, but I also had the idea of the weave—to get tail lights weaving among headlights. Unfortunately, when I tried this by using a double exposure, and the headlights were just too bright. So much for that idea, although I could

have used a neutral density filter to darken them a bit. I chose to stick with the tail light theory. We also shot *Convergence* on the east end of the tunnel, which has a more natural rock interior rather than smooth walls.

The image ended up as a combination of two photos taken from the same vantage point but with the car starting from opposite sides of the camera. I wanted the lights of the car to weave down to converge with the double-yellow line, as opposed to crossing over it. I took a total of 14 images to find the two finalists to use.

Exposure is key, along with having a dark automobile. A lighter vehicle might work because of the motion, but it might show in places.

A long tunnel and one that has no traffic is essential. I still felt fairly vulnerable in the middle of the road, even though I could see and hear cars coming from a long way off. It doesn't matter if it is raining because you are in the tunnel.

Jerry Berry

I am a clinical pharmacist working in a hospital and have been very much involved in image making for almost 40 years.

I started with the RAW images in Photoshop Lightroom and made basic adjustments to get the most I could out of the dynamic range, adjusting exposure slightly along with brightness, contrast, and vibrance. The Crop tool was used in leveling the images. Once I obtained what I liked, I opened both images in CS3 to layer them.

I copied one image and pasted it to the other, which created a new layer. I then created a mask on the new layer and began to paint on that mask to combine the lights. During this process is when the idea of the weave of the lights became apparent.

I then saved what I created and imported it back into Lightroom so that I could use my Nik Silver Efex Pro plug-in. I opened the image in Silver Efex and made some adjustments in contrast, brightness, and structure. I also chose a fine-grain film type.

I chose to complete it in black and white so that I would not have to deal with the yellow lights and the color cast they give to the final image.

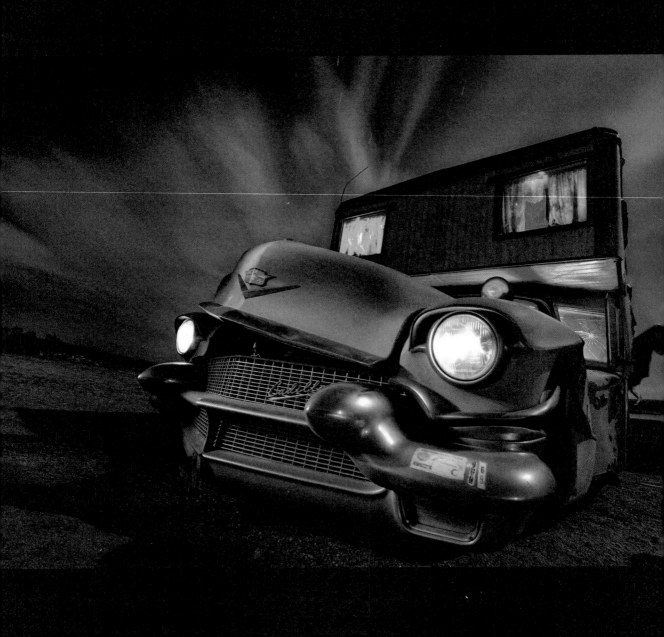

Nikon D700 • 14-24mm f/2.8 lens • f/10 • basic exposure 120 seconds • ISO 200 • RAW
Gitzo tripod with Really Right Stuff ball head • LED flashlight
Strobe with several different colors of Roscolux theatre lighting gels

Caddy Camper

I have long been interested in night photography. At age 11, it fascinated me to point my camera at the night sky and open the shutter for an hour or two and wait for the amazing star trails when I developed the film. With digital techniques the potential is virtually unlimited. I have studied the work of Troy Paiva (www.lostamerica.com) and Joe Reifer (www.joereifer.com), who emphasize shooting during the full moon and "light painting" with flashlights and strobes.

This shot is a composite of four exposures, each 2 minutes in length. A sturdy tripod is the most important piece of gear, because if there is any motion whatsoever in or between any of the frames, then the whole series is worthless. Also, I used a programmable self-timer with the interval between each exposure set to the minimum value, which is 1 second. If the interval is any longer than 1 second, then you will see gaps in the star trails because of the rotation of the earth. This approach does not allow you to "chimp" your LED screen and look at exposures between each one. You can determine basic exposure with high ISO test shots or by simply trying out a shot before you do your series.

For the first photo in the series, I make an exposure with no light painting. This is the background layer, which you use to adjust the light painting later with layer masks.

For the second exposure, I used an LED flashlight through a snoot to illuminate the headlights, and then the red light on the fender from behind, for a few seconds each. Finally, I used the flashlight to fill the shadows and provide the glow of light on the bumper.

For the third photo in the series, I put a pink gel on my strobe and fired it once down low in the cab of the truck. I wanted to emphasize the broken window and wash the underside of the camper with pink light.

For the fourth exposure, I used a green-gelled flashlight to light one of the camper windows and then a blue-gelled flashlight for the other. I wanted to emphasize the worn curtains. It is important when using a flashlight like this to keep the light in motion to avoid hotspots, to keep the light source out of direct view of the camera, and not to use the light for too long; otherwise, you will wash out all the detail in the window.

Once you have finished your series of exposures, you can review them on the LED screen, and if you need to, you can redo some of the light painting, but you will not be able to use these additional exposures to prolong your star trails or there will be a unsightly gap.

 David A. Evans

I like to take photographs as a creative outlet. During the day, I work as a surgeon (ear, nose, and throat). At night, I like to take photographs where I can try different things. You can see many more photos on my flickr page at www.davidaevans.com.

I placed the four exposures as layers in a Photoshop image and placed the image with no light painting as the bottom layer. I then highlight each image in sequence from the top and set layer blend mode to Lighten. This takes the lightest part from each image and adds it to the display. This step adds all your light painting to the image. If you want to eliminate some excess light, add a layer mask to that layer and paint out the light you do not want. You can also decrease the intensity of light painting by using this.

A sturdy tripod is the most important piece of equipment. Do not skimp on the tripod if you want to do night photography.

Try different techniques with light. It is usually best to light from an angle and not from the camera position. Lighting from an angle will show interesting shadows. Move the flashlight in a little rotation but not in big side to side motions because this will eliminate the shadows.

Shoot during the full moon. Once your eyes adjust, you can compose without much extra light. Do not wear a headlight. Turn down the intensity on your LED display.

For me, in portraiture, the story telling element is essential. It has to be open to different interpretations, making people look more carefully at a picture and coaxing them to create stories out of it. Best of all, I like it when viewers of a photo create their own stories. In my photography, I want to catch and captivate my viewers, bringing them into my world.

Creating a portrait does require preparation. For me, I tend to shoot no more often than once a month. This process requires setting out all my ideas onto a mood board, putting together the best team I can get, choosing a suitable location, and organizing the props. It is a time-consuming but rewarding process. Don't forget your make-up artist and stylist. They can bring such wonderful details into your work. I am convinced it is not the photographer alone who makes the picture; it's the entire team that's pushing the release button.

I noticed that working with a team creates a situation to work together in cooperation and with an open mind. Most of the time it leads to satisfactory results and a happy team.

Working in a studio offers the optimal control of light, props, and the best circumstances in which to work with my models. In Holland, rain is common, so being inside does create a more reliable environment. The lighting during my shoots is mainly two or three strobes, with a big softbox. I do keep my methods simple, because I am not interested in technology at all. Creativity is my focus. A major principle of mine is to concentrate on the ideas instead of the tools.

I notice that 95% of online photography discussions are about the tools. Mastery of the tools is merely a mechanical process. Anyone can learn to use the tools, and knowing the basics is important. But that doesn't guarantee that you will create a work with impact.

My ideal picture is in my mind long before my camera clicks, and seldom does the picture come out as it is in my mind. Producing an image with which you are totally satisfied won't happen often. There is always something that could have been better. Strangely enough, I realize more all the time that my favorite picture isn't usually the one the viewers seem to like most.

Photographic skills improve by trial and error. An important fact is feedback, ask your friends for fair criticism, especially on your new works.

One thing is most important of all: enjoy your photography!

–Peter Kemp

People

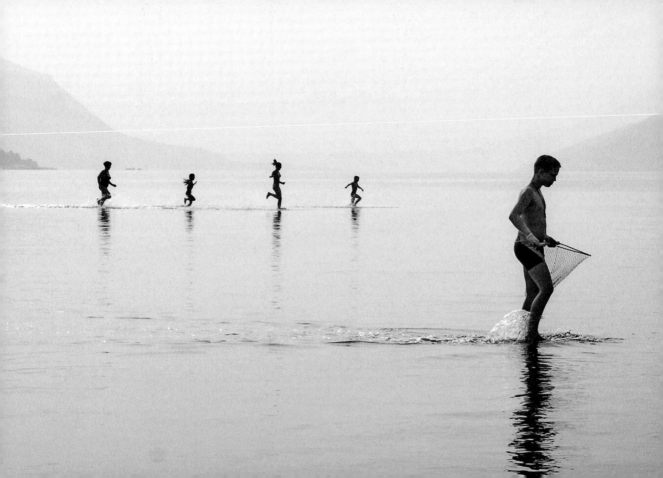

Life Is Beautiful

This photo was taken early in the morning in the beautiful sea door of Boka Kotorska (Adriatic Sea in Montenegro). This family ran merrily through the shallow water. They were constantly moving and I waited for them to come into a good position. Proper arrangement of figures in space gives the picture a perfect harmony. It was not at all difficult to come up with the name Life Is Beautiful.

With each and every photo, a photographer shouts, "see this!" And a viewer looking at it should say, "I have seen it." This photo carries a message that many of my photographs do: the body language of a human is a universal language that everyone understands. Looking at people moving we see different characters. Every silhouette does something different, because every one of them is on its own path of destiny. The task of photographers is to find a story in the expressions of a body, and the viewer can recognize himself and his destiny in that story.

You should always be close to your object. Take a look around, because you might see something more interesting. Try to see and record something that others do not see. When taking a picture of something that has been photographed many times before, find your own unique angle. Include some extra details around your subject; you can always crop the picture later. Story, composition, and inner expression are much more important than sharpness. I stick to the rules of Henri Cartier-Bresson: what reinforces the content of a photograph is the sense of rhythm—the relationship between shapes and values. In Photoshop, I only crop or clone away the disturbing parts of the photograph and emphasize the main subject by changing darker and lighter parts. My main rule: the passion that you have while taking a photo will be passed on to the ones looking at it later. It is all about the transfer of energy.

Dragan M. Babovic

I was born in Serbia in 1954 and work as a self-employed lawyer. I am an amateur photographer. Photography has been my favorite hobby for a very long time. My photos have been published far and wide and have won prizes in many photo contests. This particular photo was displayed on large billboards all over Belgrade as an advertisement for the Serbian photo magazine, *ReFoto*.

I shot the photo in JPEG format and then did post-processing in Photoshop CS5. I cloned away some disturbing elements, such as a boat, a little island, a head, and a fountain that was behind the legs of the other girl. I cropped the picture to focus attention on the people and make the image pure in expression.

Canon 5D Mark II • Canon EF 70-200mm lens f/2.8L USM lens • f/4 • 1/125 second • ISO 100

Katya

On a cloudy day in May, I saw this young and very beautiful girl walking down the street. As she was passing under an arch the sun was obscured by clouds, which filled the arch with soft and warm light. It was a tremendous moment.

We became acquainted, and I persuaded her to meet me the next day for some more shooting. I was so impressed by her and prepared myself mentally for how to pose Katya.

I wanted to shoot a portrait with natural illumination. Therefore, I did not prepare generators, flashes, or any other studio equipment. I only had the camera and my favorite lens, a Canon EF 70-200mm f/2.8L USM.

The next day, we met near the same arch. The weather was still cloudy, and the sun appeared only occasionally from behind the clouds. We needed to wait for the right moment. I understood that the opportunities for shooting would be short, so I had planned in advance. I had established ISO 100, a shutter speed of 1/125 second, a focal length between 100-200mm, and aperture between f/4 and f/8. Originally, I wanted to do a three quarter portrait and then crop it later.

We waited for the right moment and when the sun appeared for a few minutes; I set the aperture, corrected Katya's pose a bit, and took 10–20 shots before the sun was again hidden behind the clouds. Finally, it started to rain, but I was happy because we had time to get an excellent shot.

Doing the Katyusha portrait, I wanted to not only show her natural beauty, but also her private world. Her eyes are full of life: she is a strong, purposeful, proud young woman, but at the same time very child-like and vulnerable.

When you shoot on location, avoid the open sun. Find a place where the light is soft enough but still offers contrast. Do not immediately try to make an emotional shot with a model, especially if you work with her for the first time. But sometimes miracles happen. We practically did not know each other, but probably our biorhythms coincided. If the model is not skilled, you can instruct her a bit in advance; for example, how to stand with the hips to look more graceful, and so on. During shooting, correct her a little. And remember to praise and encourage.

Valeriy Kasmasov

I am Valeriy Kasmasov from Russia. I am 33 years old, and my passion is portrait, fashion, and advertising photography.

I corrected contrast, white balance and saturation in Nikon Capture One; all other post-processing was done in Photoshop CS4. By using Selective Color, I cleansed a red shade from the skin, and then I did some retouch with the healing brush. Then, I converted to black and white by using an adjustment layer with Hue/Saturation. Brightness was lifted with the adjustment layer levels. I made two more layers, one brighter and one darker, with adjustment layer Curves and corrected through a black mask. Finally, I added sharpness through the high-pass filter and cropped the image to get an eye in the golden section.

Canon 5D • Canon 28-70mm f/2.8 lens • f/10.0 • 1/160 second • ISO 100 • RAW

Butterfly

The idea developed after being inspired by a few internationally acknowledged dance photographers. I knew one ballet dancer who was prepared to model for me and found a white wedding dress that could work. The idea of the photo shoot was simply to get her to move around, combining classic dance poses with the dress flowing around her to create movement.

This is one shot, although I tried to make more of the dress in the picture. I think it worked better as a "stand-alone" shot.

I had the model move around before a white background, throwing the dress in different directions. To ensure that the background did not become too prominent, I had two studio lights directed down at it. Then, with the addition of one large fill and one long strip light on the model, I achieved the lighting effect I wanted. The tricky part was preserving the texture of the dress while still capturing the overall white feeling (see the lighting setup diagram).

Initially, I was satisfied with this image before post-processing, but once I had played around in Photoshop, experimenting with the color effects, my eyes popped out! I am not sure if I did something special. I ran it by some friends of mine, who confirmed that this image looked a lot stronger and had more impact than my original "white" version. I have no regrets now,

steering away from the pure white version, which in hindsight, I have seen so many times before. So, don't be afraid of experimenting in post-processing.

During the shoot, establish good rapport and precise communication with the model so that he or she knows exactly what you want. This also implies some pre-planning.

And always shoot RAW—this could never have been produced from a JPEG.

 John Andre Aasen

At the time this was shot, I had a full-time job as a photographer, but I am now a social youth worker by heart, and photography is for me a passion. I free up time as I can from my social work (and four kids) to experiment with different photographic projects.

The final shot was edited from RAW by using Nikon Capture One and then Photoshop.

To get the overall "white feeling," I used curves and masked out the dancer and her dress. I also removed some birth marks and the strap of her dress, which was swung across her back.

To do the editing, I first duplicated the layer, masked and blurred it (Gaussian Blur at approximately 16), and then applied a reflected gradient to the background to give it a little more impact. I then duplicated this layer, and with white as the color, used the reflected gradient tool again but this time with the opacity of around 30%. Later, I reduced the opacity of the blurred layer and added the light and bi-color effects, using a combination of purple and orange.

To avoid the gray areas in her dress, I had to lighten a few areas so that I maintained the overall fabric effect. I then added some contrast to her back to enhance her muscles, ensuring that the blending mode was set to Luminosity (to avoid over saturation).

Her body was at this point yellow/orange, so some color adjustments and reduction in saturation were needed. Finally, I sharpened her back a little, by using the Unsharp Mask.

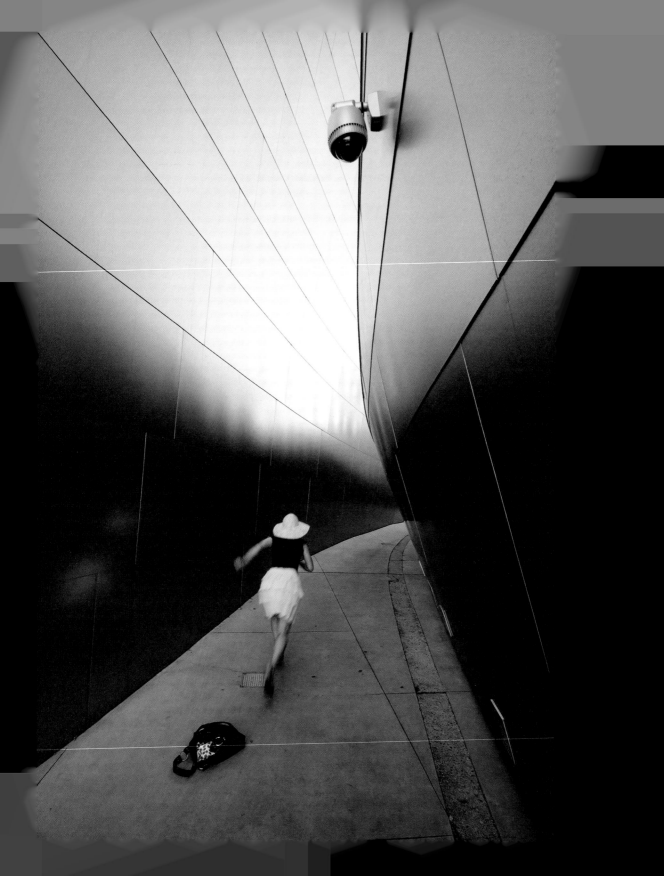

On the Lam

This shot was several months in the making. I found this walkway on the second or third level of Disney Hall and took a picture of it, but it was clear that it was just a backdrop for some kind of a story. Over the next few months, I considered various ideas until I arrived at this setup.

Pretty much everything about this photo was planned out in advance: when to take the shot to avoid direct light on the shiny metal, what my model, Esther, should wear, which bags to bring (especially the red and white one that sticks out of the brown one), what shoes to wear, what action should take place, where things should be in the frame, and so on. The objective was to produce what I call a "one-frame movie," that is to say, a photograph that invites the viewer to fill in the story line by imagining what lead up to this moment and what happens after.

I keep things as simple as possible. This is a minimally cropped, hand-held shot that was taken with a polarizer filter to control the brightness of the metal surfaces. No flash.

For this shot, it took only three or four attempts to get Esther into the right place and the intended pose, but getting the timing of everything to work out is often the hardest part. The composition is very simple. The story required the surveillance camera, the bag, and Esther moving into the direction of the natural eye movement. It was simply a matter of configuring these items to balance out the shot.

The intent was to make the viewer invent a story around the scene shown in the picture. To that end, I tried to keep it simple and accessible so that the viewer can get lost in his or her imagination, rather than the details of the image. Judging from the reaction at shows and exhibitions, this seems to have worked. People generally look at the photo for a moment and then start talking about the stories that it suggests to them.

For this type of posed, ambient light photography, it is essential to scout locations well ahead of time. Make sure that you know when the light is right for your project, that the site is accessible at that time of the day, try to take a few test shots while you scout. Think carefully about what your model should wear. Consider colors in relation to your background; consider styles in relation to you story. Have a backup plan in case something goes awry so that you don't waste everyone's time.

Martin Gremm

I am a photographer living in the United States. More information about me as well as a more complete portfolio is available at http://photography. martingremm.com

I always shoot RAW and edit at 16-bit depth in CS3. My goal for these one-frame movies is to produce images that do not look overly processed but focus on the story. However, this one seemed to require fairly extensive Photoshop work. Here are the basics for this image:

1) Remove dust spots and similar small distractions.

2) Sharpen.

3) Multiply the image with itself (here, done separately for Esther and the rest of the image with different opacities and parameters, necessary masks painted on by hand to ensure organic boundaries).

4) Curves.

5) Color correction.

6) Dodging and burning to emphasize the story and direct the attention. It is especially important to darken bright but unimportant objects. Also, I paint the dodge and burn layers with a 1% opacity brush. It takes forever to do, but building up the dodge and burn layers slowly helps to avoid that ugly "Photoshopped" look that often results from careless use of these tools.

7) Vignette via contrast and brightness adjustments to accomplish the purpose without leaving very visible traces.

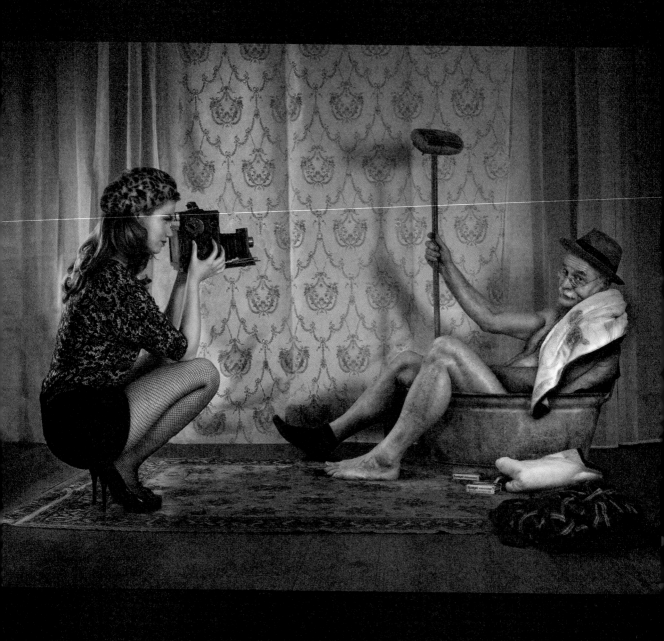

Nikon D2X • Sigma 28–70mm lens • f/9 • 1/125 second • ISO 100

Nude Photography

This photo was made for a cover of a photo magazine. What makes it unique is the reversal of the traditional roles of photographer and model. Using the old-fashioned camera—a genuine Graflex, Inc., USA, 1919—gave my picture some extra cachet. The genuine old soap, the scrubbing-brush, and the great look of my nude model should put a smile on the face of the viewers.

My models, Raffaella and RudoX, were made even more beautiful by the make-up artist, Jetty van Pelt. All the props were collected by me and my models, using our imagination and all kinds of different sources.

This picture is part of a series of three pictures called *Nude Photography*. Two flashes were used. One softbox was placed as close as possible to the male model, to create a kind of old-fashioned, yellowish light. On the other side, a flash with umbrella was positioned right behind Raffaella to create the light that caused her hair and back to glow and fill in dark spaces.

My first intention was to change the normal roles between "Mr. Photographer" (who seems to be in charge most of the times) and the good-looking, posing model. So my "model" is taking the picture instead of the photographer. Second, I wanted to make a statement against all the rough, sexually-orientated photos that are found everywhere on the Internet today. That is why my photo is called *Nude Photography*. My aim to create story telling pictures will hopefully let the viewer stop by and look a little longer to find the hidden message in this photo. From all the reactions I received by this picture, I guess I made myself clear.

When you create a picture such as this one, do it together with a team and with a smile. It is a team effort. Use and take advantage of the qualities in your team, and do not forget that creating pictures is fun. We really had a great time and laughed a lot while creating these "silly" scenes.

Peter Kemp

I am a freelance photographer from Holland, and I like to make storytelling pictures in a vintage atmosphere. I try to create some mystery and fun with my pictures. My work can be seen at www.peterkemp.nl.

I did the post-processing with Adobe Bridge and Adobe Photosohop CS4. I used a Wacom Intuous 3 tablet for adding some dodge and burn to emphasize the skin tones and details in clothing. No cropping was done, because this was the picture I had in mind, and it came out in the right composition. This was possible because everybody knew beforehand what I wanted to do. I use mood boards, which I send to my models and make-up artist a week before the actual photo shoot takes place. So, everybody knew exactly what we were going to do.

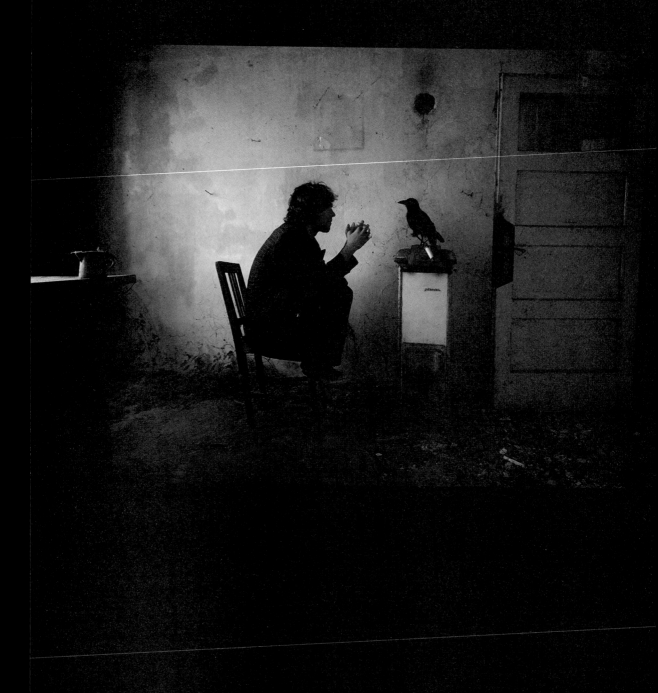

Canon EOS 450D • SIGMA 10-20mm f/4-5.6 EX DC HSM lens @ 12mm • f/5 • 1/20 second • ISO 400

The Raven

What better place to capture the atmosphere of Edgar Allan Poe or some twisted David Lynch movie than an old abandoned house with torn curtains on the windows, empty wine bottles on the floor, old religious paintings hung on the walls, and an obsolete table in the middle of the room?

For some time now, I have been trying to find a whole new concept for my photography. I wanted something slightly different and somewhat darker and atmospheric. The idea was to capture an incredibly dark atmosphere with as little Photoshop editing as possible. It was always a challenge for me to make a great, atmospheric photo with virtually no editing, because I believe Photoshop is not almighty. Sometimes the skill of making a good photo is not in the editing but in capturing the very spirit of the subject, which cannot be added *post facto* with any kind of editing.

Inspired by various books and films (one of which is *The Raven* by Edgar Allan Poe), I started to drive around in town and the nearby villages after work, searching for the perfect location for the shoot. At first, I was thinking of old factories, the woods, some remote wells, or a cornfield. Then, I came across a group of old, abandoned houses, just standing there by the road.

I managed to get a hold of a toy raven, much looked authentic enough, and with a little help from my nephew, we headed out to one of the old houses to re-create a dialogue between the raven and Poe. We spent some time waiting for the sun to set to get to softest possible light. It was all perfect, without even the slightest help from Mr. Photoshop.

Unfortunately, editing is always required with digital photography. I think that the reason I do not like post-processing is that I have worked with negatives my entire life, and when you work "the analog way," there is not much you can do in post-processing. It all depends on how well you performed that very minute when the photographs were taken. That is why the outcome satisfies me even more.

I must also thank my nephew for helping me make this photo (he is the model) and also giving me a hand with putting this tutorial together.

Inspiration is the key. I try to get inspiration everywhere: books, movies, and most importantly, music. It is hard for me to give hints to other photographers, because everyone has a unique style and their own ways of approaching photography. I think everyone should work the way they like, and pay no attention to other people's hints, suggestions, and critiques. In the end, if the photographer is not satisfied with the photo, it's unlikely that anybody else who sees it will be, either.

 Mario Grobenski

I was born in 1967. In Croatia, I dedicated my entire life to listening to music and making photographs. That is why I somehow always try to combine the two. For many years, I worked with my trusty-old Minolta, developing my own black-and-white films at home.

I processed the picture using Photoscape, but I tried to keep it as simple as possible, making only the minimum required changes. First, I darkened the photo by using the graduated tint feature. The photo itself was quite dark, but I wanted to darken the edges of the photo to give emphasis to the wall (which provided great color and texture) and, that way, emphasize the model and the raven.

Second, to enhance the colors, I added the provia low film effect. Because the picture was previously darkened a bit, I felt that a little color enhancing was necessary, to retrieve what was lost in the darkening.

That is all the editing I did in Photoscape.

In Photoshop, I played around with curves to see how dark (light) the photo should be. The edges had been previously darkened, but this adjustment was for the photo in general and not just the particular parts of it.

The last stage of the editing was to sharpen the photo just a bit, and then it was ready for uploading.

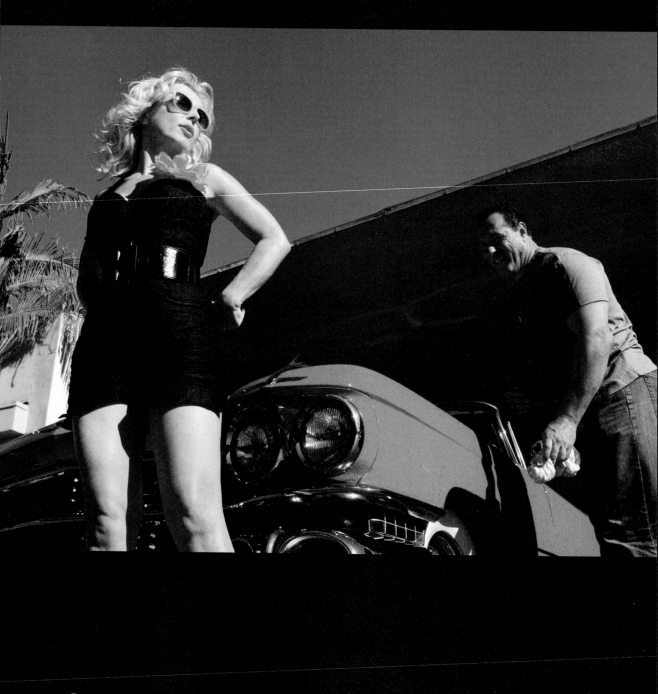

Nikon D90 • Nikkor 20mm f/2.8D AF lens • f/5.6 • 1/1000 second • ISO 200

Emma and Chris

I am a member of a website called weeklyshot.org. The idea is that there are weekly themes or "assignments." The theme for this particular week was "Ground Level."

The brief was: "Alright, it is time for everyone to get down and dirty. Let's see a bug's-eye view of the world."

I had the idea to go to a weekly gathering of classic cars held at a Bob's Big Boy restaurant, just up the street from where I work. At different times in the past, I had been there and done some low-angle shots of the shiny grills and bumpers of cars. But I needed to get down to ground level, so I needed a technique that did not have me laying on ground in a busy restaurant parking lot, crowded with folks and loud, powerful cars.

The real challenge was to get really low. I repurposed a trick we sometimes use when shooting video. I mounted the Nikon D90 on my monopod and attached the wired remote cable. I then opened up the monopod to about 3 feet total length and held it upside-down by its foot. I wound the remote cable around the monopod so that the firing button was at the "top" of the inverted rig.

I then walked around using the toe of my shoe as a pseudo ball head. I aimed the camera by adjusting the top of the inverted monopod. I tried to imagine the composition by visualizing an extension of the camera/lens angle to my subject. I then fired off a couple of quick shots with the remote button and quickly turned the rig upright to review the shots. It's a very trial and error approach, I know, but it was fun, nonetheless! I think this shot came out very nice. I was quite happy, particularly considering the chaotic nature of how I shot it, and that I wasn't able to see the viewfinder or the LCD as I was actually shooting.

What did I want to say with this shot? One word: "*Hollywood!*" It's a fun shot of two fun people and a great car.

The viewers were also apparently quite happy, as well. The shot earned a gold star and a front page feature on weeklyshot.org, and it was published on 1x.com. For my humble little hobby, that's quite a coup!

 Clyde Beamer

I have been shooting photographs since I was young. My parents always had a camera and used it a lot. My enduring interest has been sappy sunsets and landscapes, ever since I spent nearly six months on the road in the late 70s, and then subsequently three years living in Lake Tahoe, CA.

There is virtually no processing here—well, other than rotating the upside down shot 180 degrees, of course. I shoot RAW and convert through Photoshop Lightroom. I did adjust the crop slightly and used a pretty basic LR import profile that I saved for the D90. A lot of comments about this shot indicated that folks thought I had exaggerated the saturation. In fact, the car is *very* red and the sky was *very* blue that evening. I really do not remember pumping the saturation at all.

STILL-LIFE is another special direction in photography. Still-life can often be seen in commercial photography for advertising purposes with a specific concept behind it, but it is also seen as artistic compositions of different elements. The objects in a still-life photograph are inanimate/static, and the set can vary from small tabletop arrangements to setups of much bigger subjects.

The most important aspects in still-life photography are idea, concept, arrangement, and the lighting setup. Here, the photographer can demonstrate his skills in composing and arranging the subjects to a "speaking" image as well as his technical skills for creating a well-lit, sharp, clean, and clear image.

To receive an appealing result, the arrangement should be placed on a clean surface and in front of a calm and homogenous background that guides the viewer's attention to the objects. The color and brightness of background and surface depends mainly on the subject's colors and brightness.

Natural light can be used for lighting, and some photographers prefer a "one-light" setting, but often more than one artificial studio light source is used. Mastering the basics of lighting techniques with different types of light sources is very helpful to prevent unwanted effects, such as reflections, hard shadows, or imbalance in brightness and color hues. Proper lighting is very important to give the image the correct expression and the impact that the photographer wants to achieve. To manage this well can be quite skillful.

It depends on the creativity of the photographer to enhance the impact of the image by using specific additional devices such as customized or color adapted backgrounds or surfaces, mirrors, fabrics, and many more.

Still-life photography is sometimes reminiscent of the Old Master's paintings, particularly if the arrangements are composed of, for example, flowers or fruits. But still-life can also show surprising ideas, reflecting creativity together with modern technical possibilities.

The following examples will show you the beauty and the imagination of these creative works of art.

–Klaus-Peter Kubik

Still Life

Canon EOS 40D • Canon EF-S10-22mm f/3.5-4.5 USM lens @ 22mm • f/8.0 • 1/250 second • ISO 100 • RAW
Canon Speedlite 430EX flash • tripod

Sugar...?

I had the idea for this picture while browsing through an online gallery, in which I saw a photo of sugar being sprinkled over a strawberry. I just wanted to create an image with a darker and more monochrome look than that one; thus, the idea of pouring sugar into a white coffee cup in front of a black background. My setup—consisting of my dining table and black cloth for the background—was arranged in a few minutes, and I was ready to go.

The picture is a composite of three images. In the first one, I concentrated on the cup itself, for which I tried several different lighting configurations, using off-camera flash with an OC-E3 cable. The interesting light in the final picture was achieved by holding the flash upside down behind the cup, flashing directly into the saucer.

The second picture needed to show the sugar pouring into the cup. I wanted the crystals to be sharp, so I used the flash to freeze them and placed it on the table at the bottom right, behind the cup (outside the picture). After some attempts, the sugar was nicely lit from behind, and my hand with the spoon was also visible. This was not an easy task, because I had to focus the camera manually to where I was going to pour the sugar later when taking the shot.

Then I had the idea of a little steam rising out of the cup. This was tricky to do idea, because not one single shot out of many tries using hot water yielded a satisfying result. The steam was simply not visible in any of the pictures.

Later, while browsing on my computer, I stumbled upon a few pictures from an earlier session that included smoke from matches. I decided to use the smoke from one of those pictures as a replacement for actual steam.

Some advice I can give is to first make a plan or a concept before shooting. You should have the image you want to create in mind instead of taking hundreds of useless pictures. Then, be patient. Do not give up if something doesn't work as expected. Many great pictures took a lot of time (and nerves) to come to fruition. Also, try several different variations in your setup, and always have fun with what you are doing!

Pascal Müller

I am 36 years old and live in Bochum, Germany. I was always interested in photography, but I never really got into it until I bought my first dSLR (Canon EOS 40D) in 2008. Since then, I have read a lot to learn more and more about photography and image editing.

The post processing was done in Photoshop CS5. First, small adjustments for exposure, contrast, and noise reduction were made in Adobe Camera RAW. In Photoshop, I used the cup image with the interesting light as the background layer. The second layer was that of the pouring sugar. I masked out the cup with the unspectacular lighting so that only the sugar and the hand with the spoon are visible. The layer mask also hid the flash, which was originally visible above the cup in the background layer. On top, I inserted a black layer with 70% opacity and a layer mask in Multiply mode to darken parts of the image a bit (hand, parts of the table, and background). Then, I added the smoke/steam layer above the other three layers, applied a free transformation to fit it in, and duplicated it. I used the Gaussian Blur filter to soften one of these two layers because the smoke looked a bit too sharp. Both layers were set to negative multiply and 35–40% opacity.

Finally, I inserted a black-and-white adjustment layer with 80% opacity and a layer mask for the hand to give the image a more monochrome look, without making the hand black and white.

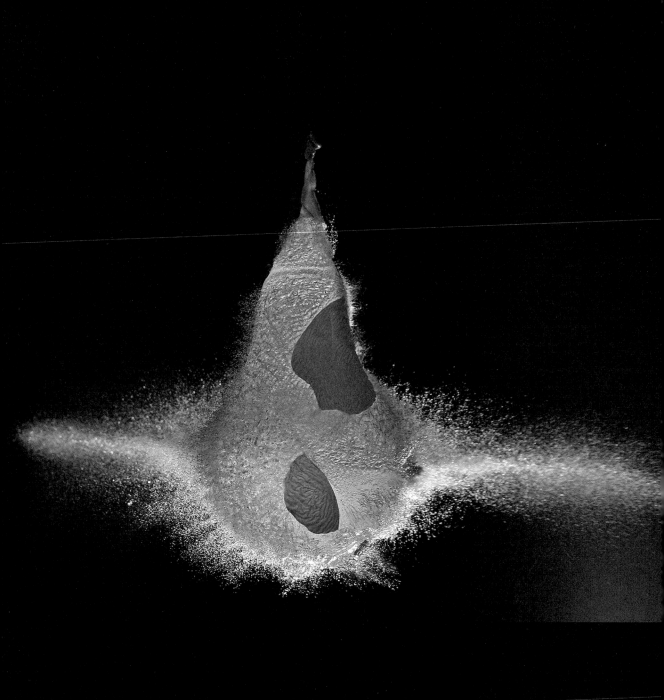

Canon 300D • 75mm lens • f/4.5 • Bulb mode • ISO 200
Flash Sigma 500DG super

Water Balloon

I was experimenting with high-speed photography, shooting different objects with an air rifle. During a discussion on a Dutch photo forum, the water balloon idea came up.

The photo was made in my garden, in the dark. The whole scene was carefully set up and timed. To trigger the release, I used a light gate mounted at the end of the barrel of my gun.

When the exiting bullet breaks the light beam, a pre-programmed delay unit is triggered, which fires the flash. The camera's shutter was open for five seconds until the event occurred. The only light registered by the camera is the light of the flash.

To calibrate the entire setup, I first shot a piece of paper. This allowed me to determine if the flash fired too soon (paper intact) or too late (paper punctured). After a couple of shots, the delay was so precise that the bullet just punctured the paper as the flash fired. Next, the paper was replaced by the balloon.

One flash was behind the balloon for backlighting, which was directly triggered by the delay unit. This was intended to make the water shine, enhancing the spectacular effect. Another flash (a slave unit) was positioned in front to illuminate the balloon itself. This secondary flash was set to a lower intensity than the backlight flash. The flash was set to 1/64, which is approximately 1/10,000 of a second.

For high-speed photography, control is everything. If you have several events to orchestrate that all must occur at the same time, there can be no room for luck in your timing; you will never achieve what you want if you are not in full control. Electronic timing is a must.

Another hint is to use backlighting for transparent objects such as glass or liquids.

 Lex Augusteijn

I am an electrical engineer and computer scientist by education. My technical background has helped me in both firmware hacking as well as in my high-speed photography. It has also been helpful with other work such as polarized light shots of crystals, which you can see by visiting my website www.lex-augusteijn.nl.

Post processing was limited to some cropping, levels, and noise reduction in Photoshop.

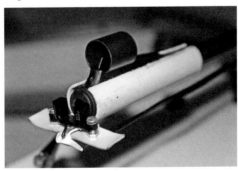

The light gate mounted to the front of an air gun.

I made the timer myself, based on a circuit from www.hiviz.com.

Olympus E-330 • Sigma 150mm macro lens • f/22 • 5 seconds • ISO 100

Cut

For a long time, I had in mind to create a still-life picture with mirrored color pencils but did not have the necessary equipment to do it in an appropriate way. Eventually, I gathered everything I needed—gear and material—and decided to give it a try.

I needed a certain amount of time to learn about different technical requirements for a still-life shot. Looking at other images and asking/reading about how specific effects can be realized was part of that process.

I had in mind to place some pencils in an appealing setting on a mirroring surface but realized that a simple glass panel or a mirror would not be the right material. I wanted to have a black background and surface, but I also needed a perfect reflection. A glass plate or a mirror can cause unwanted double reflections and wouldn't serve as a dark background. So, I ordered a black acrylic glass plate for the mirror surface. The plate was placed in an opening of a cubicle with black wooden sides, surface, and background so that the setting was completely covered in a black box. Only the front side was open.

I wanted the pencils to be of different lengths. While sharpening them down to size, I noticed how appealing the thin wood shavings looked, so I decided to place them beside the pencils in reverse color order. I did the same with the powder from the pencils' colored cores, placing each in small piles on the plate in front of their corresponding shavings. This was quite difficult to do; you need a steady hand to stand the pencils standing upright and not create a mess with the powder and shavings. I remember it took a while to achieve a satisfying look.

This is a single shot, but I took a series of more than 20 shots with different camera and light settings.

One of the light sources was a 1000 W halogen spotlight that was pointed at the ceiling in the white room. The other light (75 W daylight lamps at 6400 K) pointed from a bit aside, directly to the pencil setting. The second light source had a softbox to diffuse it and to prevent reflections.

I hoped that the viewers would be excited by this unique setting, which as far as I know has never been seen before in this way. When the image was made public, it received a lot of praise and won third prize in a photo contest.

Klaus Peter Kubik

I have been interested in photography since the late 70s. But, digital photography together with the possibilities of computer-based post-processing made photography a kind of passion for me.

I did the final processing in Paint Shop Pro.

I cropped the image a bit. The black of the background was adapted to the black of the surface. I had to do a lot of work eliminating dust particles from the black mirror surface by using the Clone tool. A bit of sharpening was also done.

Canon 50D • Canon 50mm f/1.4 lens • f/5 • 1/200 second • ISO 800

Playing Chess

The inspiration for creating this image was my father, who was a very good chess player.

I had the complete setting in my mind for several weeks, but I could not find chess pieces in the small size that I needed for the shot. No shop sold anything like it. Fortunately, I was actually able to borrow them from someone.

The complete setting was put together on a couch. For the background, I used a white cloth to cover the back of the couch. A little table was already present. I also used two lamps, one in the front and one on the left side of the setting. Additional daylight came from behind. The light is very important. I do not have sunlight in my house and can only take photos when the light outside is very bright.

Sometimes, I use a large reflector, which I place on a chair behind me.

I did not use a tripod, because rats move all the time, and it was just more practical to shoot by hand. Because of that, I had to use a high ISO (800).

Finally, I put some marmalade on two of the black chess pieces (one for each rat). Then, I let the rats free on either side of the table. They went to the chess pieces at the same time—and of course, within a few seconds, the table and chess pieces tumbled down, and the whole setting was completely messed up. I had to be very fast! This happened several times, so I had to start over, again and again. I cannot remember how many times I had to rearrange the complete set to manage at least one good photo.

I like a little humor in life. There is already so much tragedy in the world, and I hope that I can bring a smile to people with my photos.

Things to think about: work with a subject that you really like, then the photo will naturally turn out well.

Prepare your camera settings before you take the photo.

I am a more creative than technical person, but it is important to know a bit about the technical aspects of photography. That is why I read a lot about the subject.

Ellen van Deelen

I live in the Netherlands, and photography is my greatest hobby, besides music, painting, and drawing.

From time to time, I earn some money from my photos and recently had an offer to publish a book.

This is just a single shot, not a double or multiple layer combination. Photoshop CS3 was used for some sharpening, a bit of level adjustment, and some cropping. No further adjustments were necessary.

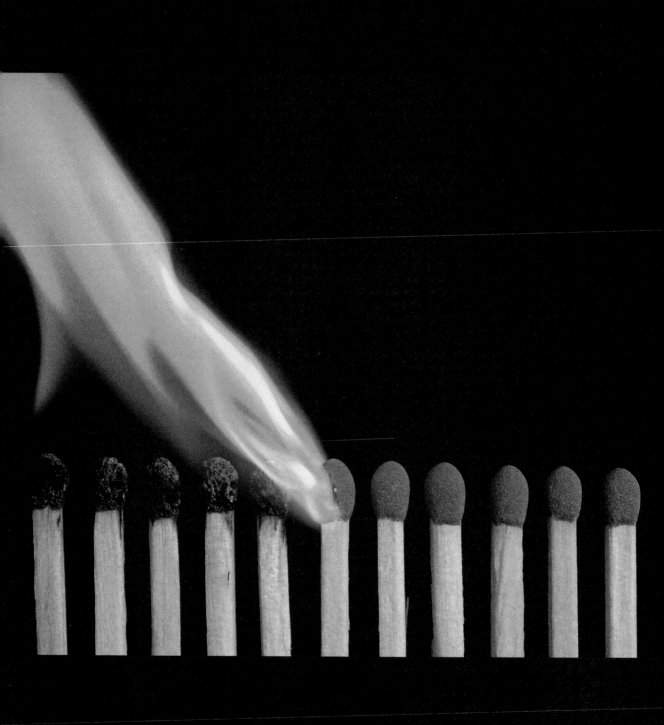

Canon XTi • Canon 50mm EF Lens f/1.8 • f/16 • 1/160 second • ISO 100 • RAW
Bowen strobe light and a wireless remote trigger

Burning

I had been looking at a number of photos of creatively captured burning matches. Many of these were macros of igniting match heads. Some focused on the smoke that the flame made. This inspired me to try some burning match ideas of my own. I was interested in capturing fire as it burned its way across matches, the proximity of each one to the next causing them to ignite.

This photo was taken on a coffee table with a black background and a strobe light positioned to the right side, about 3 feet (90 cm) away, at approximately 45 degrees. The camera was set on a tripod and centered directly in front of the matches. The black background was approximately 18 inches (46 cm) behind the matches. I selected a bit more distance so that the matches and the strobe would not cast much light on the background. This is also the main reason for arranging the strobe at an angle to the matches. I set the camera on manual at 1/160 second at f/16 and ISO 100.

The reason I set the aperture this small was because of my inability to lower the power of my strobe any further. (A neutral density filter could also be used.) Ideally, a Speedlite with a very low power should be used.

The matches were carefully arranged, one facing up and one facing down, in rows of 11 in each direction. Tape held them in place in the middle. By arranging the matches in opposing directions, I was able to maintain an equal gap of one matchstick width. For the actual shot, the matches were held vertical with a binder clip.

The matches were lit from the left side and allowed to burn across. Many photos were taken during the burning process. After a row burned all the way across, I extinguished the matches and remounted the setup upside down to expose the other side.

I did about 20 attempts before getting some that I was satisfied to process.

This image represents my final selection from among several contenders. I chose it because I liked the diagonal shape of the fire and felt the half-burned match in the middle was attention grabbing.

Earl Jones

I have had an interest in photography since I got my first SLR camera at age 12. I started shooting for my high school yearbook as well as a local equestrian organization. After high school, I drifted away from photography for a while because I did not really enjoy the photo printing process. It wasn't until digital cameras came about that I started back into photography in a serious way.

I acquired my first dSLR in 2007, and photography has once again become a passion. The flexibility of being able to shoot digitally encouraged me to experiment more. I enjoy many types of photography, including landscape, portrait, architecture, street, and night. I have a special interest in fine art, macro, still-life, and conceptual motifs.

I performed post-processing in Photoshop CS2. First, I selected the shots that were most interesting. I decided to crop the image for composition. I did sharpening, contrast/brightness adjustment, and finally, level adjustments. In the pre-processed images there was more evidence of smoke. I found this a bit distracting. The level adjustment gave it a cleaner look.

STREET photography is the graphic documentation and collection of unique moments from the urban world around us. The moment and the actors who interact in the scene will never repeat. In landscape photography, for example, much of the scene is static and only the light and weather conditions change significantly. In street photography, the weather conditions and light are variables too, but by far the biggest variable is the ever-changing actors and props in the scene. The actors come and go and interact with their surroundings in different ways, adding dynamism to the picture. The uniqueness of the final picture is not only determined by the situation itself, but also how you as photographer interact with the scene; literally, how you see the unfolding situation. The photographer is also an actor in the scene. You need to get in close.

Whenever you go out in the street, there are opportunities for making pictures. The biggest obstacle to doing this is a big, bulky camera and an array of different lenses. Carrying too much gear is not a good idea. Bring only a single body with a fixed-focal lens or perhaps a moderate zoom, and leave everything else at home. My favorite lens for street photo gives me an effective focal length of 24mm to 120mm. Many of the true masterpieces in street photography are shot with range finder-type cameras with a single lens, say 35mm to 50mm effective focal length. If you restrict yourself to a minimum of gear, you will concentrate far more on the scenes as they unfold around you. Changing lenses all the time will take your eye of the ball, and you will miss many opportunities, so travel light.

People who are good "social commentators" or good storytellers, usually make good street photographers. The picture needs to be a little story by itself, without the need for a lot of additional explanations. Perhaps the title can add some spice to it, but the picture needs to fully stand on its own. The picture becomes a little graphic social commentary, a little graphic essay, as seen through the eyes of the photographer. The picture itself needs to capture and bind the viewers so that they stay and linger and start to interact with it, emotionally. The viewer must not only see the picture, but also feel the picture. Henri Cartier-Bresson spoke about the importance of the "decisive moment" in this style of photography. The same scene, shot too soon or too late, will miss the decisive moment. The decisive moment is that moment in time that gives the viewer the maximum "wow factor" when viewing the picture. The photographer herself needs to interact emotionally with the scene if she hopes to evoke the same feeling in others when they view the picture. Thus, be sure that you are emotionally connected to the subject matter and shoot on feeling rather than lots of logical analysis; the picture is captured in a fleeting moment.

The best part of shooting street is the constant potential to be surprised—it will continually re-energize your photography. Also, you will meet lots of friendly people along the way. Remember the line from the movie *Forrest Gump*, "Life's like a box of chocolates; you never know what you're gonna get"? Well, street photography is a little similar. Just go out and do it.

–Colmar Wocke

Street

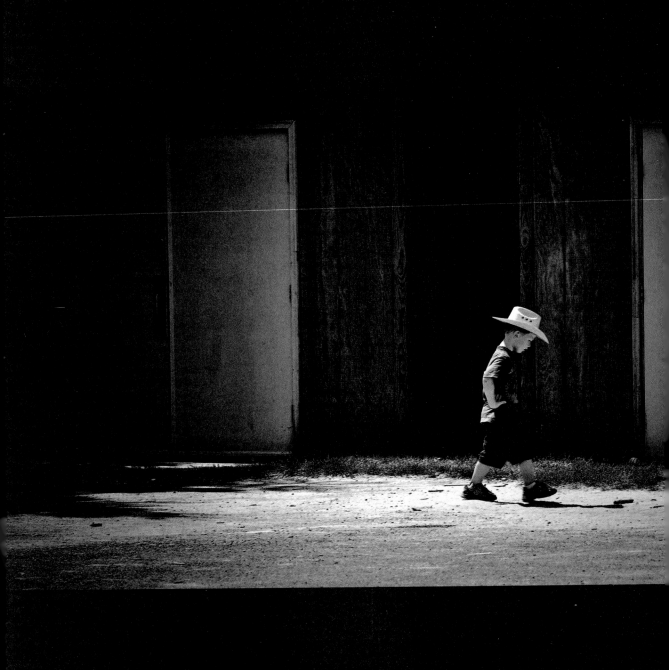

Nikon D700 • 80-200mm f/2.8 lens • f/5.6 • 1/1250 second • ISO 200

The Little Man

This was taken at a little league baseball game, the young boy here was walking in front of two utility sheds. The title was apt for the image, I thought. It could also have been, "When men become boys" or "The Sheriff." In the end, simplicity won.

Earlier on, the seeds of the context were there, although not clear. A static pose could have worked, but I wanted to catch him at the right moment, doing something else, set against the background of the wooden shed. I had been shooting other subjects just minutes before that, so I knew that my exposure, shutter, and metering was just right. It started with the cowboy hat, then the personality of the boy as he walked, then the hand movement as he was stepping while looking at his feet; these were the decisive moments. In the literal sense, all boys will become men, whereas some men will remain boys.

As a result, I believe I was able to convey the theme throughout the composition and the post-processing work. The black-and-white conversion is what completed the image. The contrasts in the dark and bright areas preserve the details. Those same details can either detract or enhance the story; the goal is always to enhance the story.

Some general advice: use Photoshop Lightroom (or equivalent) for file management and backup purposes as well as quick previews of what images can look like depending on choice of post-processing techniques. Create a solid workflow, an organized way of importing digital images from the source media into filing/database software, then into editing software, and then for export.

When taking street shots, take the time to look around, talk to people, and find places and spaces less ventured. Surprise yourself.

Francis Marquez

I am originally from the Philippines, now permanently residing in New Jersey, USA. Photography came later in life, upon the birth of my children. It began with my father, he is the artist from which this started.

The image was shot RAW and then imported and renamed in Photoshop Lightroom, where I checked the alignment, applied camera profile, adjusted lens corrections, and checked the overall exposure levels.

In Photoshop CS5, I made a copy of the first layer. Then I applied a high-pass sharpening filter and changed the blending mode to Soft Light. Sharpening value was set to 2 pixels. From the same sharpening layer, I made two copies named Copy 1 and Copy 2. I desaturated Copy 2 and changed the blending mode to Soft Light. This allowed for a stronger contrast while the image was still in color. Once satisfied, I then merged all the layers and desaturated the entire image by using Hue/Saturation. The original did not have many color shifts, so taking the Saturation level all the way to zero was a safe setting.

I then created a layer filled with gray and selectively toggled between dodging and burning. I really wanted the texture of the wood to show through as well as shadows in most of the picture. The last layer using Levels was applied to deepen the dark levels and boost lighter areas for an overall change. I merged all the layers and applied a final sharpening during the file export.

Nikon D700 • Sigma 150-500mm f/5-6.3 APO DG OS HSM lens @ 350mm • f/6 • 1/800 second • ISO 1250

Curiosity

This photo was taken in Bogor, a city in West Java province in Indonesia. During my last trip to that city, I saw this elderly man who was curiously peeking through a mosque window where some construction work was going on.

Lately, I have been studying portrait and human-interest photography. For me, these genres of photography can tell much about the life and soul of a person. When I saw this man, I decided to enter the mosque to get a portrait of him from inside the building. Fortunately, he was kind enough to let me take his picture. Afterward, I had a short conversation with him.

By the time I started looking through the viewfinder, I was amazed by the natural light on the old man's face, and even more so with the emotion and the character in his eyes. For me, it was a great experience.

It was a cloudy and gloomy afternoon, so lack of sunlight was the main problem for this shot. I quickly changed the ISO setting to 1250 to compensate for the lack of natural light. I was not afraid of the noise that can result from a high ISO because I know that the Nikon D700 has very good noise reduction capability. In fact, even if the noise was a bit much, it would add drama because I knew that I would turn the shot into black and white.

As the result, I believe that I got a good portrait of this man. The black-and-white conversion added more character to the portrait itself.

My advice for pictures such as these: always bring your camera whenever you go on a trip, because a good moment can appear anywhere and at anytime.

To make a good portrait, I believe that even a short conversation with the person whom you want to photograph helps you to get a better shot because the person will feel more comfortable with you and your camera. Maybe in some cases, like mine, you can shoot first so that you don't lose the moment and then start the conversation later.

Evan Pratama Ludirdja

I am from Jakarta, Indonesia. I started photography about two years ago, when I bought my first dSLR for documenting pictures of my holiday in Europe.

For me, photography is a way to express my passion. It is a simple and effective "getaway" from the boring and hectic everyday life. I love every genre of photography. Each genre has its own uniqueness and difficulties.

I used Nikon ViewNX software to convert this RAW image into a JPEG. Before converting the image, I increased the sharpness a little bit. I used Nik Silver Efex Pro in Photoshop CS3 to convert the image into black and white. I slightly raised the texture panel in the Silver Efex Pro a little bit to show a more detailed portrait of the old man. Finally, I did some cropping.

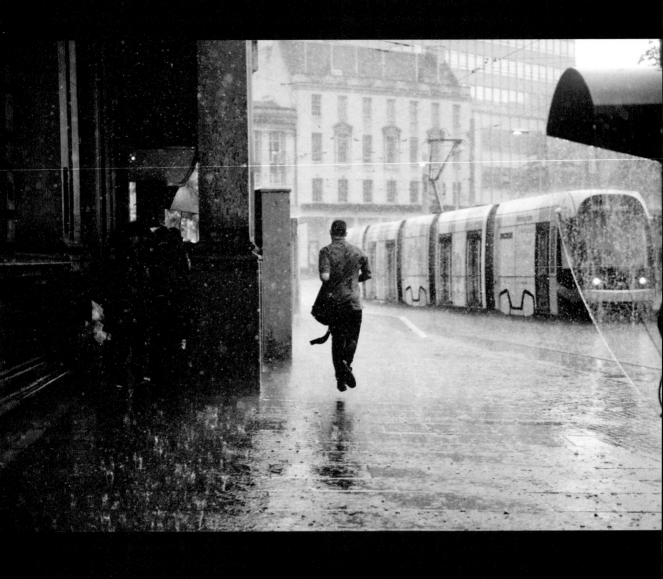

Nikon D700 • Nikkor 24-70mm @ 70mm lens • f/2.8 • 1/1000 second • ISO 2200 • RAW

Run for Cover

I live near the city center and had seen huge thunderclouds forming. Anticipating stunning light, I rushed into town intending to shoot architecture on a tripod, possibly some long exposure images. The light never really got going. Instead, it started pouring within a few minutes, raining as hard as anything I can recall in the UK.

I had been thinking of shooting this sort of image for some time, so I changed approach. I had a 24-70mm lens fitted and was trying to shelter it under a flimsy umbrella. I used this to keep the camera just about dry and walked through the busy city center, looking for candid shots of shoppers and office workers running for shelter.

This shot was a single RAW file. The conditions were so difficult that my main priority was keeping the camera dry. Holding an umbrella in one hand and shooting with the other meant that I could not really change the focal length of the zoom or change camera settings. I tried a number of wide-angle candids, and although the subject's expressions were great, the images did not really capture the extreme rain. I zoomed to 70mm, and the torrential rain was much more accurately recorded. I had just emerged from a dark alley, so the ISO was already at 2200, shooting in aperture priority at f/2.8. My dodgy one-handed camera technique combined with the heavy body/lens required a fast shutter speed. I also let the camera select the focus point, which I normally do not do, but now it was easier. With hindsight, I would have selected a lower ISO for better image quality. That said, the D700 copes so well with noise that I do not really think it is much of an issue, particularly in black and white.

Conditions were so difficult that most of the shots I took, including this one, were instinct shots—there was limited time for composition and limited opportunity to select camera settings. A man ran though the frame from behind me and I recomposed. By luck, this frame had him in mid air as he ran. The telephone box on the right was also in the image by chance. I did not crop it out as it creates depth in the image. The tram acts as a lead-in line to the main figure. I am not sure how much was luck and how much was instinct. Often instinct shots are the best.

Nobody notices a photographer hidden under an umbrella if they're getting soaked in the rain. I was standing next to people, taking pictures of them, and they had no idea.

A couple of hints for these kinds of images: use a long lens, and use a lens hood.

Dan Deakin

I am a photographer living in Nottingham, United Kingdom.

I converted the RAW file into a reasonable black-and-white image in Photoshop Lightroom. I used the Black And White Mix tool in the same way as I use the Channel Mixer tool in Photoshop. I then used the curves tool in Photoshop to adjust different areas of the image, using layers. I also used the curves tool to lighten the rain droplets in a few areas of the image.

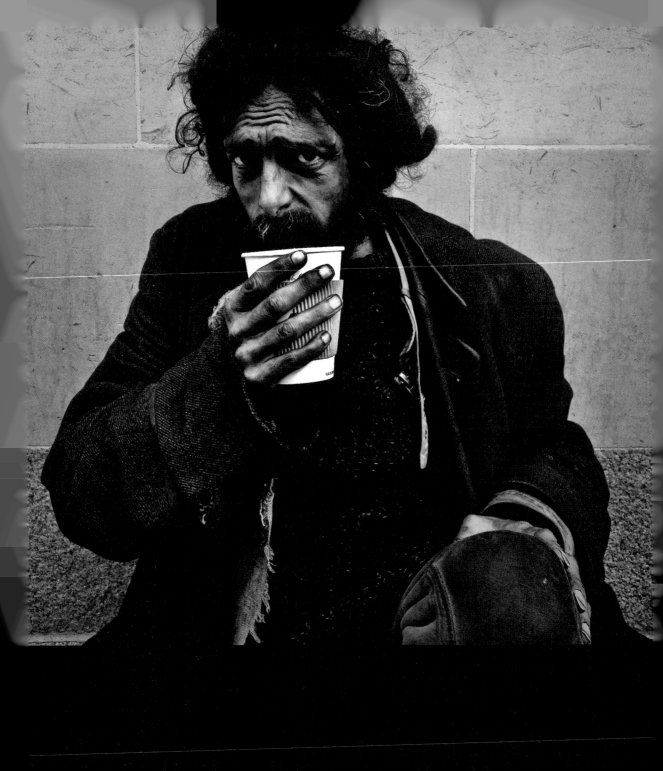

Olympus E-3 • Olympus Zuiko 12–60mm f/2.8–4.0 lens @ 28mm equivalent • f/5.6 • ISO 100

Coffee

This was taken on a OneXposure outing in London. After the traditional English Breakfast, we walked to the National Gallery, and there he was, sitting up against the wall at the one entrance!

I asked him if I could take his picture, to which he agreed. I spent quite a bit of time with him, chatting, and took quite a few shots of him, with this being the best. I thanked him and gave him some money to buy more coffee later in the day.

To me, the success of the image hinges on the ability to contrast the crisp, clean white coffee cup with the grubby state of the man. To achieve this, you want the texture available in the picture to stand out well. I was very pleased with the result. It's reception on onexposure.org was good, and it is one of my favorite images.

What is important in this kind of picture, in my view, is to ensure that the final contrast is correct to bring out the textures against the crisp, white coffee cup. Also, one is not just taking a picture—it needs to stem from an interaction with the subject. In summary: ask the subject if he/she agrees to have their picture taken and respect their answer. Ensure that the post-processing renders the image crisp and sharp, with the right balance between the personality and the contrasting, clean coffee cup. Try to make the subject stand proud of the blank wall/other surroundings.

 Colmar Wocke

I have been taking pictures since around 1968, having started with a Diana plastic camera. I used to enjoy doing street photography as a student. Street photography delivers so many surprises.

The processing was mostly done in Photoshop Lightroom. I used the General Punch preset as a basis. Then, I converted the image to black and white. Because I wanted the crisp, clear coffee cup to stand out, I used the Clarity setting at 100% on the whole image. The exposure needed bumping up due to the gray wall in the background to which the camera had metered. I burned in a little around his hands, to accentuate the state of his nails. I also lightened specific areas on his jacket—the worn threads, the buttons, and so on to accentuate their state. I sharpened the picture by setting that slider on 80 and gave the image a slight vignette, to put him in the center, so to speak. I finally toned the picture in the black and white version using a slight brown tone to bring out the feeling of coffee.

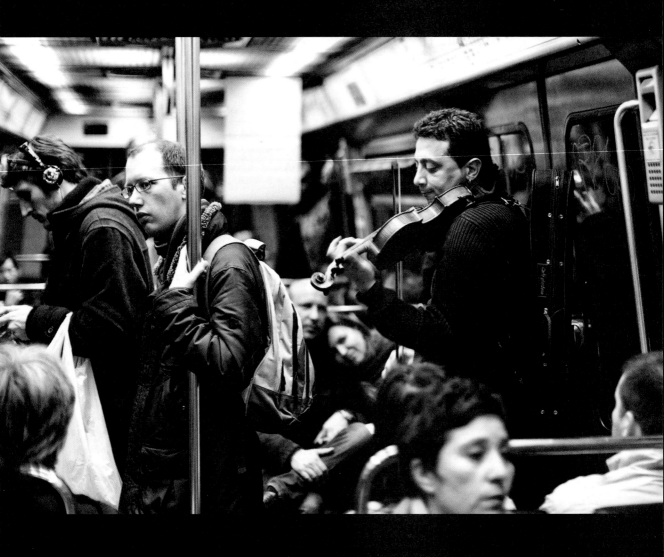

Canon EOS 5D Mark II • Canon 50mm EF f/1.2 lens • f/1.2 • 1/40 second • ISO 320 • RAW

Metro Musician

This spring, I went to Paris for a convention and had to take the Metro from the hotel. The weather in Paris was warm and nice, and it was crowded everywhere. I noticed a lot of street musicians playing in the Metro stations and on the trains themselves.

One thing I have learned is to always carry a camera because you never know when a good photo opportunity will arise. This was one of them.

When shooting street photography, things often happen very fast. You do not always have time to change the camera settings. If you start fiddling with your camera, the moment is often gone. So when I walk around looking for street shots, I usually set my camera to aperture mode with a large aperture. That way, I know that my main focus subject will be sharp and I will also get good bokeh (background blur) for the rest of the scene. My ISO is set to auto because my full-frame camera is able to capture stunning low noise shots, even at high ISO.

The scene on the Metro was perfect with the musician in the focus. The passengers surrounding him, absorbed in their own thoughts and pursuits; it just made the image come to life. The romantic couple listening to his music, the man by the pole looking awkward, the other man with the headset who was fiddling with his phone, and the woman in the front just looking out of the image. All I had to do was to freeze the moment.

The hint for these kinds of candid street shots is to always have your camera ready. I never have the lens cap on when I go out on the street shooting like this. Check your exposure settings if you wander from one place to another and the lighting is substantially different. Try to visualize the scenes that you are going for so that you can somewhat pre-compose the shots in your head.

The goal for this image was to document the street musician. My bonus was that all the other passengers on the Metro took the image to another level.

Bård Ellingsen

I am a 41-year-old Norwegian, married with two kids, and working as an audiologist. My main hobby and passion is photography. I am a self-taught photographer and always keep learning new stuff. Much of my tutoring has come from reading books and photo blogs. My main goal is to get better at composing images. I enjoy all sorts of photography: landscape, portraits, street, sports, and so on.

The file was first processed in Photoshop Lightroom. I did a little cropping and exported it as a JPEG. Then, I converted the image to black and white by using Nik Silver Efex Pro. Next, I made an extra layer in Photoshop CS5 and added the high-pass filter for some additional sharpening with a 1.5 pixel radius. I blended the layers with Overlay and flattened the layer before saving it as a JPEG. There are several ways you can sharpen your images. If I am processing several images at once, I often only use the sharpening slider in Lightroom. But for those "special" images that I process in Photoshop, I use the high-pass filter.

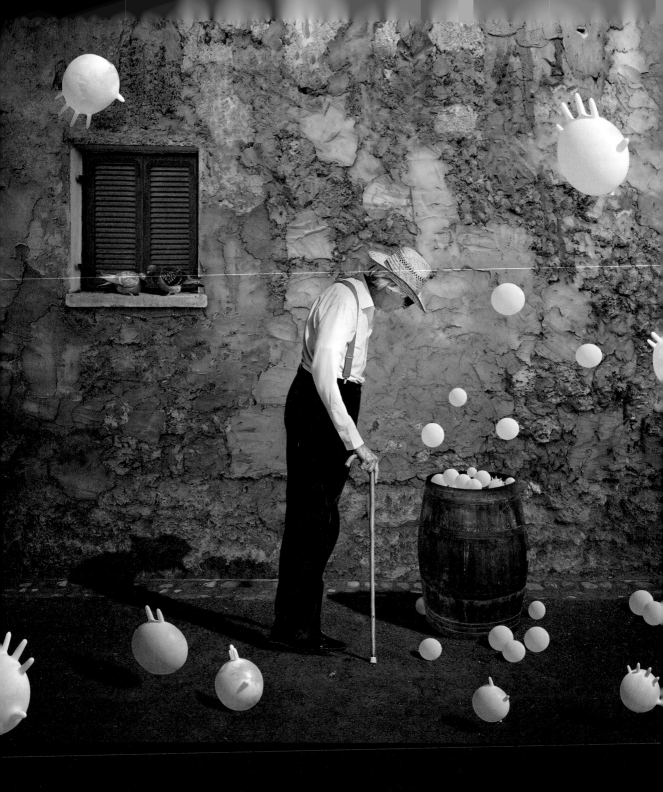

Nikon D80 • Nikkor 18-200mm VR lens @ 175mm • f/3.2 • 1/2500 second • ISO 100 • RAW

Allegory of a Dream

 Dina Bova

It was a hot, sunny day and the streets were filled with people. Among the crowd, clad in t-shirts, shorts, and jeans, was an unusual, older gentleman. He was tall, holding a cane, and dressed differently from everyone else. Near him was a little boy, throwing an inflated rubber glove into the air. The old man looked thoughtfully at the white glove as it rose into the air triumphantly, two fingers extended in a "V" reminiscent of Winston Churchill— then it fell to the ground with a gesture of "live or die."

A light breeze shook the glove from the side, giving the illusion of not one glove, but many. The man kept staring as if the gloves were his dreams—fulfilled and unfulfilled—or perhaps the dreams for which destiny is still unknown...

I was born in Moscow and moved to Israel when I was 13 years old.

My profession is algorithms engineer, specializing in computer-vision algorithms.

I started to become interested in photography during my travels around the world. This was my first push into artistic photography. But soon, I felt too constrained by classic photography. I understood that I can do much more with digital photography and extend my horizons. I didn't want to limit myself. I wanted to create dreams.

For me, art is something that appeals to our senses and emotions, and not to our intellect and instincts.

This moment was the first inspiration for what would later be an artwork named *Allegory of a Dream.*

This piece is a composite of five main elements:

1) The protagonist—the old man.
2) The white medical gloves—I took several photographs of the gloves in various locations.
3) The barrel.
4) The pigeons.
5) The wall with the window.

The five main elements of *Allegory of a Dream.*

I shot all of the elements that same day, apart from the barrel, which I took at a different location, altogether.

Before going further, let me touch upon the composition and how I chose the optimal location of all elements in the scene. In this particular case, I felt that a square "stage" would be most effective for composing the scene and situating the characters within it. In the illustration below, I've drawn some guidelines to clarify the main idea.

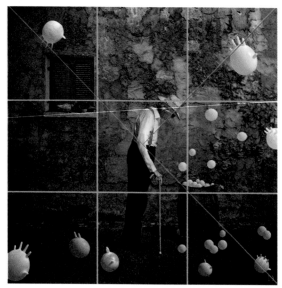

The human eye trains its focus most on the objects near the edges of the inner square. These edges are found on the horizontal and vertical thirds.

The old man's head is located exactly on one such edge (the upper-horizontal third).

His eyes are located near this edge and on the diagonal line that descends from the upper-right corner; this line is also perpendicular to the opposite diagonal.

The man's center of mass is located exactly on the square's center.

The barrel, the man, and the window are located on the same diagonal that descends from the upper-left corner to the lower-right corner.

These classical laws of composition have been used by painters and masters of the past. But, for every rule, there are exceptions. We should know the rules and also know if and when to break them.

I used Adobe Photoshop CS4 software to create this artwork. I also used Adobe Photoshop Lightroom for making a few adjustments on exposure settings for the RAW images.

This piece was created in six stages:

1) *Building the background* The stage for the characters: a wall with a window and a barrel on the ground.

2) *The old man* Using the Pen tool, I carefully cut the old man out of the original image and placed him in the background.

3) *Creating the shadows* I added a broken shadow of the old man in two parts: on the ground, and on the wall. There's also a conceptual aspect to making the shadow broken and bended, but I'll leave it to you to interpret it in your own way.

4) *Inserting the gloves* I cut different variations of the gloves, adjusting the shapes of some of them. I also created the balls from these gloves.

5) *Adjusting the lighting* I used the Lighting effects filter to create proper lighting on the gloves. I also created the gloves' shadows on the ground, taking into consideration the lighting direction and the estimated distance from the ground.

6) *Adding the pigeons and finalization* Finally, I added the pigeons and made final adjustments to contrast and colors until I achieved the result that I liked.

In this work, I wanted to tell a story about fulfilled and unfulfilled dreams; a story with an open end. We all have dreams. Will our dreams come true?

In the words of 5th century Indian writer and poet, Kalidasa, "Yesterday is but a dream, tomorrow is only a vision. But today well lived makes every yesterday a dream of happiness, and every tomorrow a vision of hope."

This work also has several international photography awards:

- *2011, Hasselblad Masters, Denmark* Finalist and a Nominee to "Hasselblad Master" title
- *2011, Blindonkey Art Prize, Italy* Finalist in "Photography" category
- *2010, International Photography Awards (IPA), USA* Honorable Mention award in professional Fine-Art category, "Collage."
- *2010, Trierenberg Super Circuit, Austria* Gold medal of Excellence
- *2009, French Digital Tour, France* Best of Show Gold medal

It's hard to advise how to create such artworks, but I think the following is important:

Composition and lighting Study and learn from the masters of the past, both photographers and painters. In the era of the Internet, it's possible to study the masterpieces without leaving home. Explore their works. Observe how they position the characters, how they draw the light, feel the harmony of the colors, learn, get inspired, but never try to copy; develop your own style.

Technique Don't let creative ideas be ruined by a bad execution and a bad technique. It's important to be as accurate as possible, never forgive yourself small flaws, pay attention to details, learn from others, and strive for perfection.

Creativity Open your mind; allow yourself to flow with your imagination. Look around with eyes wide open. Don't be afraid to try and to experience, do crazy things. I think artwork can be created with any tool and any medium, but it should speak for itself and convey a very special mood. It should need no explanation, no elaboration, and no apologies. It can be very aesthetic or the complete opposite. The most important thing is to free the imagination, such that "the sky is the limit."

My art is a world of allegories, metaphors, and multifaceted associations. This world is sometimes absurd and paradoxical, sometimes strange and surreal, but this world is a reflection of my true feelings. In this world, different emotions coexist side by side: irony, fear, joy, pain, sometimes even madness and despair, but there's always a presence of hope and there's never hatred. I don't like to impose my point of view on the spectator. I only slightly open a door to a wonderland, where everyone can find something of his own.

For most of my works, I first think of an idea, which is only a basic melody of the work. Then, I stage the scene and photograph it. It's similar to composing a piece of music for different instruments. And finally, like in a jazz, I flow with creative improvisation during the post-processing, which might take me far away from the original photograph.

But, sometimes I simply walk with my camera and photograph whatever seems interesting around me. I call it "potential material" for future works. These works wait for their time to be emerge.

If you want to know more about me, you're welcome to visit my site at www.dinabova.com.